# Edgar Degas

By Maria Tsaneva

First Edition

*****

Edgar Degas
*****

Copyright © 2014 by Maria Tsaneva

## *Foreword*

Edgar Degas seems never to have reconciled himself to the label of "Impressionist," preferring to call himself a "Realist" or "Independent." Nevertheless, he was one of the group's founders, an organizer of its exhibitions, and one of its most important core members. Like the Impressionists, he sought to capture fleeting moments in the flow of modern life, yet he showed little interest in painting plain air landscapes, favoring scenes in theaters and cafes illuminated by artificial light, which he used to clarify the contours of his figures, adhering to his Academic training. Unusual vantage points and asymmetrical framing are a consistent theme throughout Degas's works.

Degas was born in 1834, the scion of a wealthy banking family, and was educated in the classics, including Latin, Greek, and ancient history, at the Lycee Louis-le-Grand in Paris. His father recognized his son's artistic gifts early, and encouraged his efforts at drawing by taking him frequently to Paris museums. Degas began by copying Italian Renaissance paintings at the Louvre, and trained in the studio of Louis Lamothe, who taught in the traditional Academic style, with its emphasis on line and its insistence on the crucial importance of draftsmanship. Degas was also strongly influenced by the paintings and frescoes he saw during several long trips to Italy in the late 1850s; he made many sketches and drawings of them in his notebooks.

Evidence of Degas's classical education can be seen in his relatively static, frieze-like early painting, Young Spartans Exercising (c. 1860; National Gallery, London), done while he was still in his twenties. Yet despite the title, and the suggestion of classical drapery on some of the figures in the background, there is little that places the subject of this painting in ancient Greece. Indeed, it has been noted that the young girls have the snub noses and immature bodies of "Montmartre types," the forerunners of the dancers Degas painted so often throughout his career. After 1865, when the Salon accepted his history painting The Misfortunes of the City of Orleans, Degas did not paint Academic subjects again, focusing his attention on scenes of modern life. He began to paint scenes of such urban leisure activities as horse racing and, after about 1870, of cafe-concert singers and ballet dancers.

Degas's choice of subject matter reflects his modern approach. He favored scenes of ballet dancers, laundresses, milliners (At the Milliner's, 1882), and denizens of Parisian low life. His interest in ballet dancers intensified in the 1870s, and eventually he produced approximately 1,500 works on the subject. These are not traditional portraits, but studies that address the movement of the human body, exploring the physicality and discipline of the dancers through the use of contorted postures and unexpected vantage points.

Thirty-eight sketchbooks by Degas have survived essentially intact. They cover the period between 1853 and 1886 and constitute the most significant sustained record of any Impressionist artist. His early sketchbook contains diligent student work, such as sketches of antique statuary and copies of Renaissance frescoes and paintings. The subjects range from the whimsical to the thoughtful, with quick portraits of dinner guests, sketches of dancers, and scenes from a Turkish bath in the later notebook.

Degas' much-heralded explorations of dancers — in rehearsal, on stage, and at rest — began in the 1870s and intensified during the ensuing decades. This period also marked the beginning of his success as an artist. One of Degas' principal concerns as a draftsman was analyzing the movements and gestures of the female body. On view are several drawings featuring dancers, including Three Studies of a Dancer (ca. 1880), easily recognizable as the study for the celebrated wax sculpture Little Dancer, Fourteen Years Old, depicting the young dancer Marie van Goethem. In this large sheet, the artist studied her from three different angles, attempting to understand the figure in the round in preparation for sculpting it.

Other examples of drawings with dancers include Seated Dancer (ca. 1871), one of the studies for Dance Class at the Opéra on the Rue le Peletier, now in the Musée d'Orsay in Paris, as well as Two Studies of Dancers (ca. 1873), Dancer with Arms Outstretched (ca. 1878), and Two Studies of a Ballet Dancer (ca. 1872).

Though noted for his attention to the female figure, Degas executed many studies of grouped horses and jockeys from which he would use figures in later compositions. Later in his career, Degas experimented with mixing drawing media and printmaking techniques. He began the drawing in 1885 using an impression from his 1877–78 lithographs of a concert at Café des Ambassadeurs, which he extended along the bottom and right edges, and drew over in dense strokes of pastel. Degas first produced a monotype—a unique print made from drawing in ink on a metal or glass plate—of two singers on stage, seen from behind, with a view to the audience. He then enlivened the print with richly colored pastels. In the village of Diénay near Dijon, Degas recalled scenery from the drive through the Burgundian countryside and produced about fifty monotype landscapes. To create this drawing, he used oil paint (and apparently his fingers) to indicate a few lines of landscape on the plate and printed one or two proofs, hanging them to dry. Later, he completed the composition with a rich layer of pastel.

Degas absorbed artistic tradition and outside influences and reinterpreted them in innovative ways. Following the opening of trade with Japan in 1854, many French artists, including Degas, were increasingly influenced by Japanese prints. But whereas his contemporaries often infused their paintings with Eastern imagery, Degas abstracted from these prints their inventive compositions and points of view, particularly in his use of cropping and asymmetry. Degas had also observed how sixteenth-century Italian Mannerists similarly framed their subjects, sometimes cutting off part of a figure. He experimented with an array of techniques, breaking up surface textures with hatching, contrasting dry pastel with wet and using gouache and watercolors to soften the contours of his figures.

By the late 1880s, Degas's eyesight had begun to fail, perhaps as a result of an injury suffered during his service in defending Paris during the Franco-Prussian War of 1870–71. After that time he focused almost exclusively on dancers and nudes, increasingly turning to sculpture as his eyesight weakened. In his later years, he was concerned chiefly with showing women bathing, entirely without self-consciousness and emphatically not posed. Despite the seemingly fleeting glimpses he portrayed, he achieved a solidity in his figures that is almost sculptural.

In later life, Degas became reclusive, morose, and given to bouts of depression, probably as a consequence of his increasing blindness. Degas continued working as late as 1912, when he was forced to leave the studio in Montmartre in which he had labored for more than twenty years. He died five years later in 1917, at the age of eighty-three.

# *Paintings*

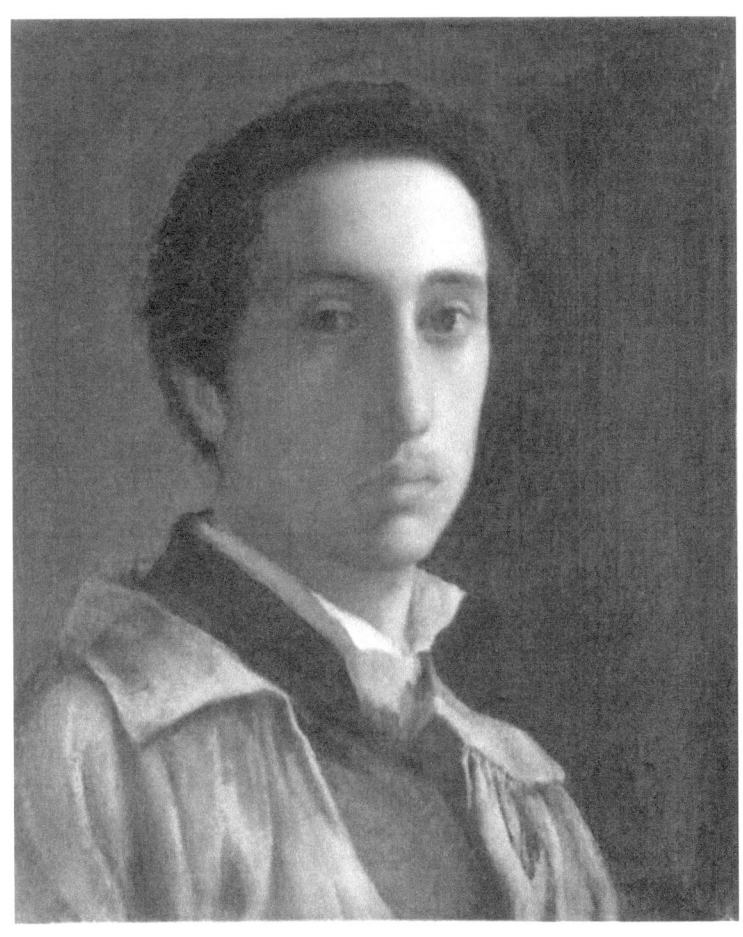

Self-Portrait
1855–56, Oil on paper, laid down on canvas

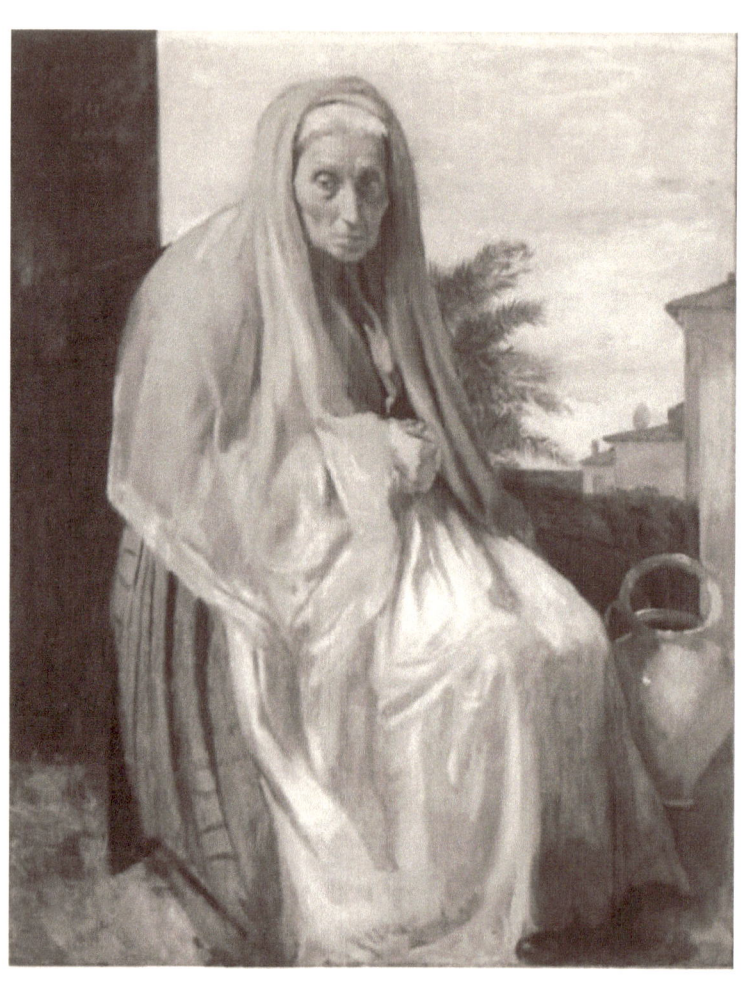

The Old Italian Woman
1857, Oil on canvas

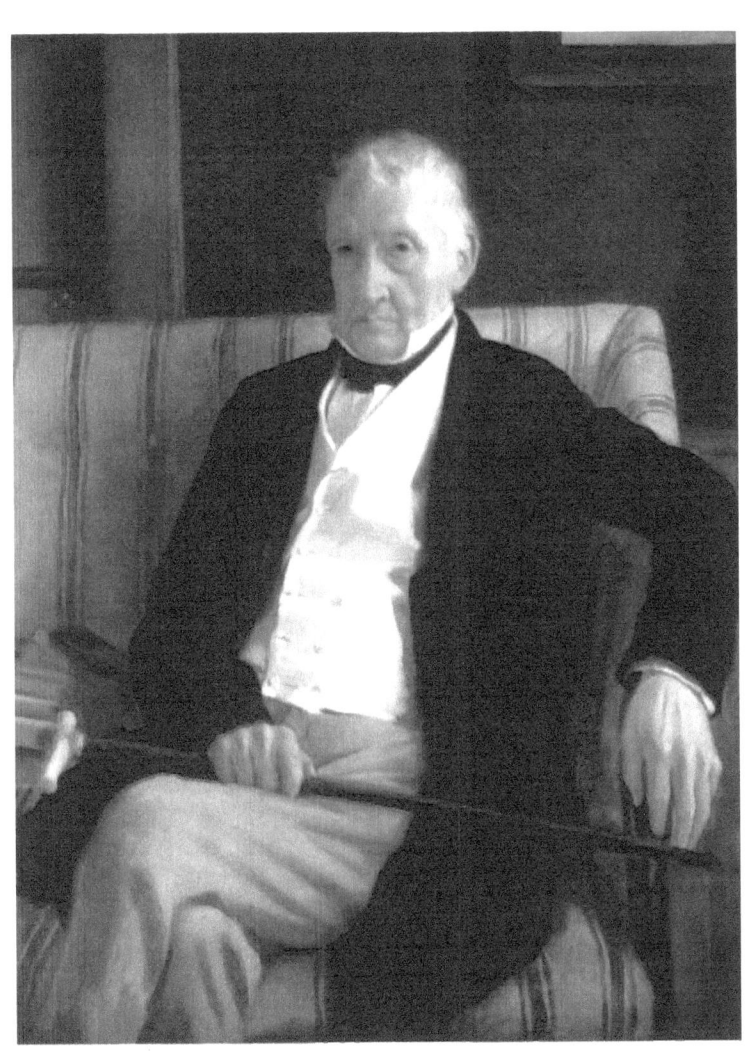

Hilaire de Gas
1857, Oil on canvas, 53 x 41 cm

Degas's family were related to the Italian aristocracy, among them Baroness Bellelli and Duchess Morbilli. In 1856 he traveled for the first time to Italy, where he intended to make the acquaintance of his Italian relatives. This journey, which was followed by another in 1858 and several more in 1859, was Degas's real education. In Italy, Degas preferred the Quattrocento painters and the exponents of Florentine Mannerism.

The people Degas depicted in that time were almost all members of his family, especially his sisters and brothers, and himself. His early portraits achieve their culmination in his group portrait The Bellelli Family.

The present painting represents Hilaire de Gas, the painter's grandfather.

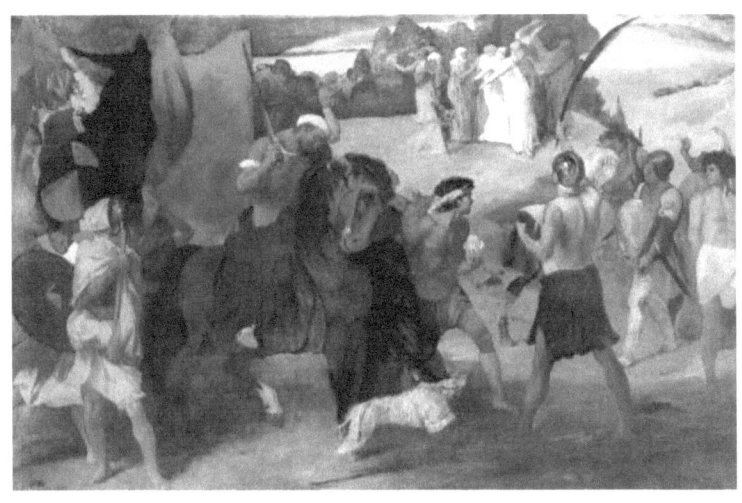

Jephthah's Daughter
1859-60, Oil on canvas

Beside portraiture, Degas's early work was also centred on historical themes drawn from religious tradition or mythology. Between 1860 and 1865 he painted five historical paintings, for which there are several sketches and versions: Young Spartans Exercising, Semiramis Founding a City, Alexander and Bucephalus, Jephthah's Daughter, and The Sufferings of the City of New Orleans, the latter being his first entry at the Salon.

These paintings are very original and unlike any historical painting in the nineteenth century. They conformed to the rules of classicist composition, but they were also innovative because of the freshness of his figures and the warm colours of his landscapes.

The Jephthah's Daughter is probably the most successful of these early pictures. It depicts a scene from the Old Testament. Jephthah was a great Old Testament (Judges 11:30-40) warrior, who was called upon to lead the Israelites in their war against the Ammonites. On the eve of the battle he made a pact with God, that, in return for victory, he would sacrifice 'the first creature that comes out of the door of my house to meet me when I return'. The battle won, 'who should come out to meet him with tambourines and dances but his daughter, and she only a child'.

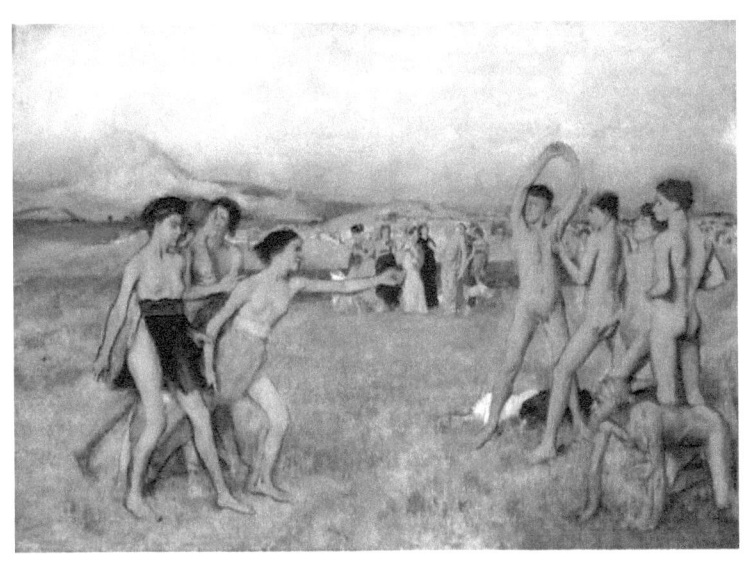

Young Spartans Exercising
c. 1860, Oil on canvas

Beside portraiture, Degas's early work was also centred on historical themes drawn from religious tradition or mythology. Between 1860 and 1865 he painted five historical paintings, for which there are several sketches and versions: Young Spartans Exercising, Semiramis Founding a City, Alexander and Bucephalus, Jephthah's Daughter, and The Sufferings of the City of New Orleans, the latter being his first entry at the Salon.

The Young Spartans Exercising was reworked several times, and numerous related drawings and studies survive.

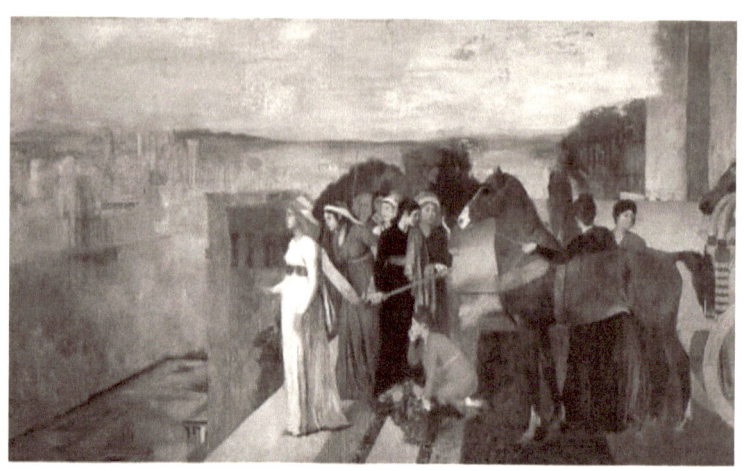

Semiramis Building Babylon
1861, Oil on canvas

In the early 1860s, Degas experimented with history paintings which never left his studio. One example is the Semiramis Building Babylon which may have been an allusion to the radical redesign of Paris being undertaken by Baron Haussmann

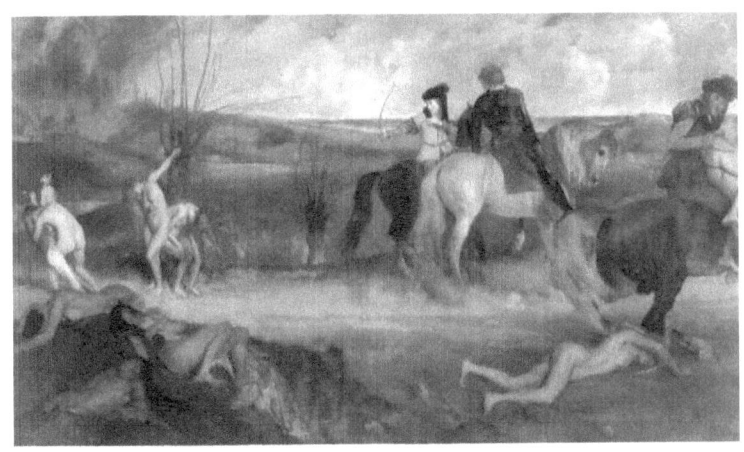

The Sufferings of the City of New Orleans
1865, Oil on paper, mounted on canvas

Degas made his Salon debut in 1865 with The Sufferings of the City of New Orleans. To the artist's disappointment, it was given scant attention. It must have seemed anachronistic and artificial; a medieval landscape setting was being used to symbolize the sufferings of the American city of New Orleans, which was occupied by Union troops in 1862 in the course of the Civil War.

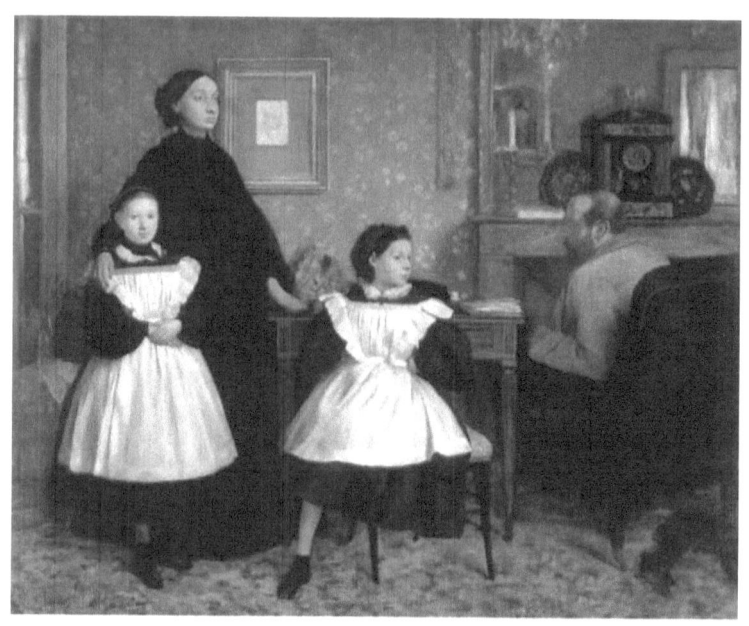

The Bellelli Family
1860-62, Oil on canvas

Edgar Degas had come to Italy, where part of his family lived, in 1856. In Florence in 1858, he painted his portrait of the Belleli family, which represented his first brush with tradition. He worked on the picture for almost ten years before showing it under the title Family Portraits at the 1867 Salon in Paris, where it passed unnoticed. He did numerous detail studies (faces, hands) and packed the composition with deliberate meaning.

The picture portrays the domestic drama of a family exiled from Naples to Florence, much to the despair of Laura (his seriously depressive cousin) and her irascible husband Gennaro, who had no proper job and whom we see turning almost reluctantly to face his wife and daughters. The youngest, Giulia, sitting on a stool with one leg tucked under her, appears impatient, lending animation to the whole, while in the great tradition of group effigies from the classical era Degas includes a portrait of his grandfather Hilaire Degas, on the wall behind his daughter Laura. Hilaire had just died in Naples (in 1858), hence the dark mourning dress, alleviated only by the girls' pinafores.

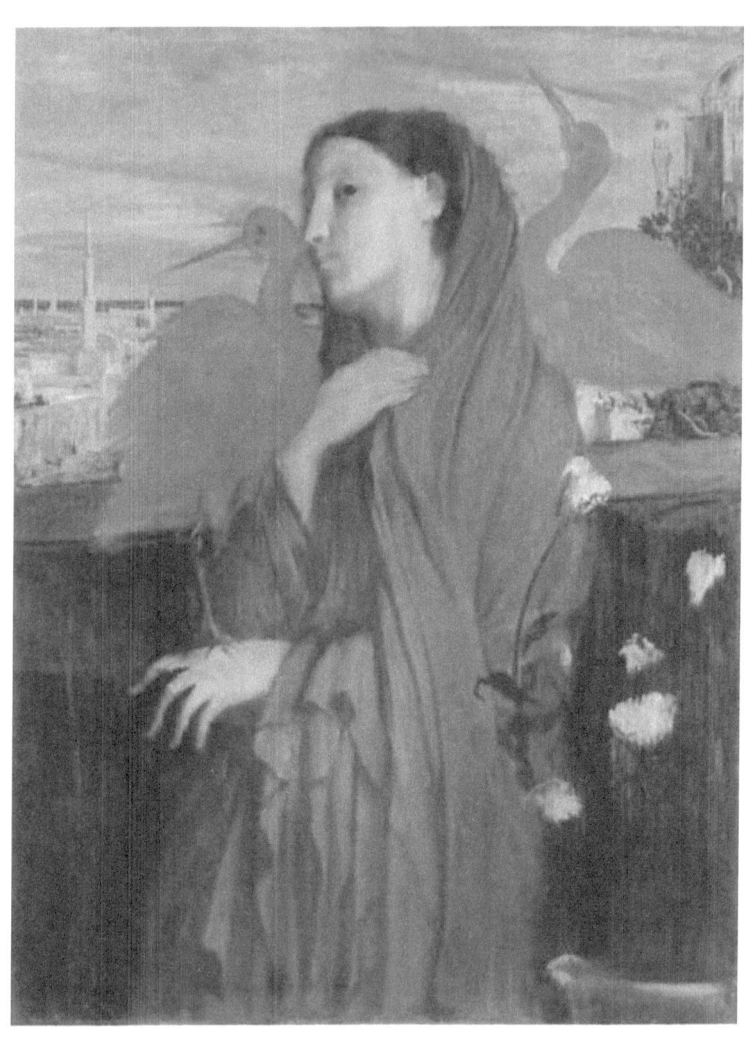

Young Woman with Ibis
1860–62, Oil on canvas

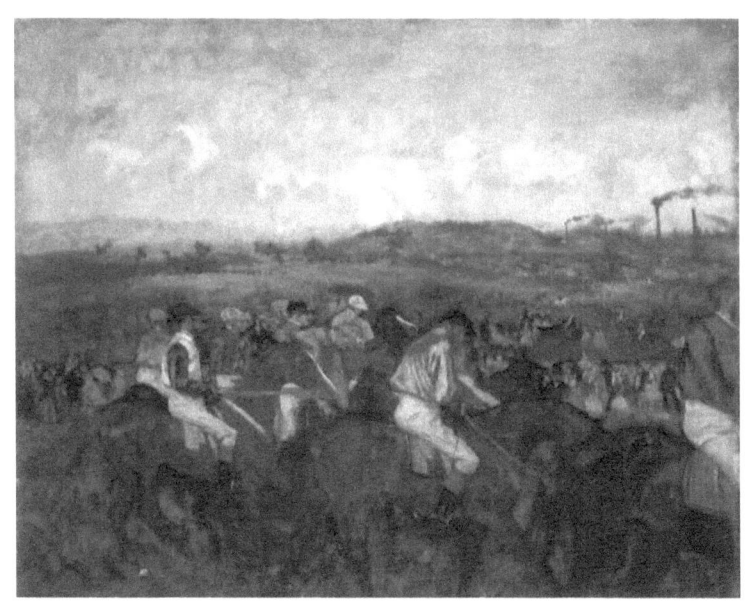

Gentlemen's Race, Before the Start
1862, Oil on canvas, 49 x 62 cm

Degas's paintings used a restless patterning of colour patches and combined a precision rendering of positions with sketchy brushwork - especially for the background, where smoking factory chimneys or a glimpse of a railway train suggested the proximity of a modern city. Degas cropped his figures brusquely as if to emphasize that the picture could convey no more than a spatial and temporal section of a larger scene and continuing motion.

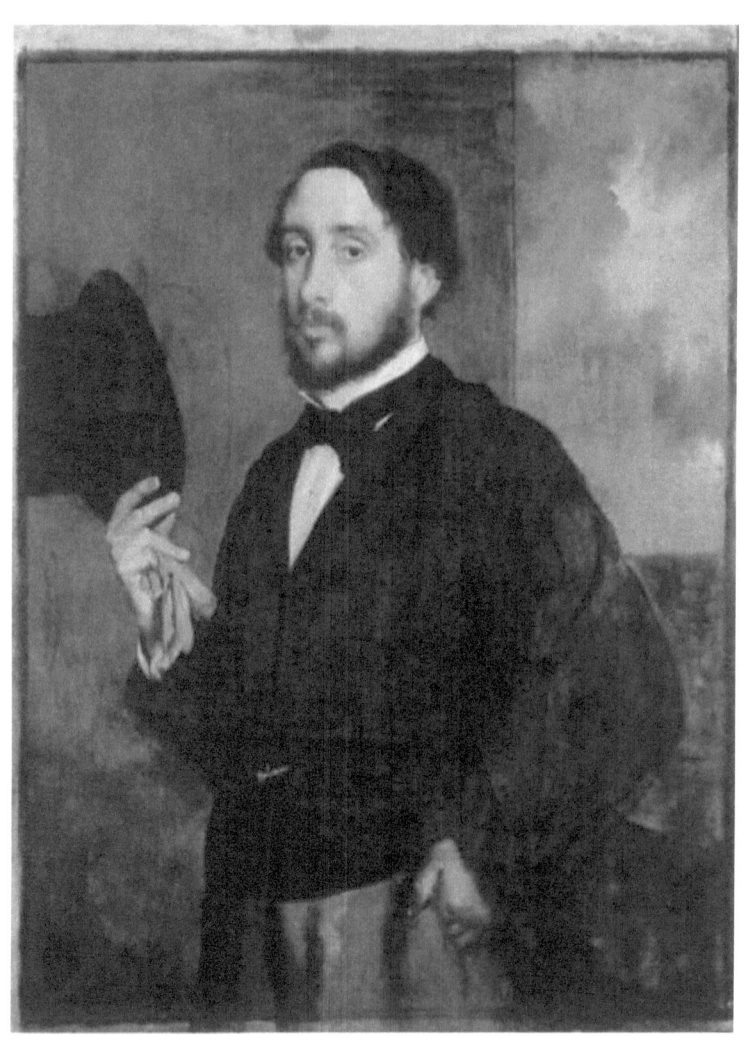

Self-Portrait
c. 1863, Oil on canvas

This unfinished self-portrait shows a man not quite thirty, a stylish man of the middle class, with gloves and top hat, facing whatever the future may have in store with calm self-assurance.

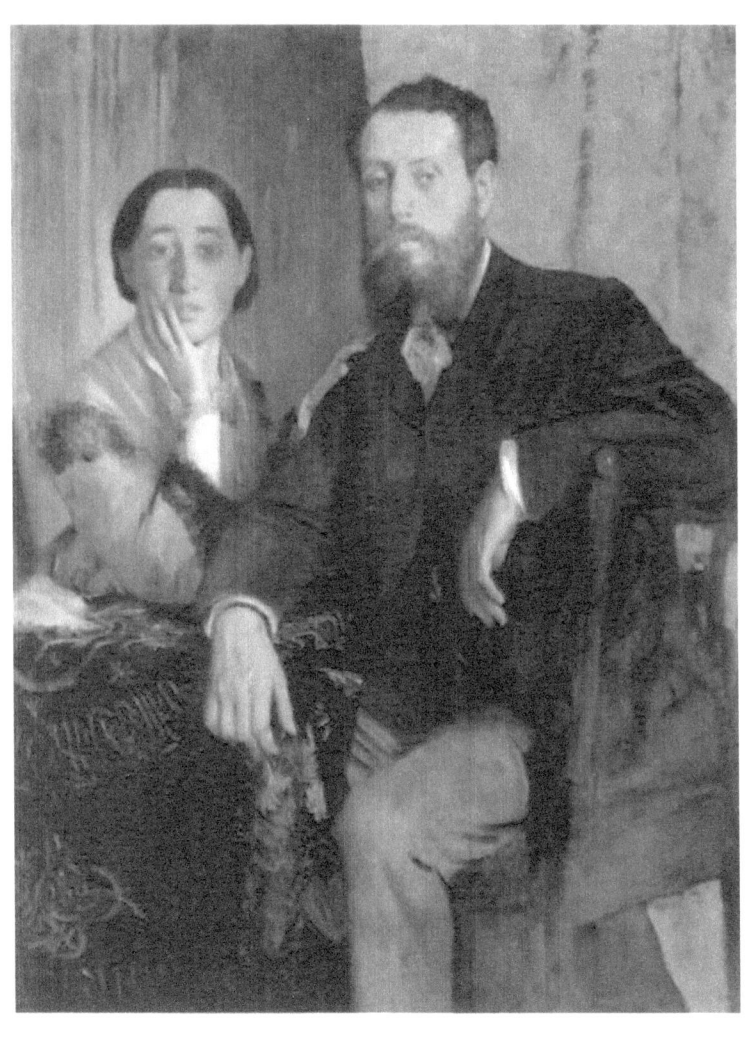

Monsieur and Madame Edmondo Morbilli
c. 1865, Oil on canvas

Degas produced many portraits between 1865 and 1870, too, the major ones of which were Thŭrŭse de Gas, Double Portrait, The Collector, Madame Hertel, Duke and Duchess of Morbilli, Jacques Joseph (James) Tissot, Mademoiselle Dihau at the Piano, Madame Camus at the Piano, Portrait of Hortense Valpinuon as a Child.

Conventional as they may be, these portraits highlight both what is characteristic and what is casual in the personality and deportment of the sitter.

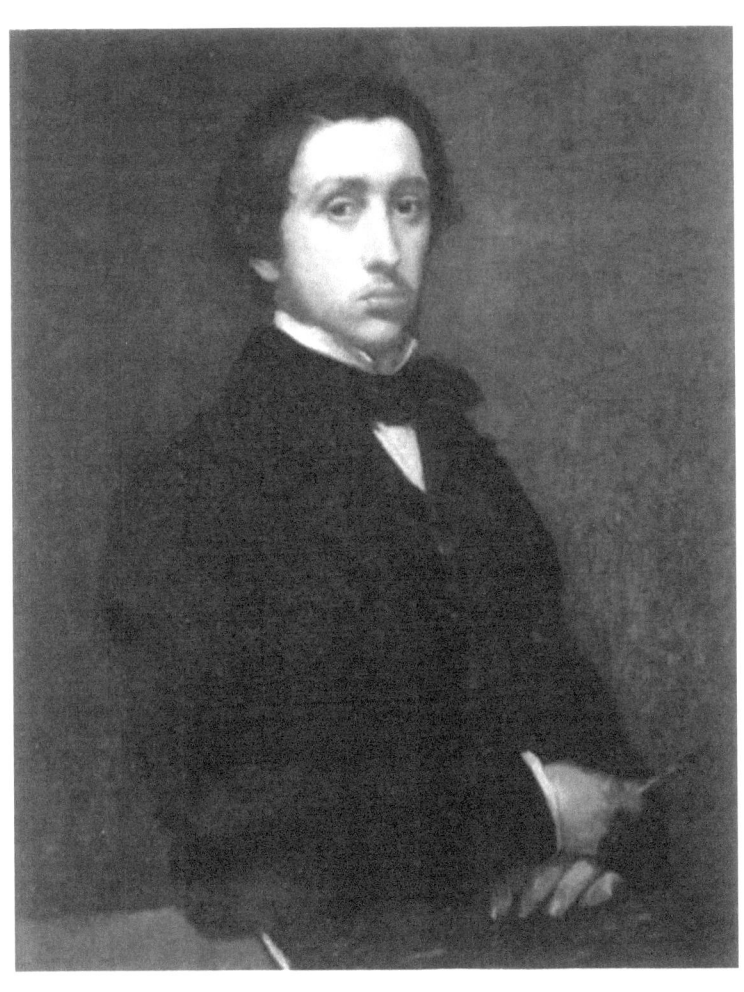

Self-Portrait
c. 1865, Oil on paper

Degas, as a young man, was very ambitious in some of his early works, tackling both portraiture and even historical painting. His self-portrait shows the 21-year-old painter as a reserved and even aloof observer. An overall sense of restraint permeates the painting.

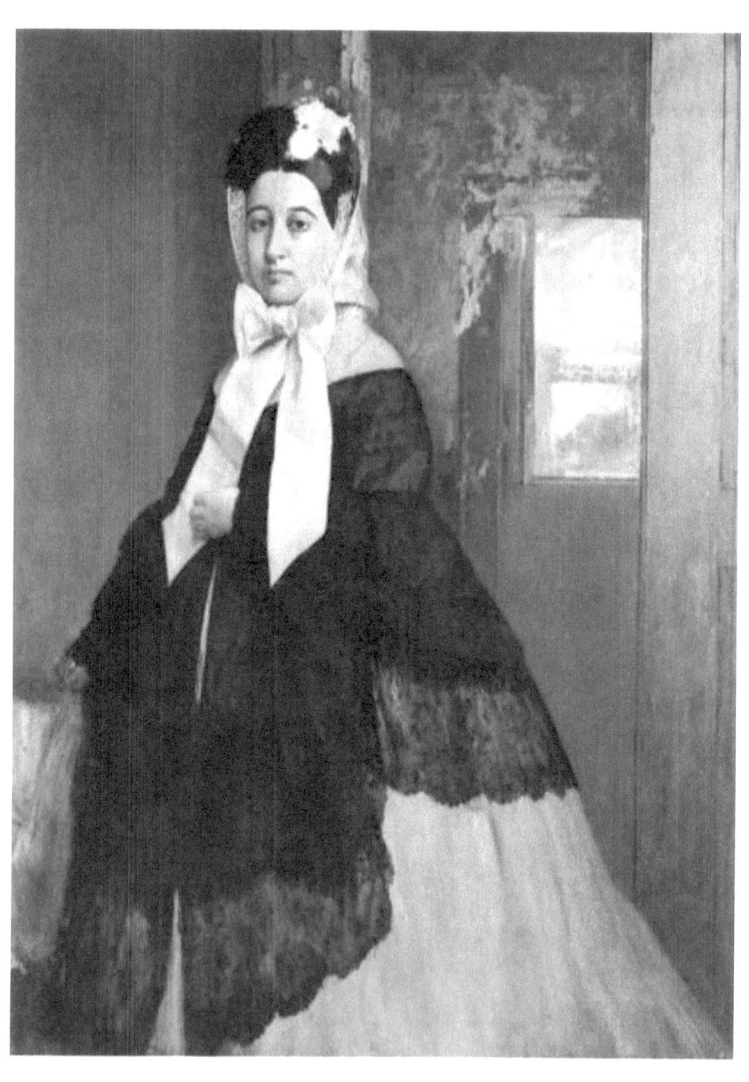

Portrait of Therese de Gas
c. 1865, Oil on canvas

Degas's family were related to the Italian aristocracy, among them Baroness Bellelli and Duchess Morbilli. In 1856 he traveled for the first time to Italy, where he intended to make the acquaintance of his Italian relatives. This journey, which was followed by another in 1858 and several more in 1859, was Degas's real education. In Italy, Degas preferred the Quattrocento painters and the exponents of Florentine Mannerism.

The people Degas depicted in that time were almost all members of his family, especially his sisters and brothers, and himself. His early portraits achieve their culmination in his group portrait The Bellelli Family.

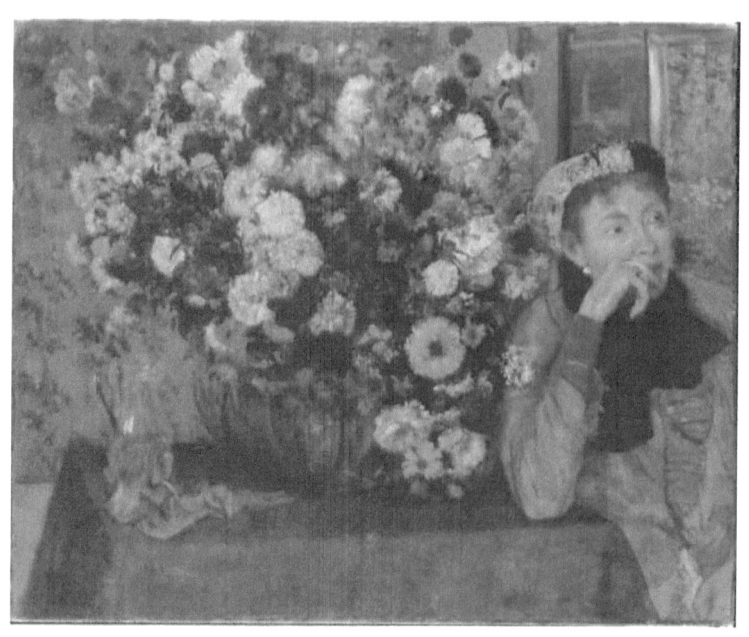

Woman Leaning on an Elbow beside a Vase of Flowers
1865, Oil on canvas
The woman depicted is probably Madame Paul Valpinuon.

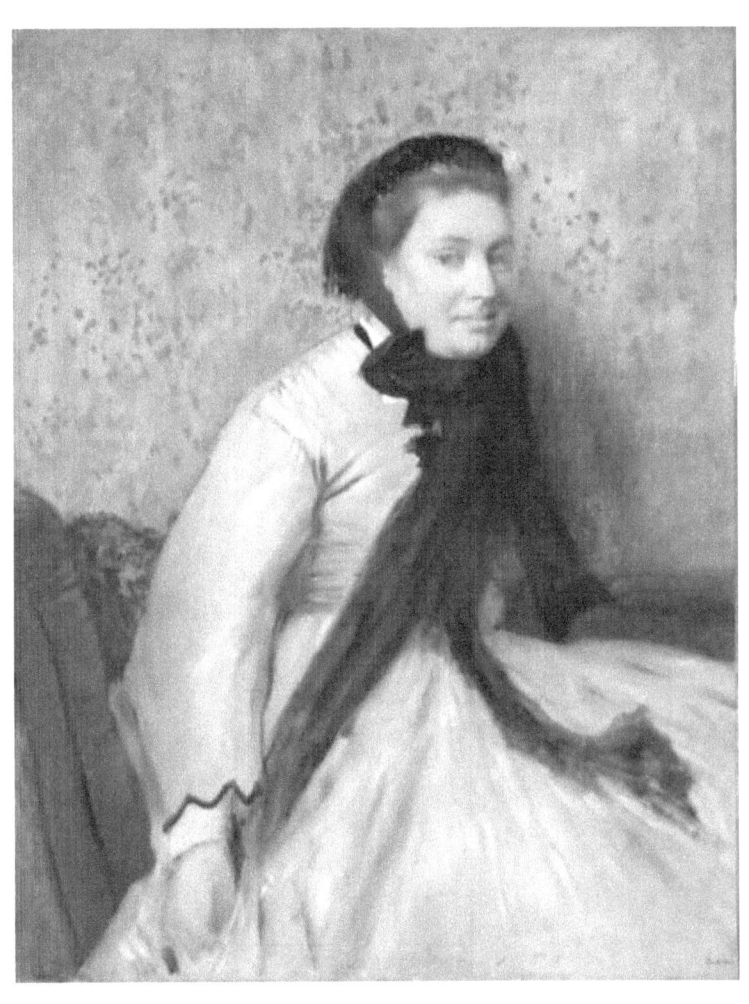

Portrait of a Woman in Gray
c. 1865, Oil on canvas

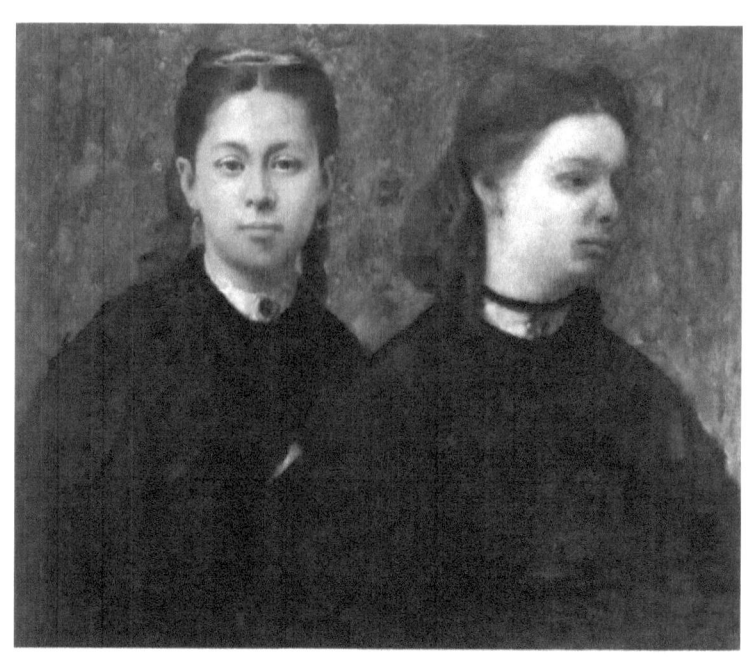

Double Portrait
c. 1865, Oil on canvas, 57 x 70 cm
The painting represents the cousins of the painter.

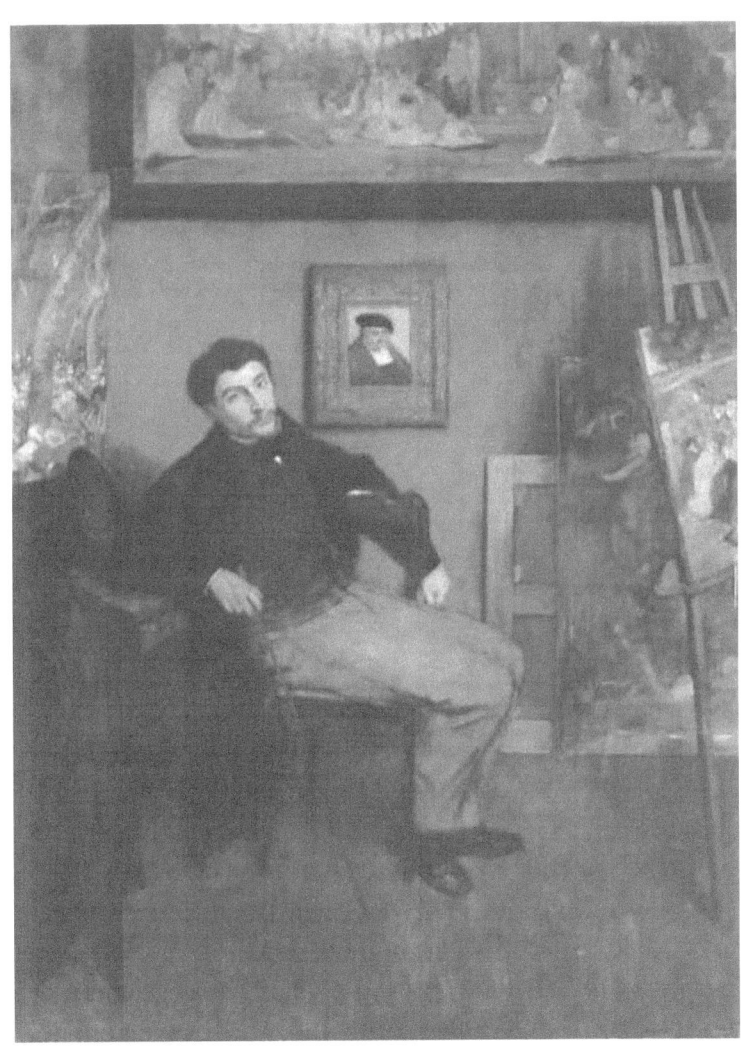

Jacques Joseph Tissot
1866-68, Oil on canvas
James Tissot was a French painter who spent part of his career in London.

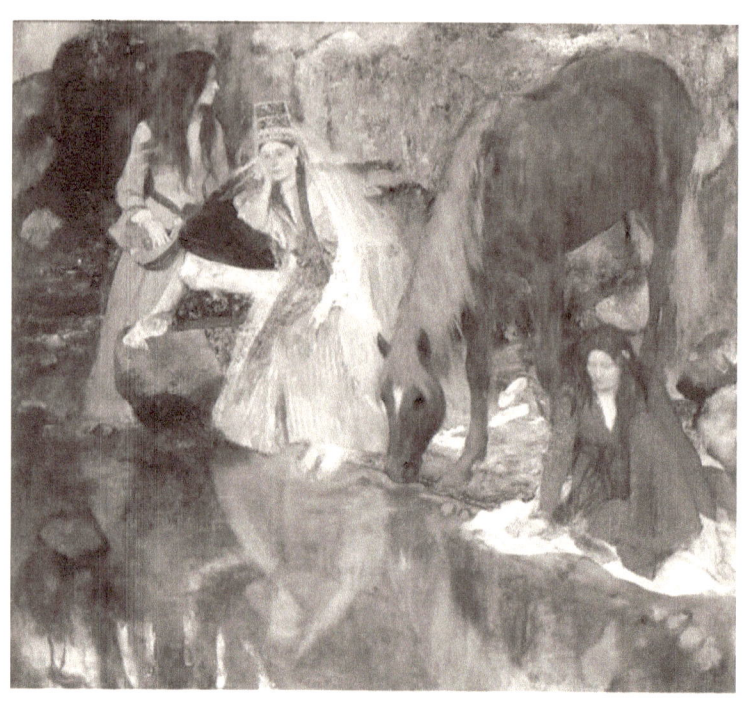

Mademoiselle Fiocre in the Ballet "La Source"
c. 1866, Oil on canvas

The theme of this work comes from the world of the theatre. Eugenie Fiocre was a ballerina at the Paris Opera, and one of her main parts was the role of Nouredda in Saint-Lňon's ballet "La Source." There is a romantic undercurrent in this painting showing a charming exoticism. The theatrical setting is not taken from the reality of the stage, as in Degas's later paintings of dancers, but appears as an element of romanticism. However, the drinking horse is a realistic detail, a real life study.

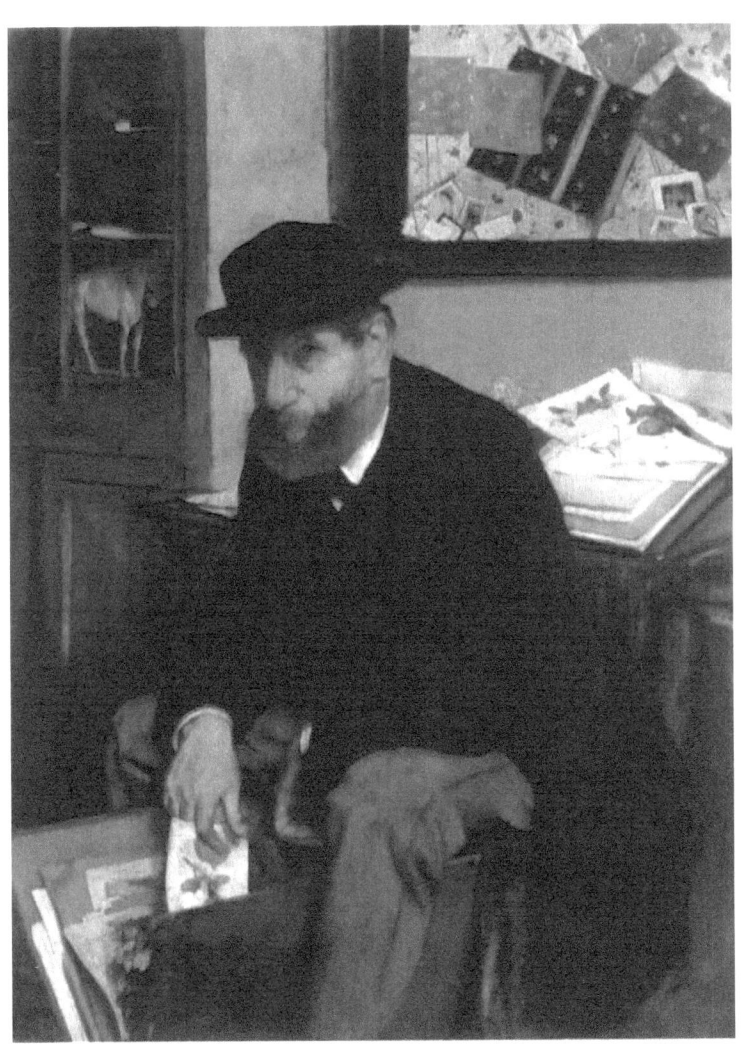

The Collector
1866, Oil on canvas, 53 x 40 cm

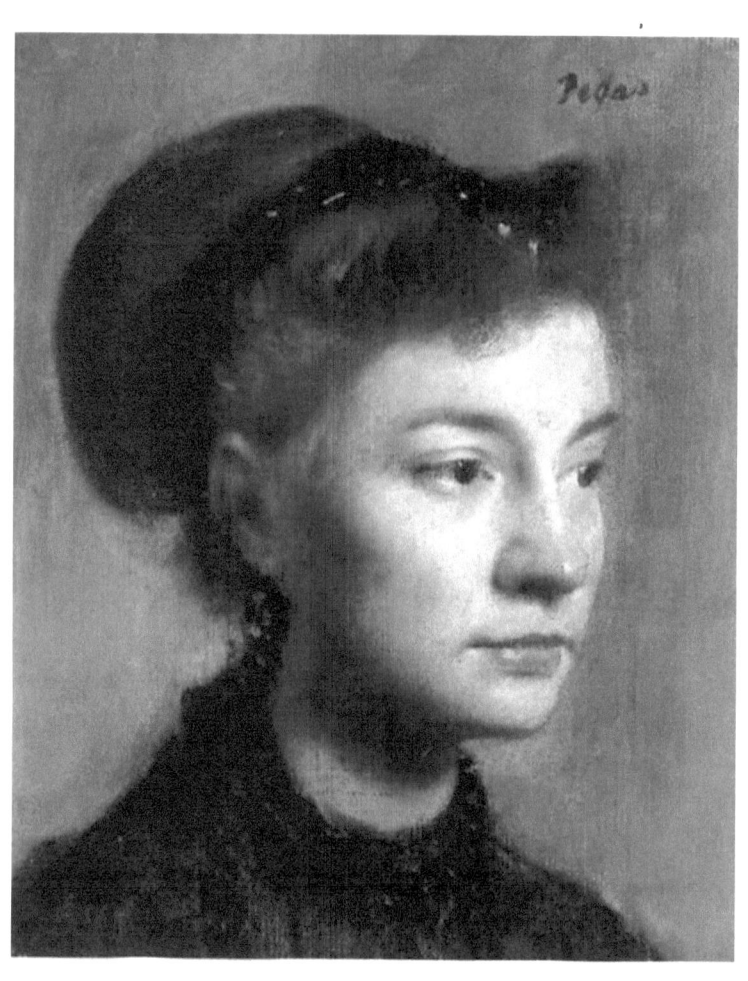

Portrait of a Young Woman
1867, Oil on canvas

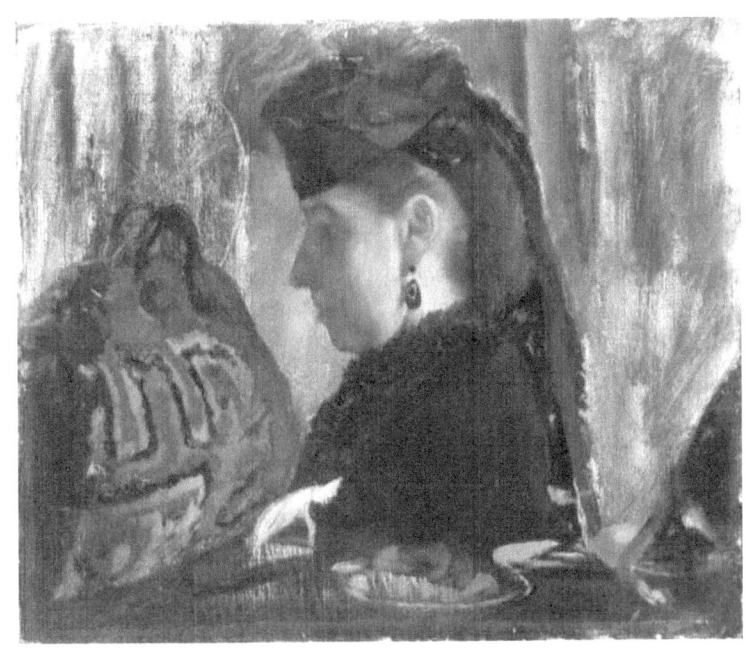

Mademoiselle Marie Dihau
1867–68, Oil on canvas

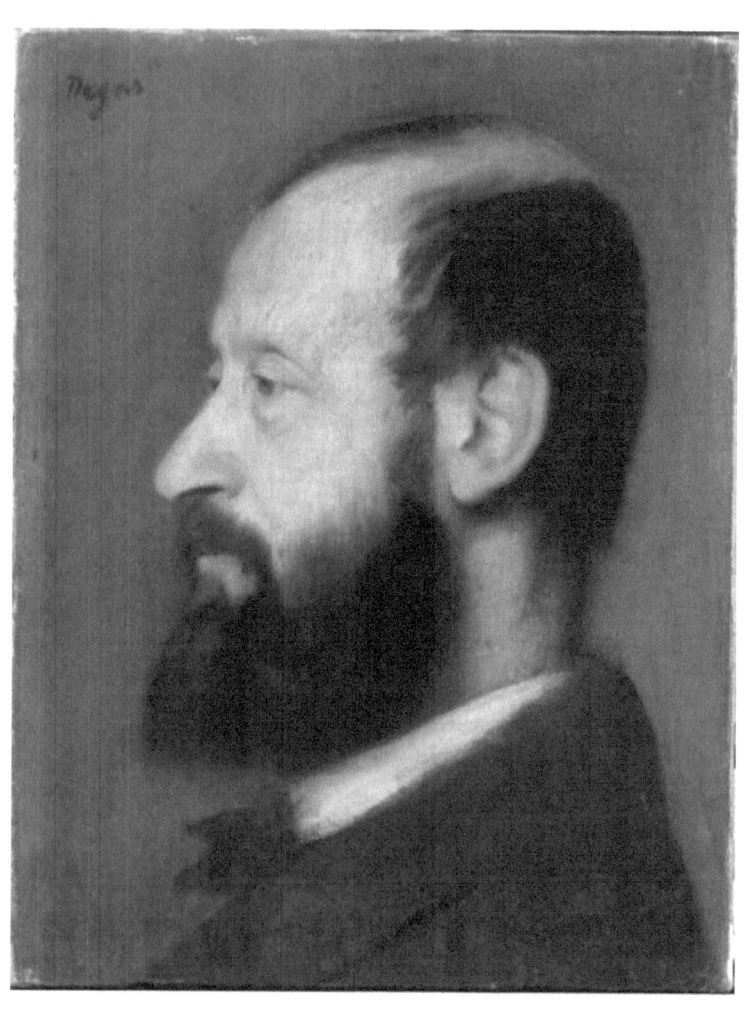

Joseph-Henri Altes
1868, Oil on canvas

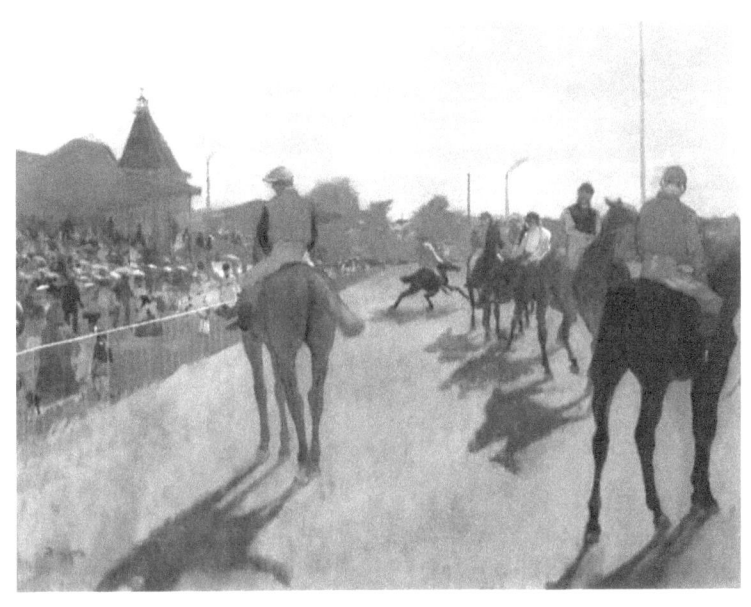

The Parade
1866-68, Oil on paper on canvas

Many of Degas's drawings and studies of movement after 1860 are inspired by race-course scenes. His paintings of horse races reflect how much he was influenced by the works of famous painters such as Thèodore Gùricault and Ernst Meissonier. He was similarly influenced by Japanese woodblock prints. The asymmetry of this composition derives from Oriental art. Horse racing, a sport imported from England, was a novelty at that time. Degas discovered racetracks as a subject for art in the early 1860s. However, he rarely painted the course itself, he preferred to look elsewhere. He was fascinated by preparations for a race, by false starts and the wait before the start, by the tension and the release of tension - all of them moments hardly laden with action.

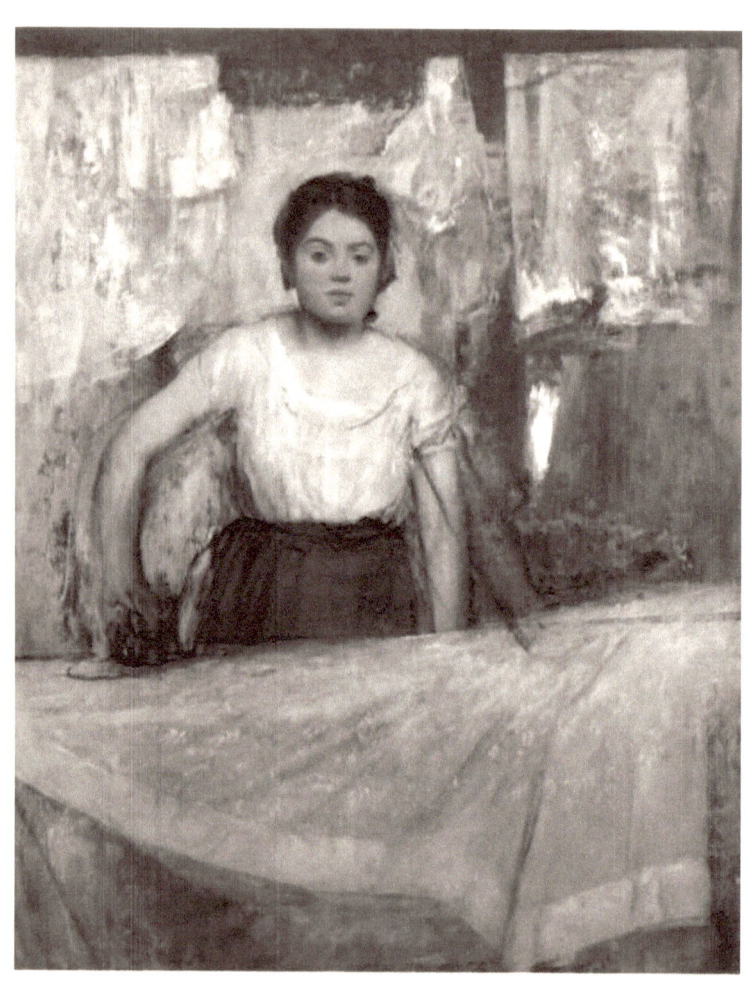

Woman Ironing
c. 1869, Oil on canvas

From 1865 on, the women who toiled at their ironing in the basic, steamy, hothouse rooms of the laundries featured regularly in Salon paintings. The artistic attractiveness of laundry women lay partly in the fact that they were widely perceived as loose-living, since their miserable pay forced many of them into prostitution. Not that this is apparent in Degas's earliest studies, which in 1869 resulted in an unfinished painting, Woman Ironing. It is a delicate, arresting portrait of an unknown woman seen in a fragrantly sketched setting of whites, greys and pale pinks.

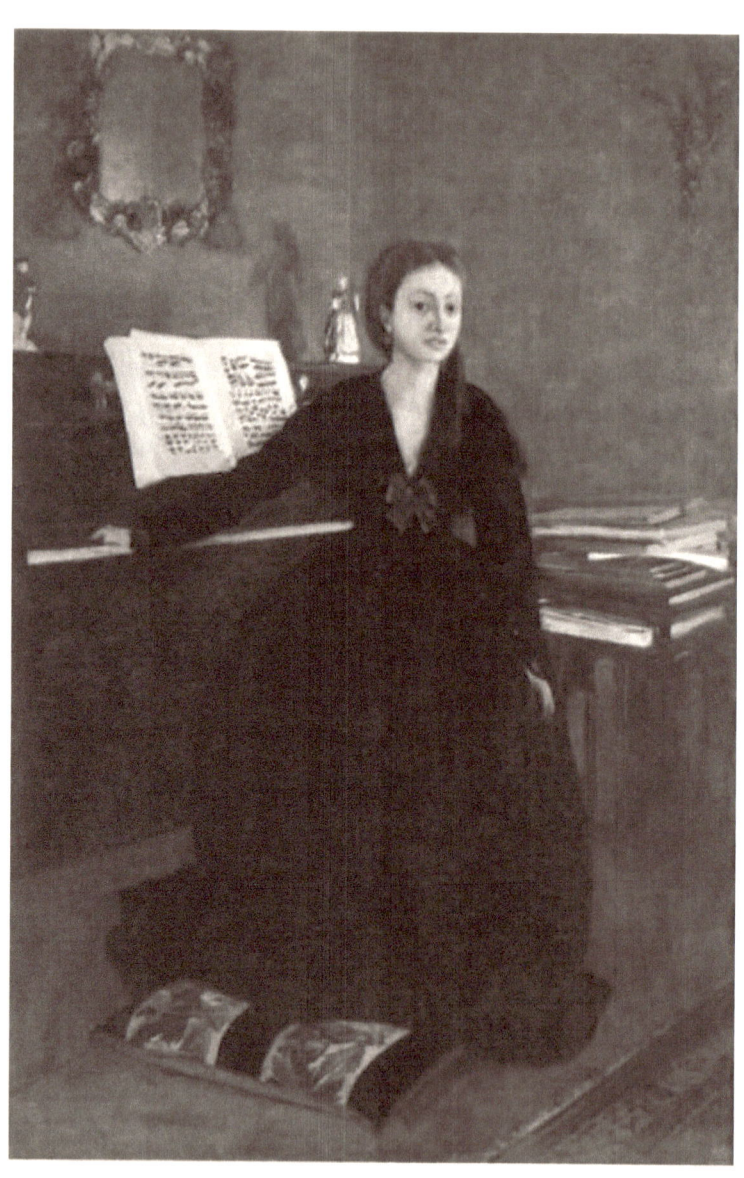

Madame Camus at the Piano
1869, Oil on canvas

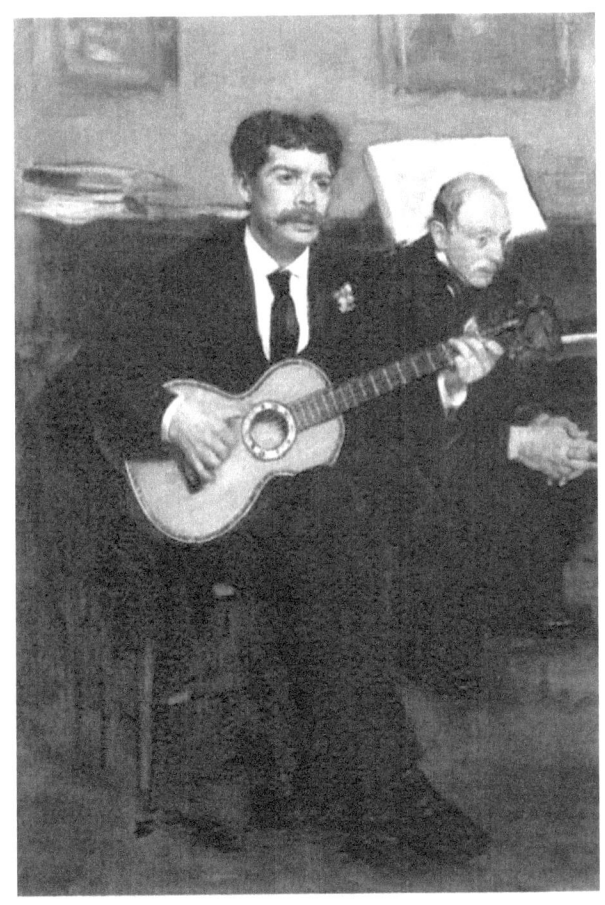

Portraits of Lorenzo Pagans and Auguste Degas
1869, Oil on canvas

The painting represents Lorenzo Pagans (1838-1883), a famous Spanish tenor and guitarist and Auguste de Gas, the painter's father.

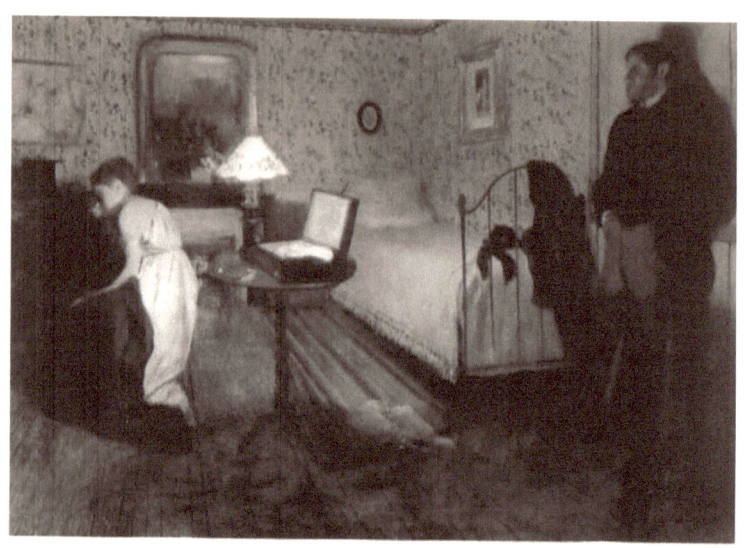

Interior (The Rape)
1868-69, Oil on canvas

The title of the painting, The Rape, may be misleading. It perhaps refers to a scene in Zola's novel, "Madeleine Ferat," in which Madeleine says to Francis that he is tormented because he loves her and she cannot be his. However, it is probably not a literary illustration. Degas himself never accepted this title. To his way of thinking the picture was primarily a study in nocturnal light effects in an interior.

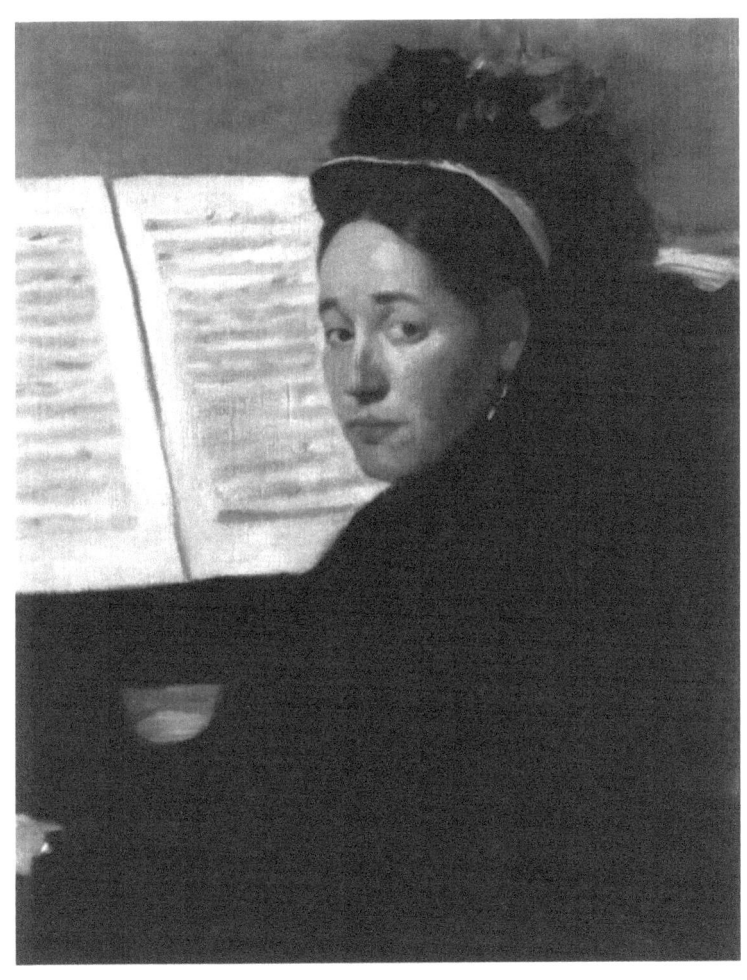

Mademoiselle Dihau at the Piano
1869-72, Oil on canvas, 39 x 32 cm

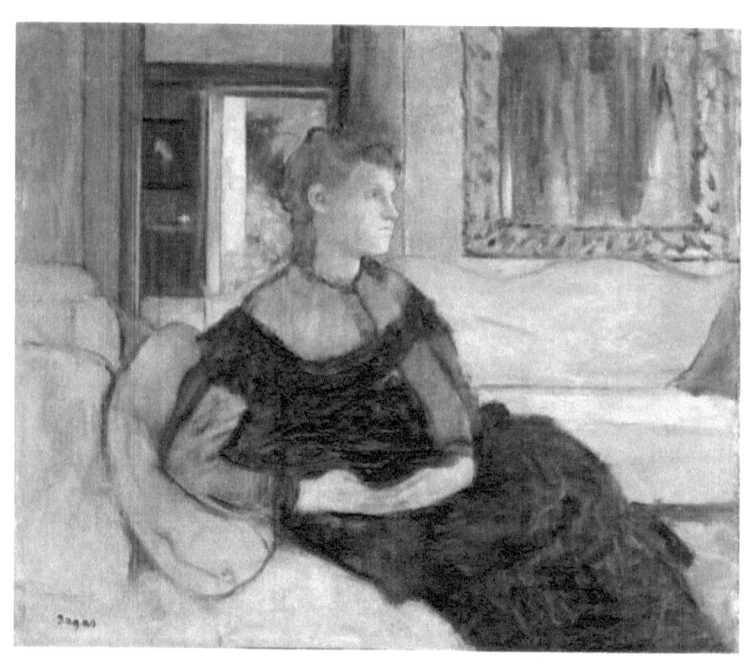

Yves Morisot
1869, Oil on canvas

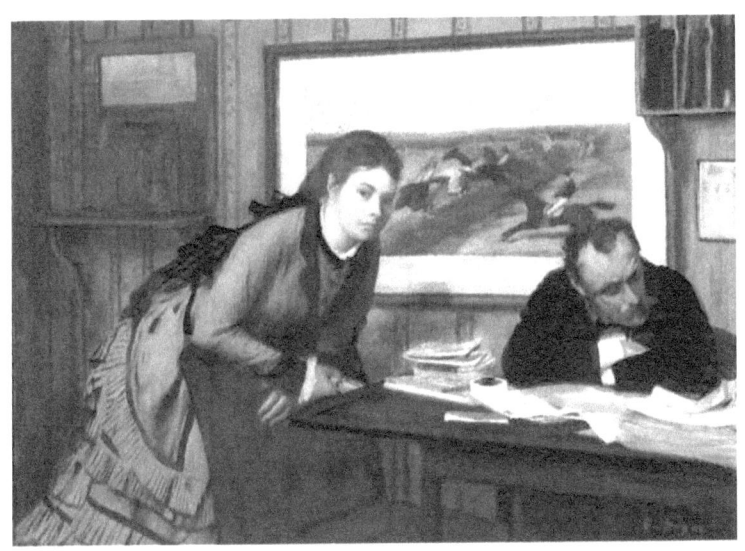

Sulking
c. 1870, Oil on canvas

The sitters for the figures were the writer Edmond Duranty and the young model Emma Dobigny.

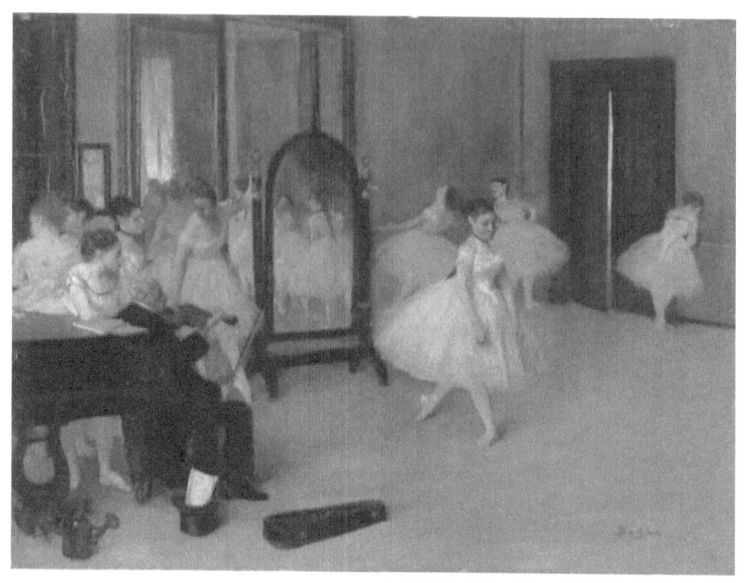

The Dancing Class
c. 1870, Oil on wood

This is the first of Degas's numerous scenes of ballet dancers in the Paris Opйra. The dancer at the centre of this composition is Josйphine Gaujelin (or Gozelin). Even more than his jockeys, it is Degas's ballerinas who have determined his popular image to this day. From 1870 he increasingly painted ballet subjects; among other reasons, they were easier to sell, and the family bankruptcy left Degas needing money.

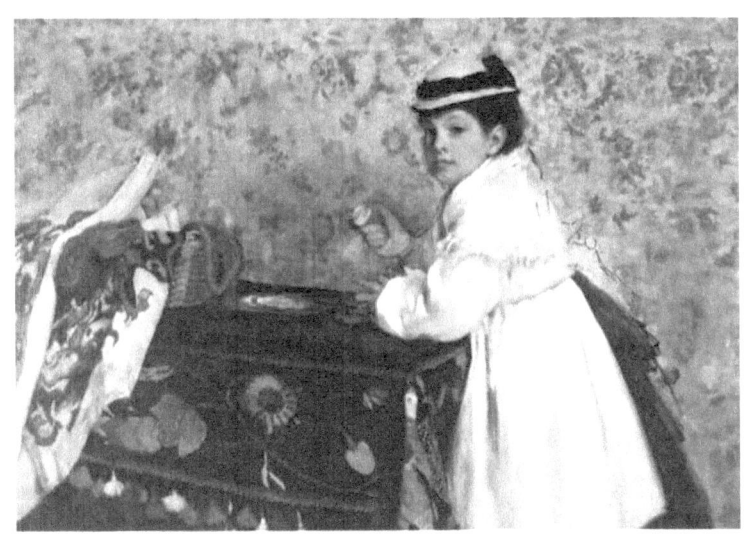

Portrait of Hortense Valpincon as a Child
1871, Oil on canvas

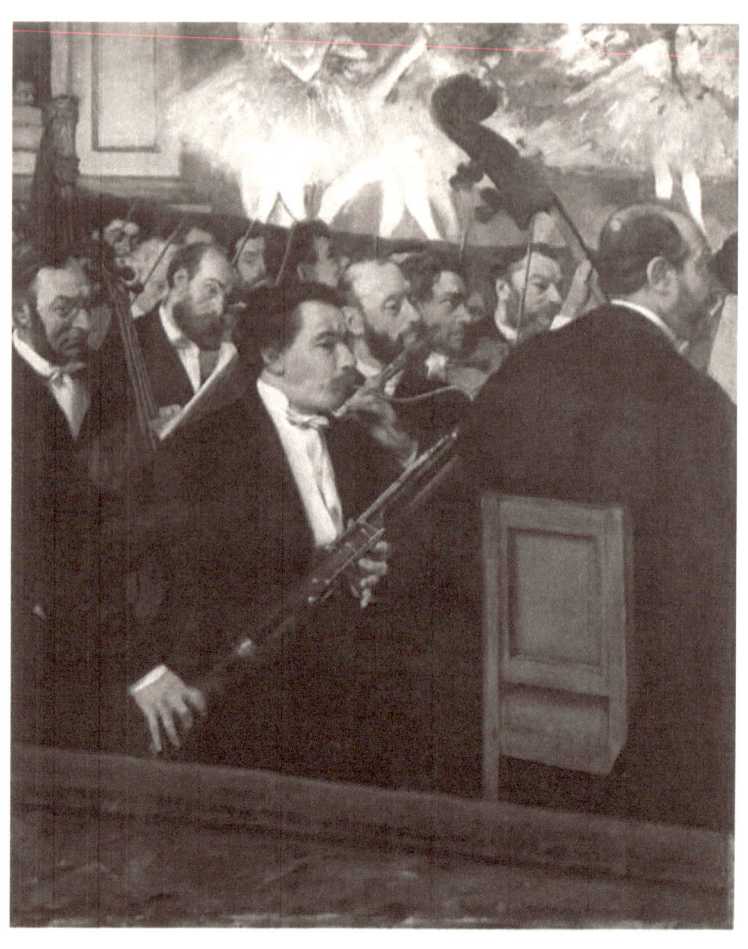

The Orchestra at the Opera
c. 1870, Oil on canvas

fter the sporting world of the turf as a source of inspiration, Degas turned toward the stage and the ballet. These seemingly different themes have one major element in common: movement. They both allowed Degas to explore that which interested him the most: a body in motion. He had a passion for the world of music and opera and his paintings of the stage broke new ground.

His first paintings from the theatre were portraits. In The Orchestra at the Opera, Degas portrayed a number of musicians seated in the orchestra pit, among them such friends as the composer Emmanuel Chabrier, the flautist Joseph-Henri Altus, the cellist Pillet, the first violinist Lancien, the violist Gouffú, and the bassoonist Dйsirй Dihau. There are other versions and many preparatory studies for this picture, which is an excellent example of the goal he had set himself of portraying people in a public setting.

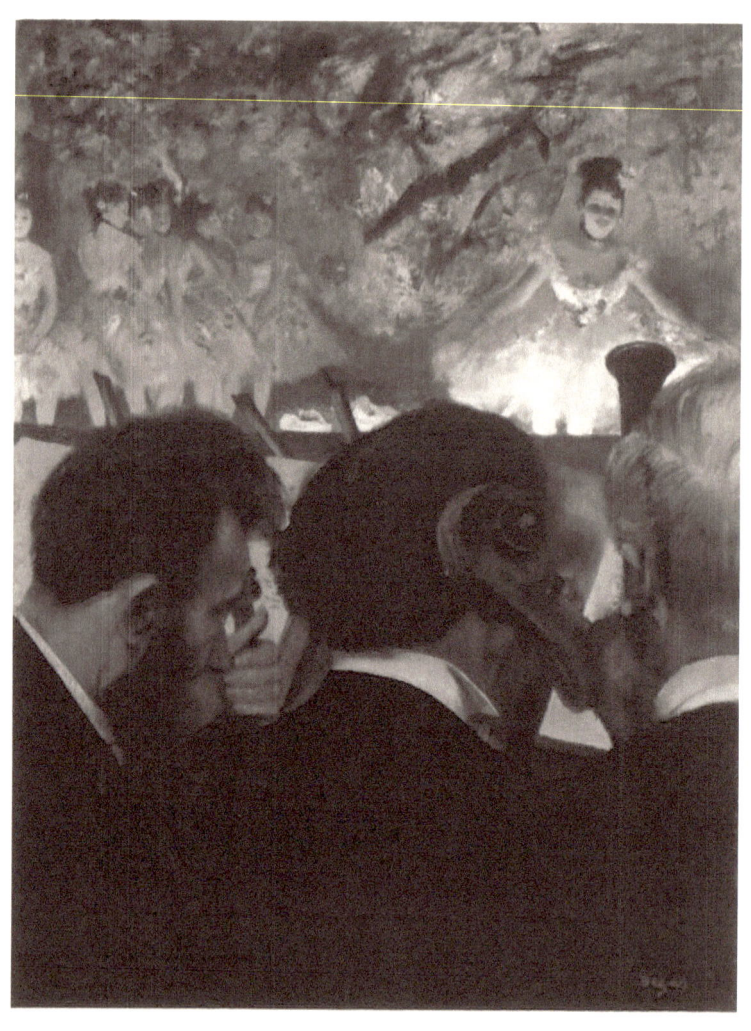

Musicians in the Orchestra
1870-71, Oil on canvas, 69 x 49 cm
This painting is Degas's second treatment of the subject. It opposes stage and pit as two halves of the pictorial space.

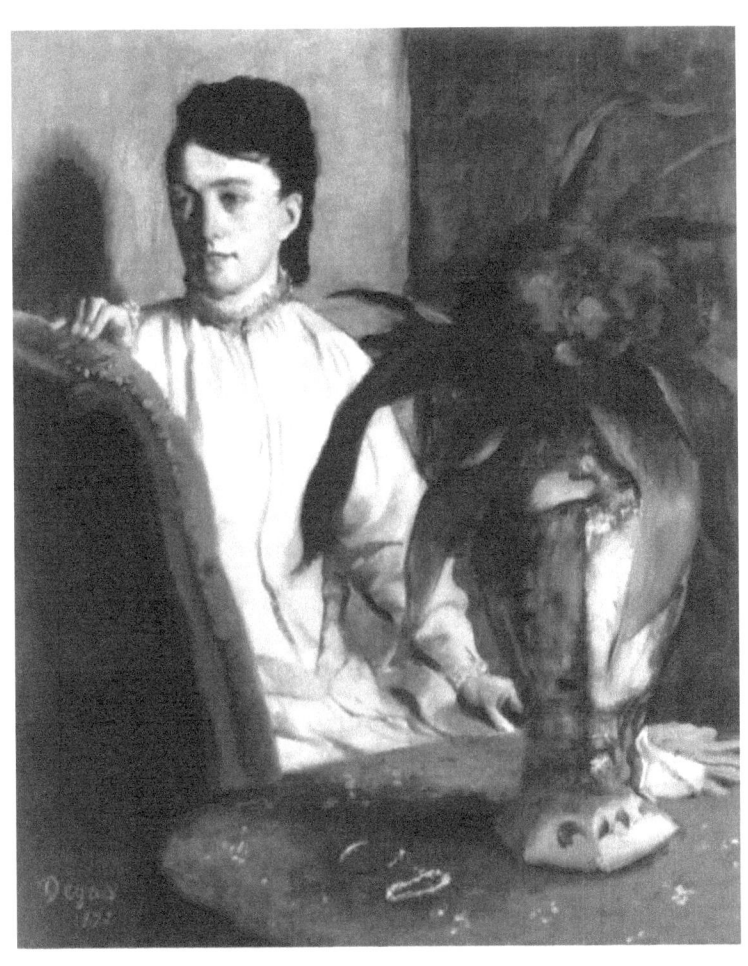

Seated Woman
1872, Oil on canvas

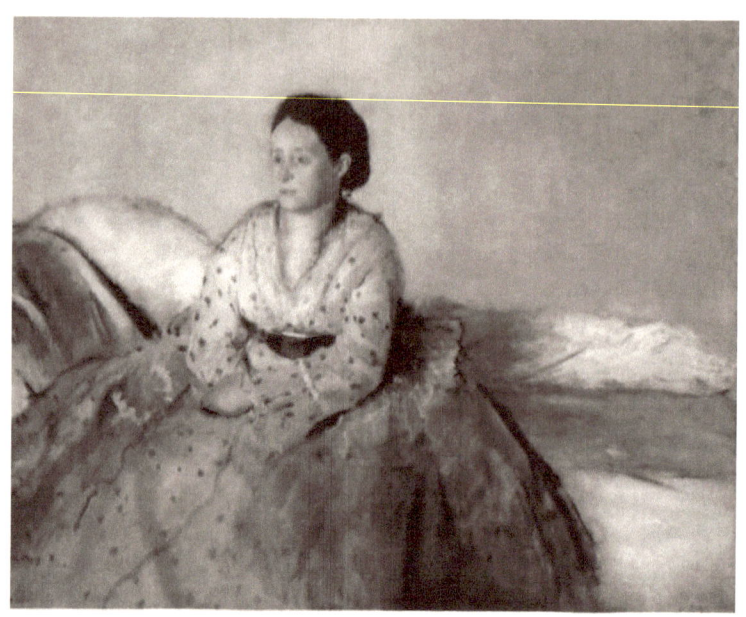

Madame Rene de Gas, nue Estelle Muston
1872-73, Oil on canvas

The portrait of Estelle Musson, the artist's first cousin, was painted during Degas's 1872-1873 visits to New Orleans. Not long after marrying Renū de Gas, Estelle had gone blind. Degas shows her gaze by passing us, a vacant gaze bent upon vacancy. It is a discreet and simple portrait of one woman's solitude and isolation.

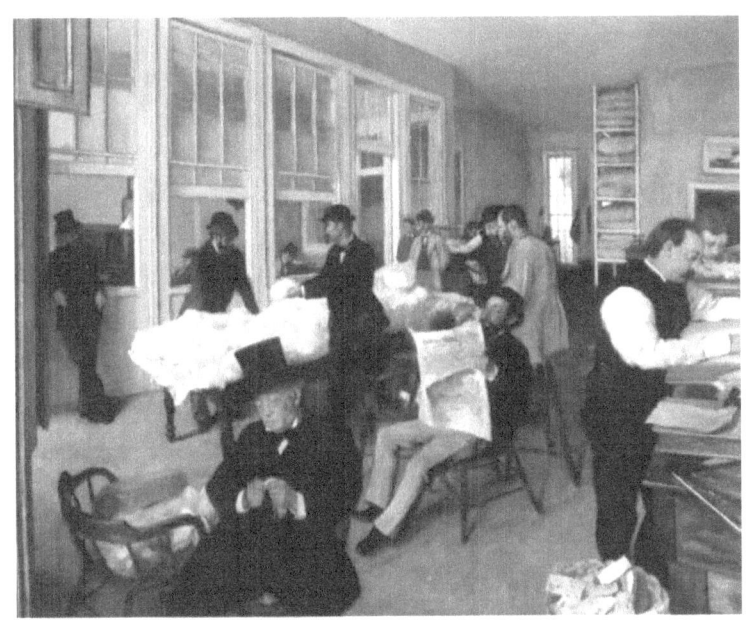

The Cotton Exchange in New Orleans
1873, Oil on canvas

In the fall of 1872, Degas traveled to America with his brother Rene, in order to visit two other brothers who settled as cotton traders in New Orleans. He remained there until April 1873. He found the exoticism of the "colonial" society of New Orleans very attractive.

Apart from a few portraits of relatives, Degas painted only one major work in New Orleans, The Cotton Exchange in New Orleans. This is a painting of interiors, revealing a new and very elaborate approach to group portraits. The artist's uncle, Monsieur Musson, sits in the foreground, wearing a top hat and testing cotton samples. Renū de Gas sits behind him, reading a newspaper, while the other brother, Achille, leans on the frame of a glass partition on the left.

This painting is one of Degas's most mature works in his naturalistic style.

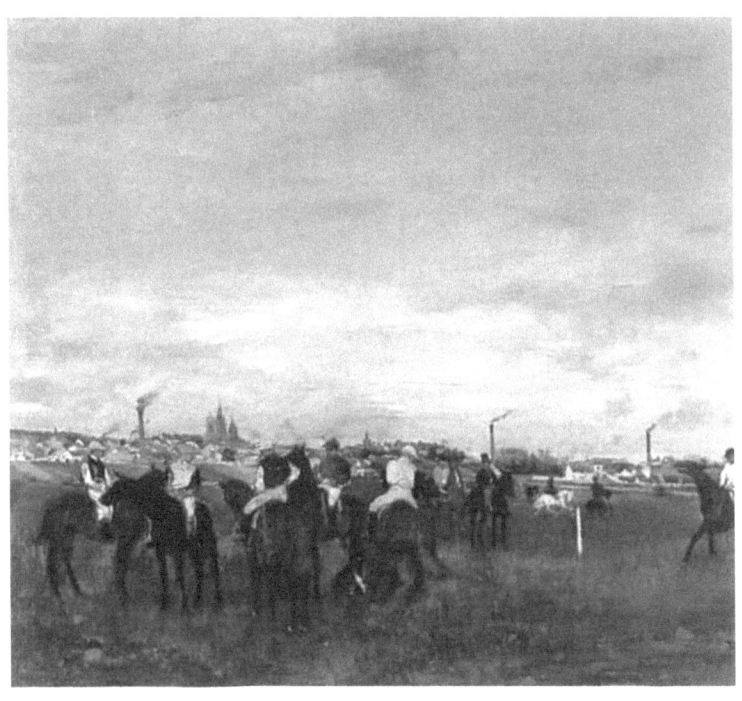

The Races. Before the Start
1873, Oil on canvas

Degas, free of the need to sell pictures in order to live, pursued his interest in people, their characters and temperaments, their faces and body language. He painted uncommissioned portraits or had his acquaintances present situations that conveyed typical behaviour. Crowds at racetracks and the lean, diminutive jockeys on their delicate, nervy horses supplied him with open-air motifs.

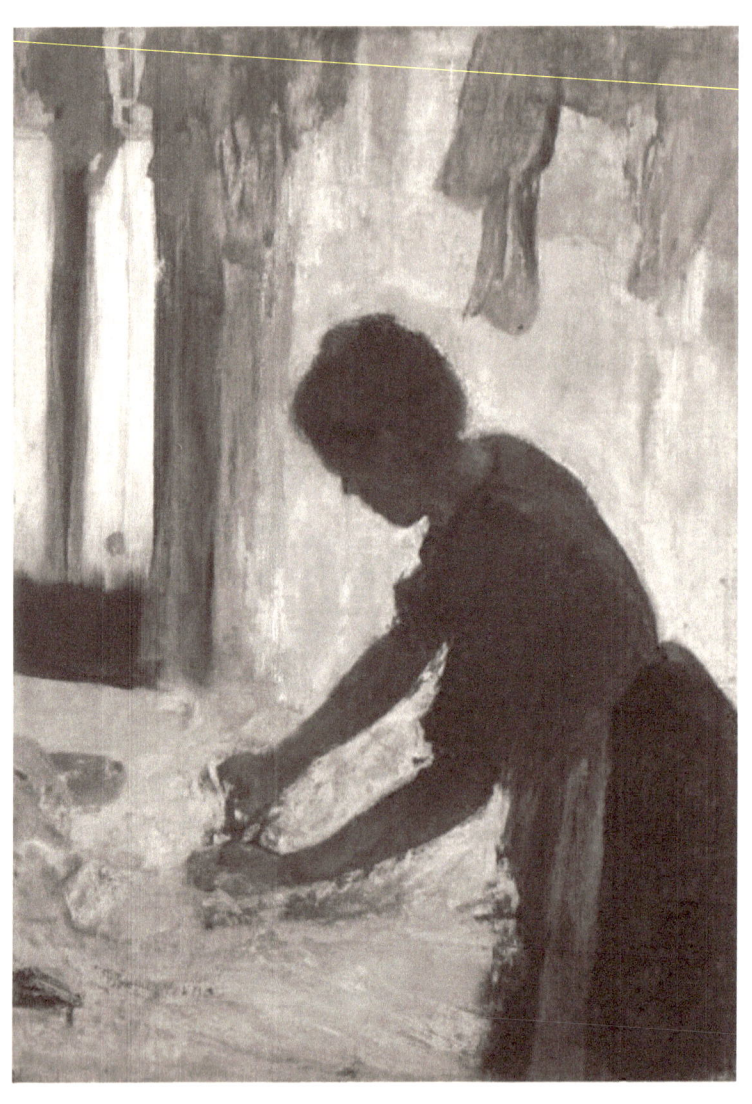

A Woman Ironing
1873, Oil on canvas

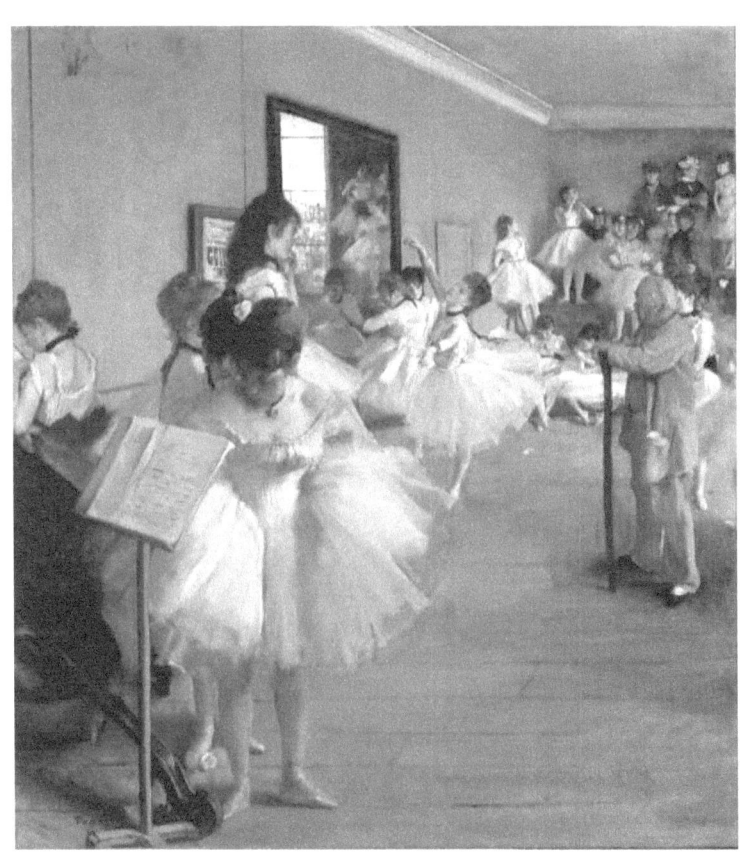

The Dance Class
1873-76, Oil on canvas

From 1870 Degas increasingly painted ballet subjects. In these paintings he explored the subject's potential through variations on the theme. In The Dance Class he has grouped some twenty girls and one or two mothers too, watching or comforting their daughters. Dominating the scene (and painted in as an afterthought) is instructor Jules Perrot, with the huge stick he used to beat out a rhythm. This trial session under the famed teacher is taking place in the rehearsal rooms of the old opera house in Rue Peletier, which has long since burned down.

Despite the working of the scene as an overall harmony, the girls are individual, with individual gestures.

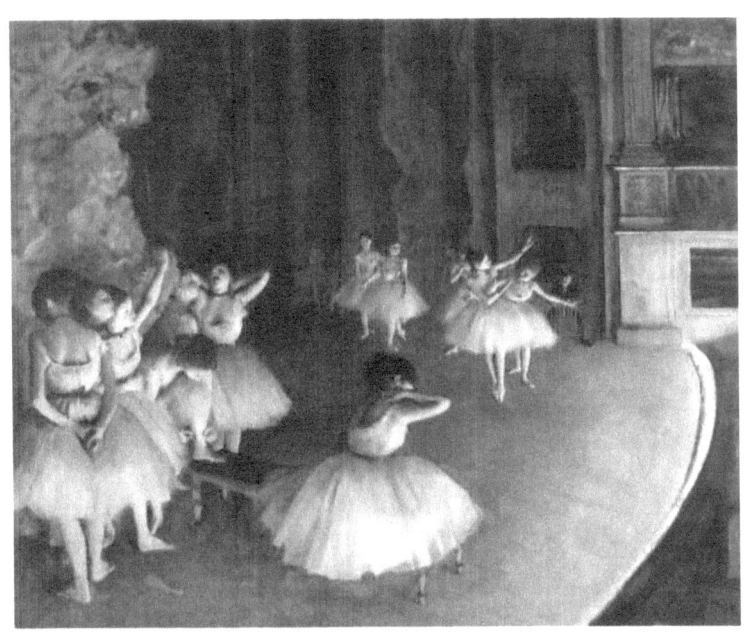

Rehearsal of a Ballet on Stage
1874, Oil on canvas

Fom 1872 on, Degas devoted most of his attention to ballerinas practicing under their master or rehearsing on stage, where occasionally gentlemen would be looking on and would afterwards express a wish to take one of the girls home with them.

The style of this painting resembles grisaille work. The non-colourful chiaroscuro is some kind of allusion to the new visual technique of photography. The man straddling the chair functions as an observer within the scene we observe; and we notice that not only the lighting but also the unaccustomed emptiness of the theatre makes an eerie impression.

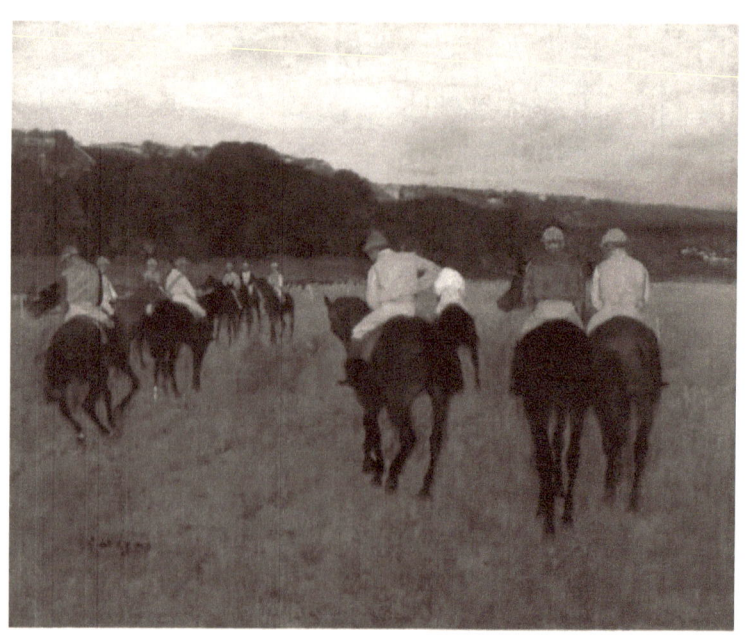

Racehorses in Longchamps
c. 1874, Oil on canvas, 34 x 42 cm

Horse racing, a sport imported from England, was a novelty at that time. Degas discovered racetracks as a subject for art in the early 1860s. However, he rarely painted the course itself, he preferred to look elsewhere. He was fascinated by preparations for a race, by false starts and the wait before the start, by the tension and the release of tension - all of them moments hardly laden with action.

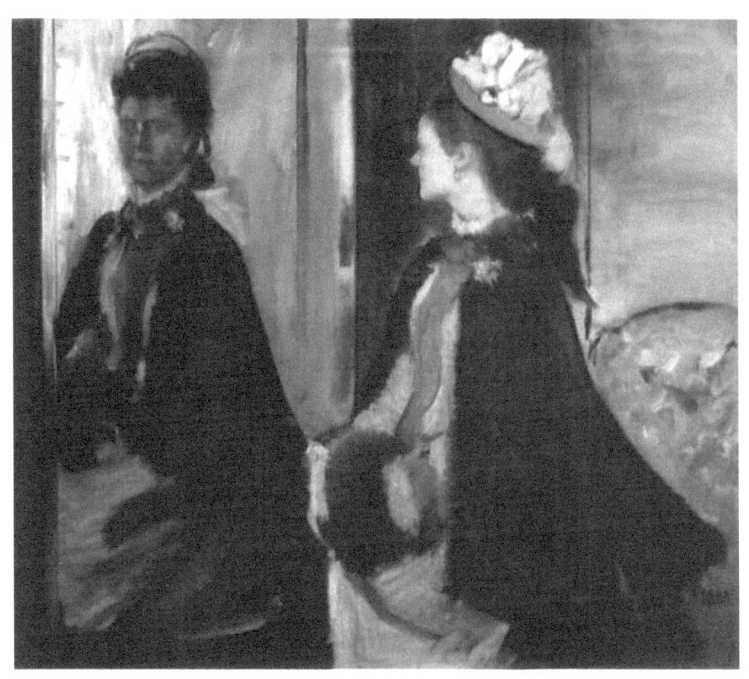

Madame Jeantaud in the Mirror
1875, Oil on canvas, 70 x 84 cm

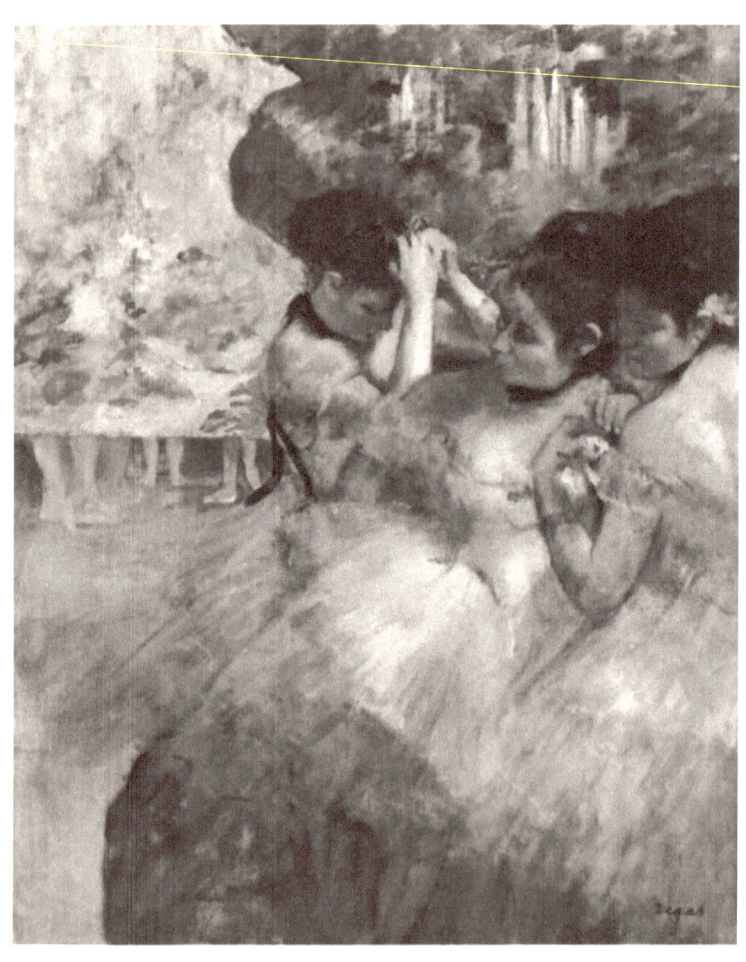

Dancers Preparing for the Ballet
c. 1875, Oil on canvas, 74 x 61 cm

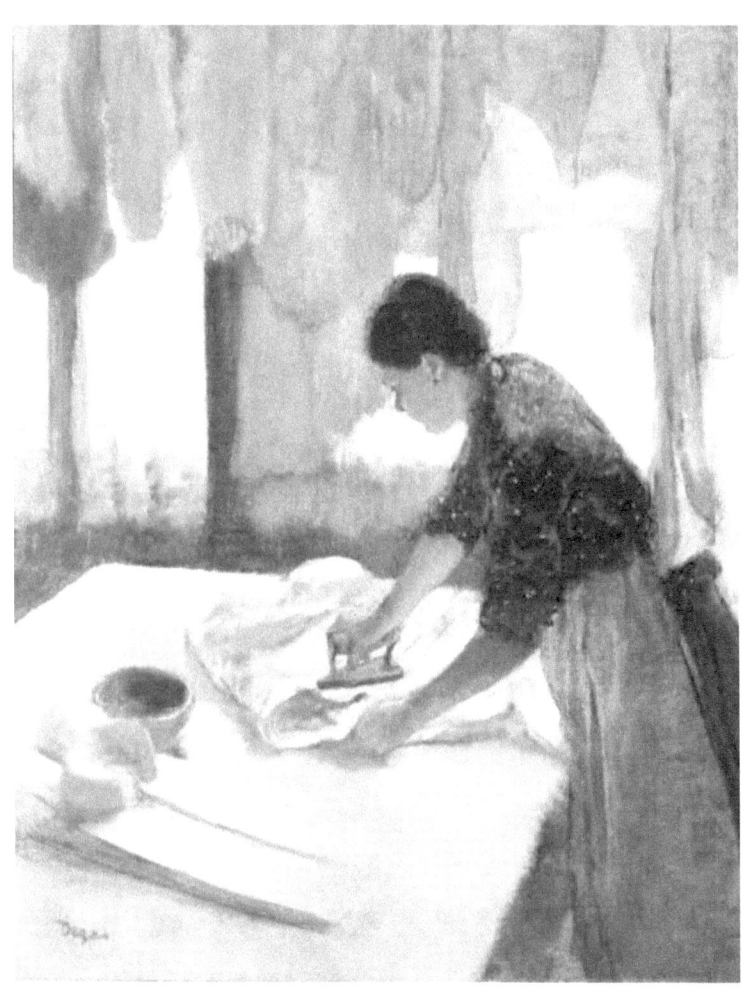

Woman Ironing
1876, Oil on canvas

Degas's paintings of the working class have a social content. He took up themes treated earlier by Honorū Daumier and painted women ironing, washerwomen. In contrast to Daumier, Degas saw no heroism in everyday modern work. He was interested in women who did the ironing at laundries. His first picture on this subject was done in 1869. By the turn of the century Degas had painted fourteen pictures on the subject, showing women ironing from various angles, singly or in twos, silhouetted or behind laundry.

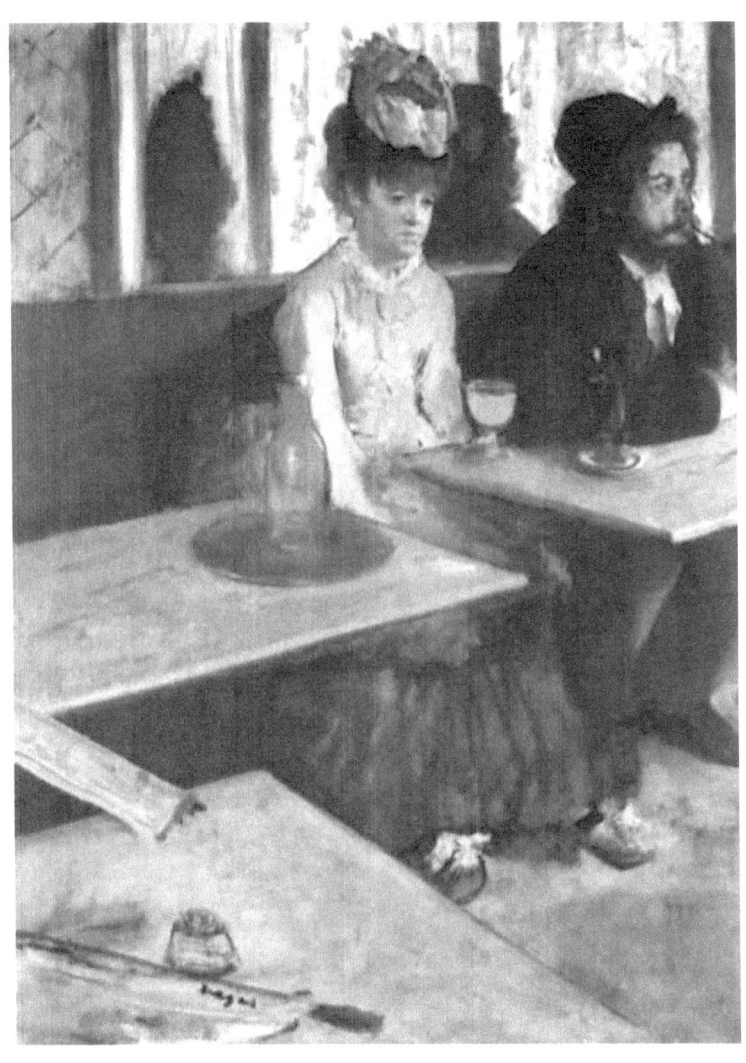

Absinthe Drinkers
1876, Oil on canvas

This painting contains an element of social criticism, similar to that in Zola's L'Assommoir" denouncing the destruction caused by alcoholism. The last two customers at the cafũ are seated in the right-hand part of the painting, with the gray reflection of the street behind them. The couple is surrounded by emptiness. The actress Ellen Andree and the engraver Marcellin Desboutin served as models, but the painting goes beyond a mere portrait. They become the symbol of a nameless destiny.

Degas simply referred to this painting as In the Cafe, the present title was added later.

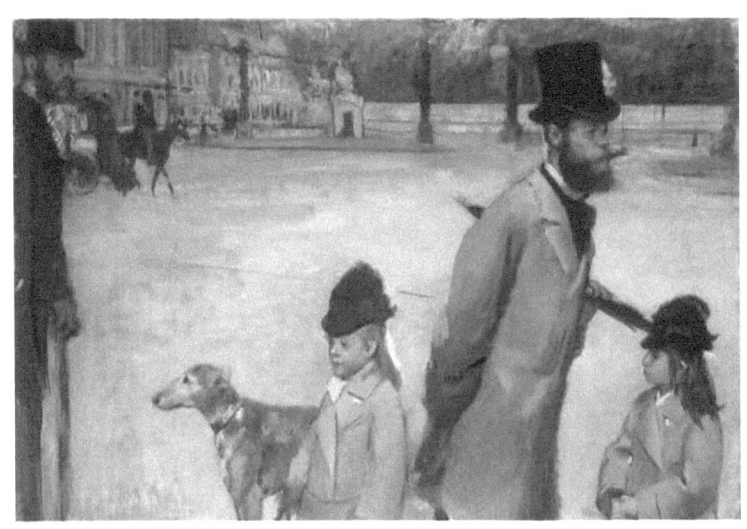

Place de la Concorde
1876, Oil on canvas

Degas's pictures recorded images of life in a modern city. The present painting - probably destroyed in World War II - shows Baron Lepic and his daughters strolling along a boulevard. Lepic, art connoisseur and dog breeder is immaculately turned out. Cigar in mouth, one hand behind his back, an umbrella under his arm, he is walking across the empty Place de la Concorde with his daughters and dog.

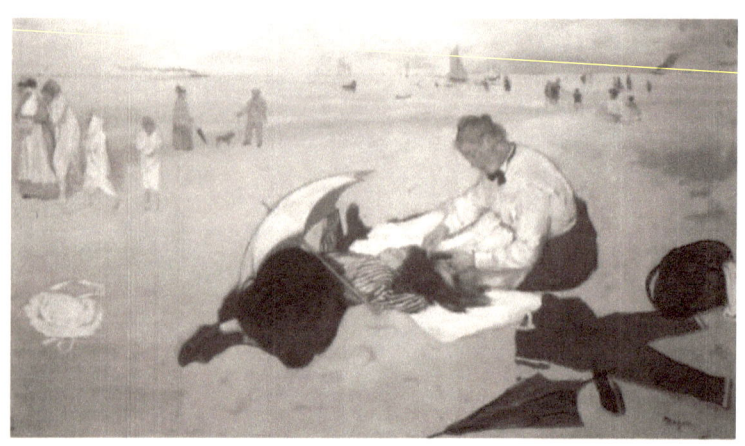

At the Beach
1876, Thinned oil on paper on canvas, 46 x 81 cm

This painting is among Degas's few genuinely Impressionist landscapes. However, this is no Manet or Monet beach scene; rather, it gathers a number of characteristic Degas motifs, such as the nanny combing the girl's hair.

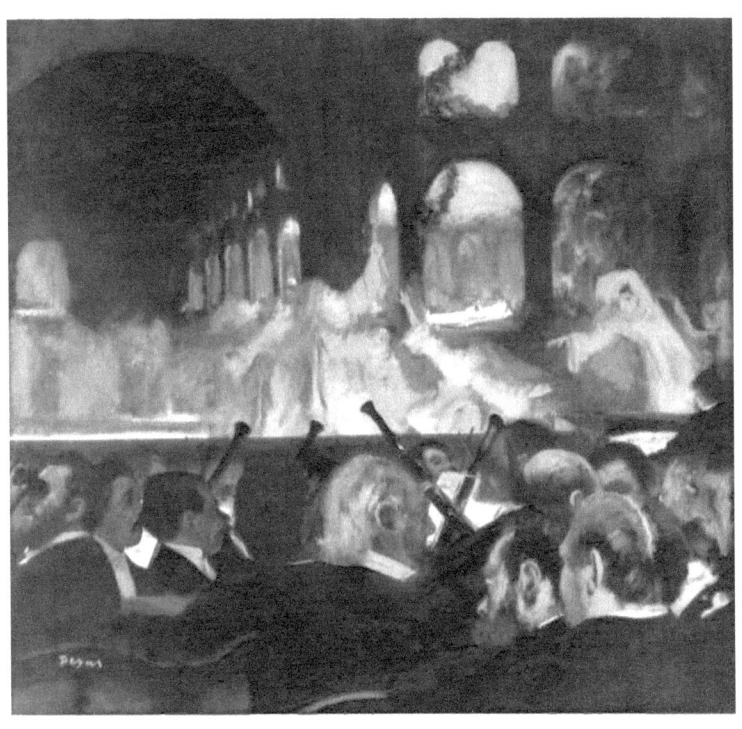

The Ballet Scene from Meyerbeer's Opera 'Robert le Diable'
c. 1876, Oil on canvas, 75 x 81 cm

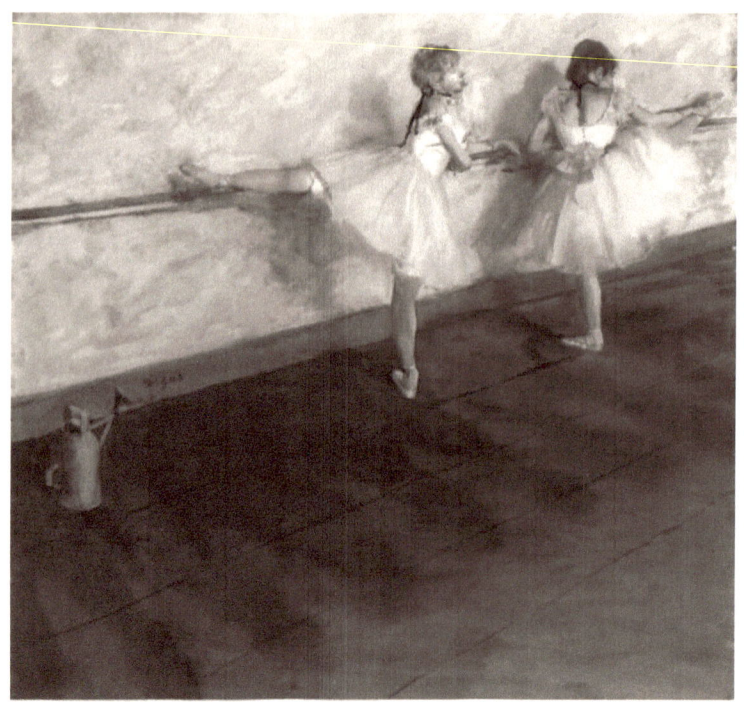

Dancers Practicing at the Bar
1876-77, mixed media on canvas, 76 x 81 cm

Although the dancers appear to be casually observed, the composition was meticulously worked out. The artist's fascination with form and structure is reflected in the analogy between the watering can (used to wet down the dust on the studio floor) and the dancer at the right. The handle on the side imitates her left arm, the handle at the top mimics her head, and the spout approximates her right arm and raised leg. Later in life Degas regretted this visual joke and wished to paint out the can, but the owner of the canvas, a friend of the artist, refused to allow Degas to retouch it.

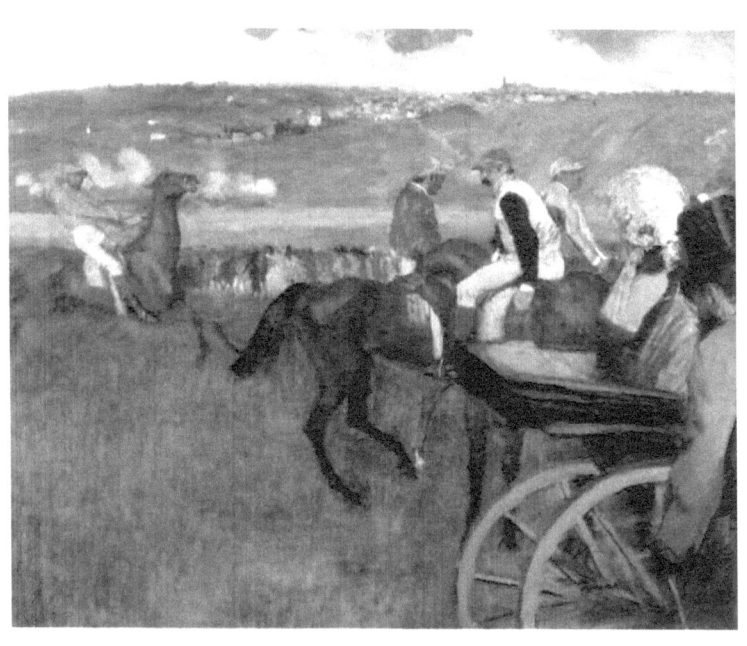

The Race Track. Amateur Jockeys by a Carriage
1876-87, Oil on canvas

Horse racing, a sport of English origin, became popular on the Continent at the end of the eighteenth century, and soon inspired such painters as Carle Vernet and Thẽodore Gũricault, who were both influenced by English artists. It attracted the interest of later painters, too. Manet emphasized the elegance of these occasions, while Degas preferred to observe the horses in motion. He focused on the movements of man and animal. His first sketches of racecourses date back to the beginning of the 1860s. At first he was interested in the jockeys, but he also turned a keen eye on the spectators.

In the present painting the figures are grouped in the lower right-hand corner, cut off by the corner of the frame. The composition is similar to that of the earlier At the Races in the Countryside, but the emphasis on realistic drawing, which is evident in the earlier work, is replaced here by an arrangement of broad patches of colour. Degas is still attracted by the nervous elegance and disciplined dancing grace of the horses, but everything is blended in a harmony of colours, which turns the canvas into a mosaic.

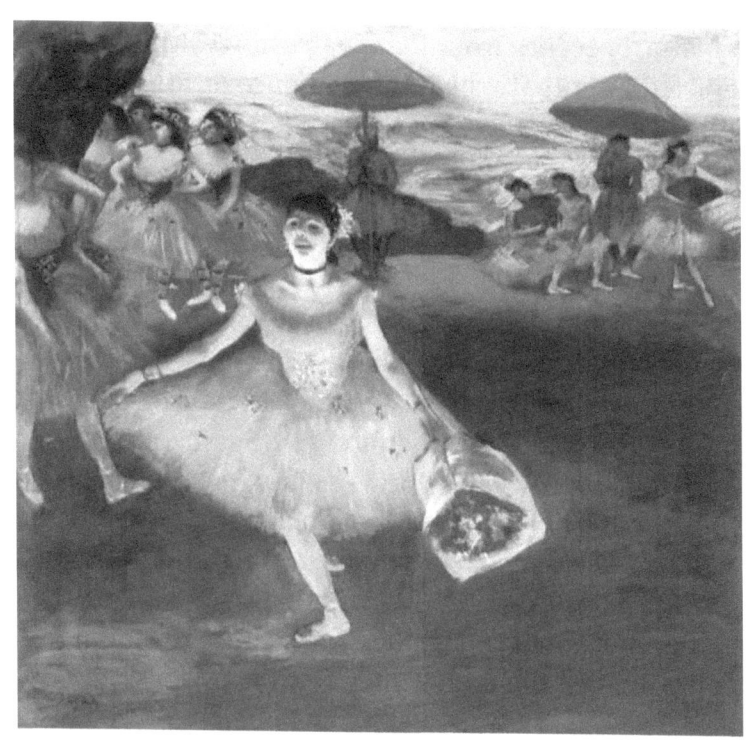

Ballerina with a Bouquet, Curtsying
1878, Oil on canvas

In his early scenes from the theatrical world, Degas depicted only that which the audience or musicians could see of the stage. However, later he went backstage, and he became a cool observer of rehearsals. In his paintings the stage changed from being an incidental setting of the picture to become the theme of the picture itself. Following his works showing the rehearsal room and the stage as a whole (even when only a corner is depicted), there came his series of astounding variations on the theme of dancers, in groups or isolated, in which the artist gained more and more freedom of vision, forever changing angles and capturing the ballerinas in the most surprising positions. The dancers are painted more and more in close-up. They do not move within a well-defined three-dimensional space, they fill the foreground with colours against the wings and curtains.

The most remarkable among these works are the different versions of Ballerina with a Bouquet, Curtsying. The dancer is a sylph, arms outstretched, and still carried by the last movement at the close of her solo. She bows, bathed in the brilliant spotlight, with the unreal, fantastic decor of the ballet as her background.

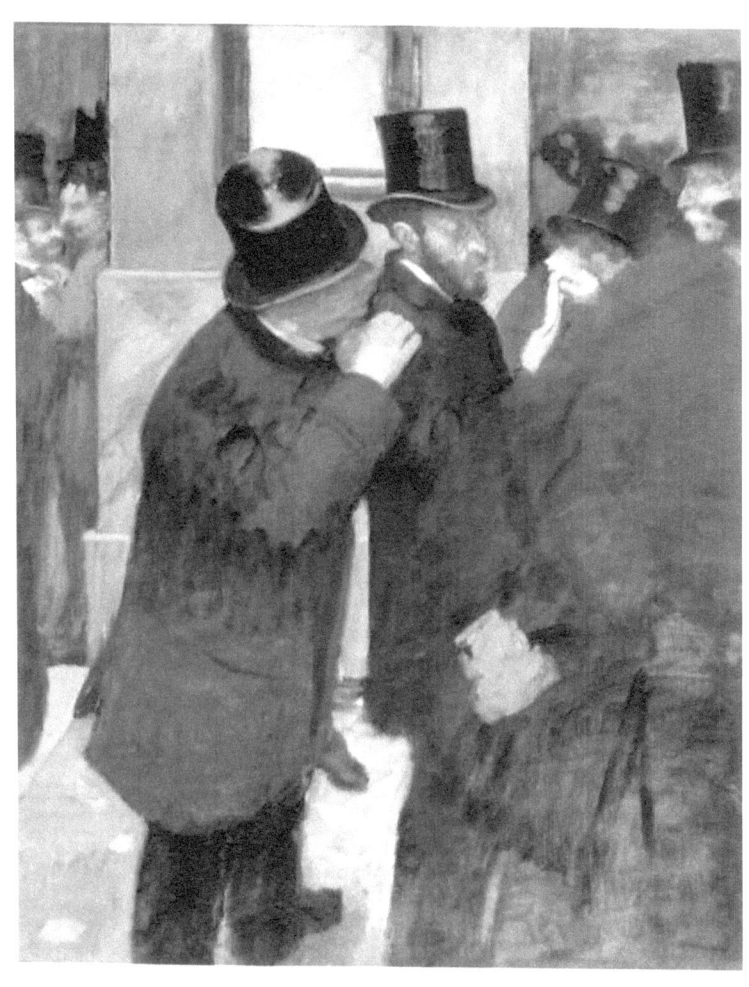

A la Bourse
1878-1879, Oil on canvas

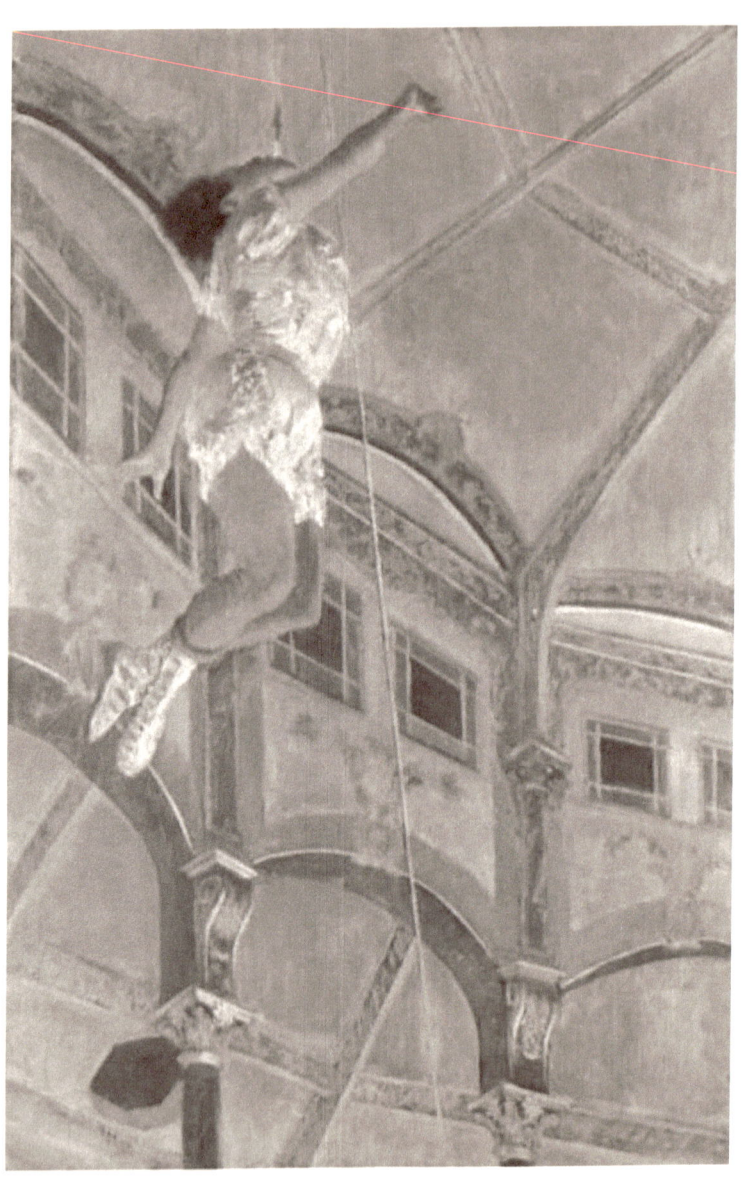

Mademoiselle La La at the Cirque Fernando
1879, Oil on canvas

The Cirque Fernando was established in 1875, in 1890 it was renamed Cirque Medrano. It was a major attraction for Montmartre artists. In January 1879 Degas went there several times to see a mulatto trapeze artist who called herself Mlle La La. In the present painting Degas's attention is on the visual interplay of artiste and architecture. Everything else (the trapeze, the ring, the audience) has been left out.

The sheer, angular viewpoint from below is a modern variation on Baroque sotto-in-su perspective.

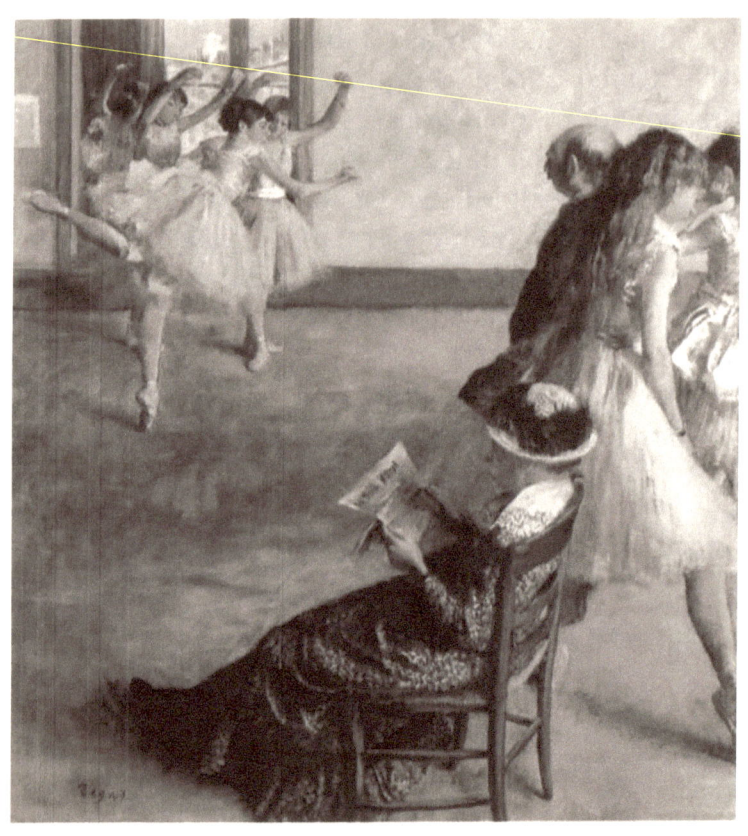

Ballet Class
1881, Oil on canvas

The composition of this extraordinary picture is one of thorough calculation. Down the centre runs a diagonal demarcation separating Jules Perrot, the instructor, two resting dancers and a mother from the three dancers currently exercising. The mother in her flowery dress and straw hat is reading "Le Petit Journal" and taking no interest in the class.

Degas has played a subtle trick with our perceptions: the glimpse we have of Paris beyond the room is not seen through a window on the rear wall it is in fact the dancers' mirror.

At the Milliner's
1882, Oil on canvas

Degas painted several pictures set in millinery shops. The milliners are caught in the most absurd positions, surrounded by brightly coloured hats and slanting mirrors often placed at the edge of the painting. They are completely absorbed by the fitting of hats.

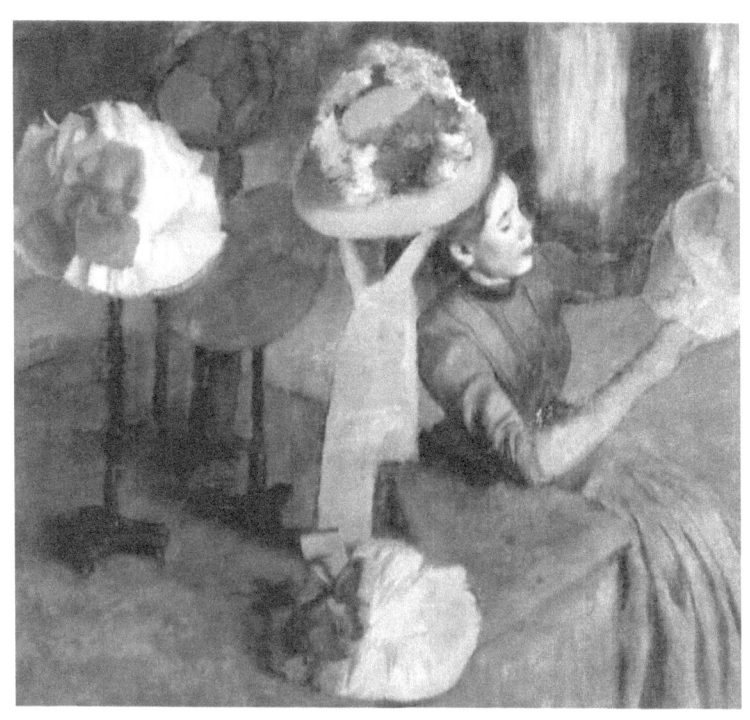

The Millinery Shop
1882, Oil on canvas

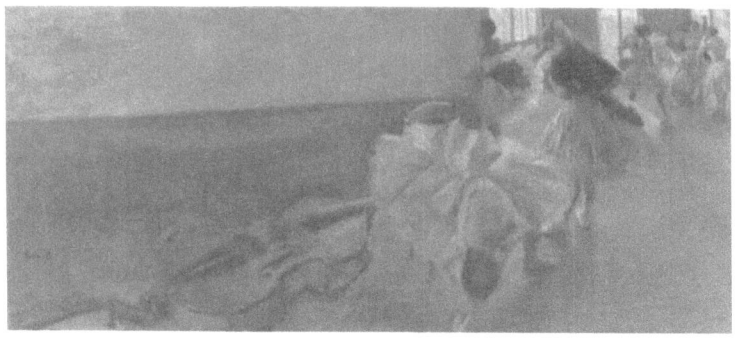

Dancers in the Rehearsal Room with a Double Bass
1882–85, Oil on canvas

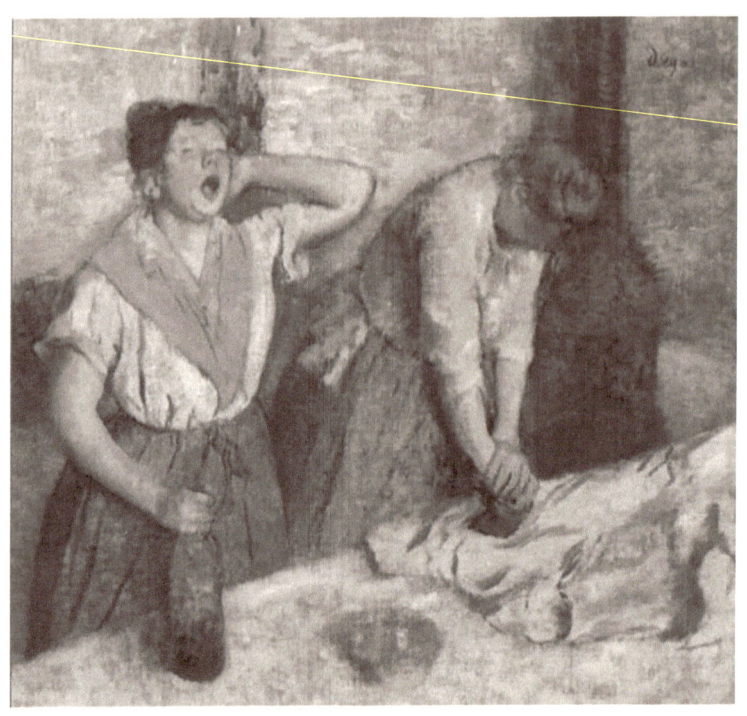

Two Laundresses
1884, Oil on canvas

Degas's paintings of the working class have a social content. He took up themes treated earlier by Honorŭ Daumier and painted women ironing, washerwomen, milliners. In contrast to Daumier, Degas saw no heroism in everyday modern work. There are four versions of this composition.

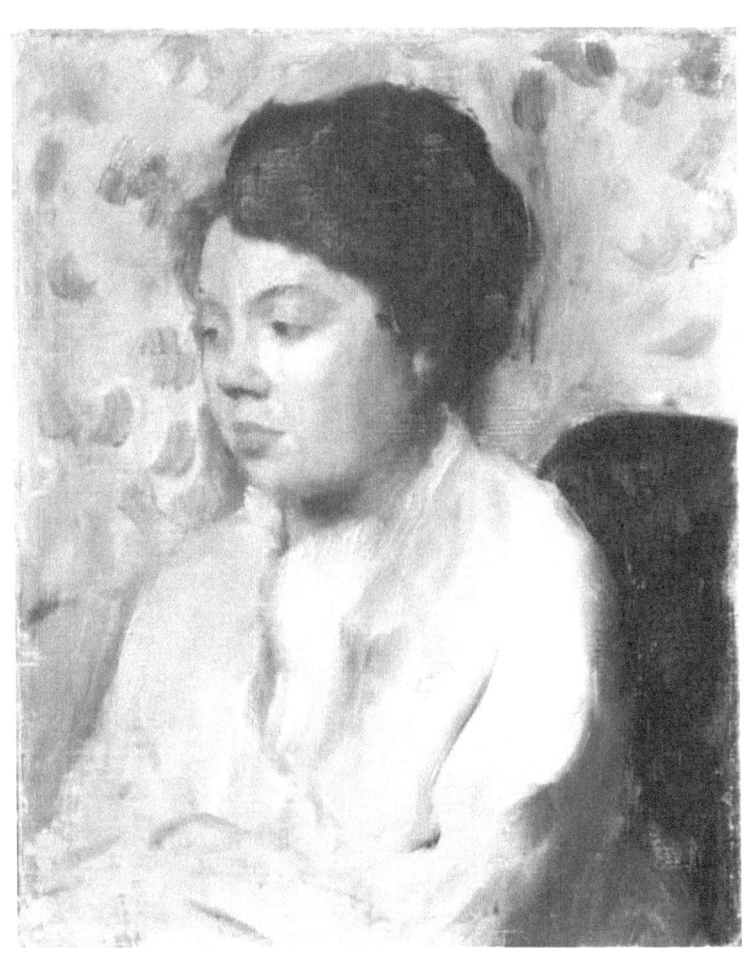

Portrait of a Young Woman
c. 1885, Oil on canvas

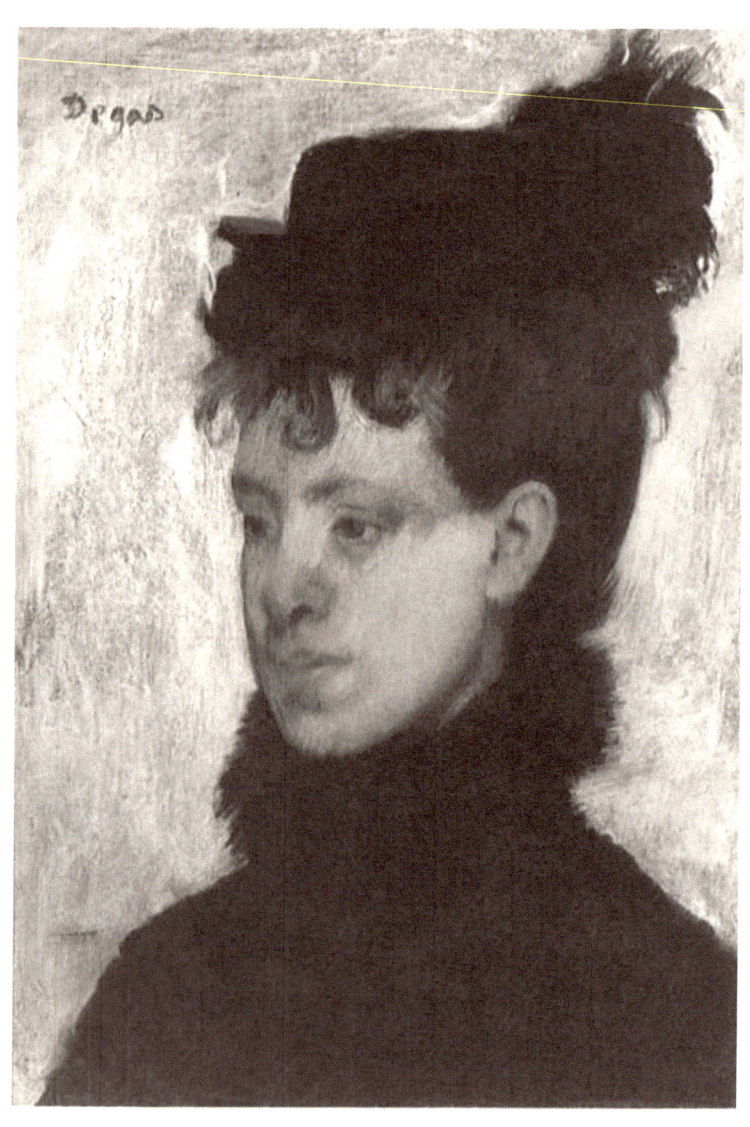

Girl with a Hat
1887-90, Oil on canvas

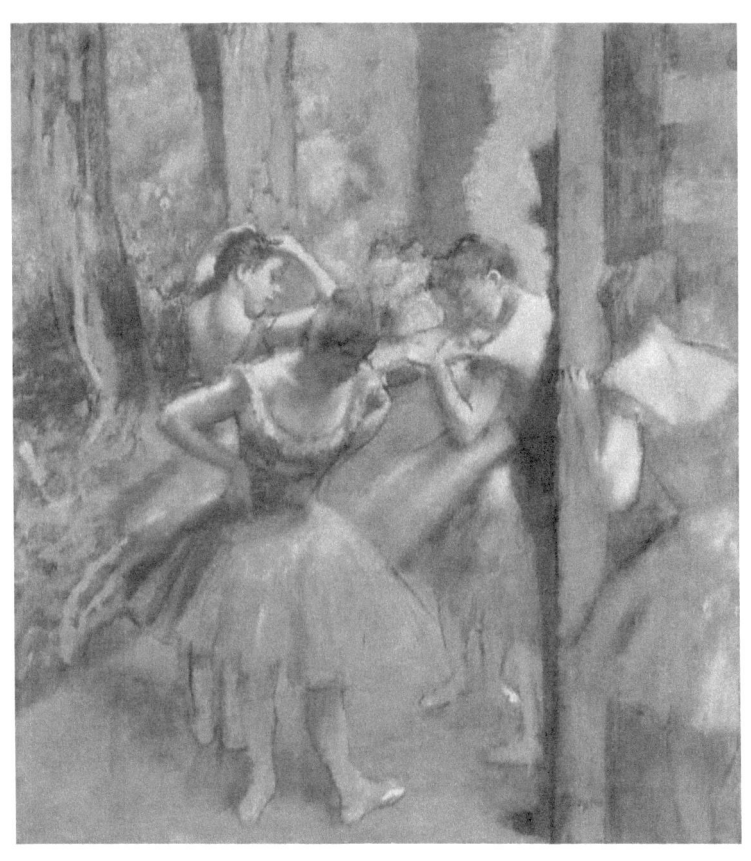

Dancers, Pink and Green
c. 1890, Oil on canvas

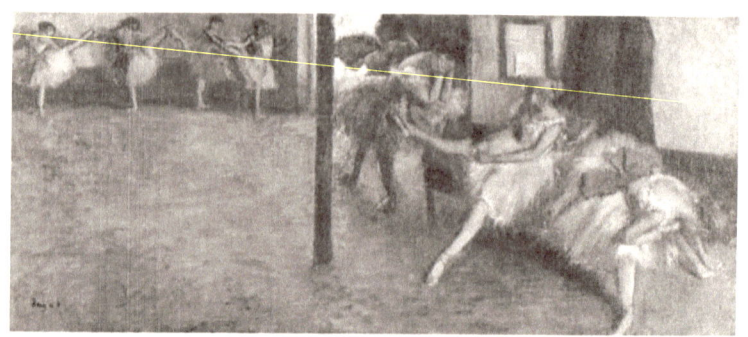

Ballet Rehearsal
c. 1891, Oil on canvas

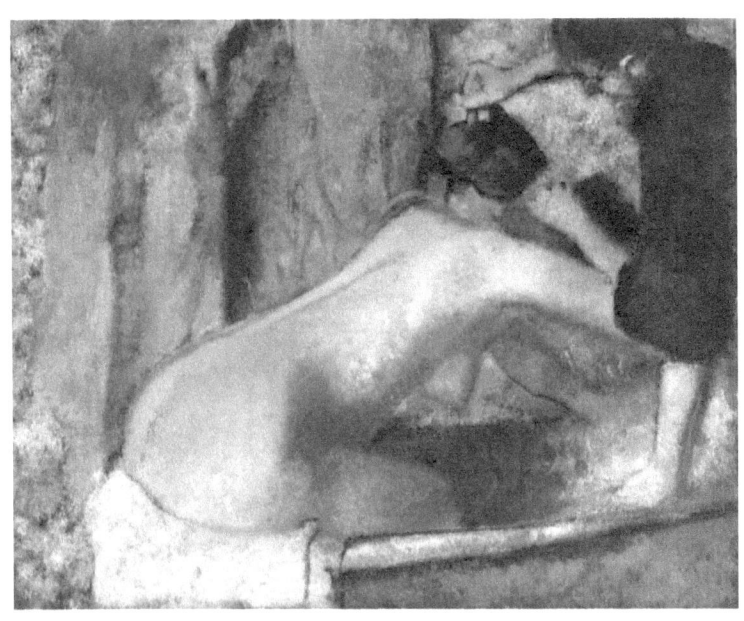

Woman in Bath
c. 1892, Oil on canvas

After 1880 Degas also explored the theme of women bathing. French artists devoted a significant part of their work to the praise of woman's beauty, albeit less in the nineteenth than in the eighteenth century. Unlike to his predecessors, Degas describes intimate scenes without intimacy, bodies without sensuality. The women bathing, washing, drying themselves, combing their hair or having it combed, are mainly seen from behind. They do not seem to heed the intimacy of the boudoir or bathroom scene. Degas's matter-of-fact depictions of woman were criticized by his contemporaries.

Degas was forever inventing new ways of seeing and devising new approaches to his models. The present picture is an example it.

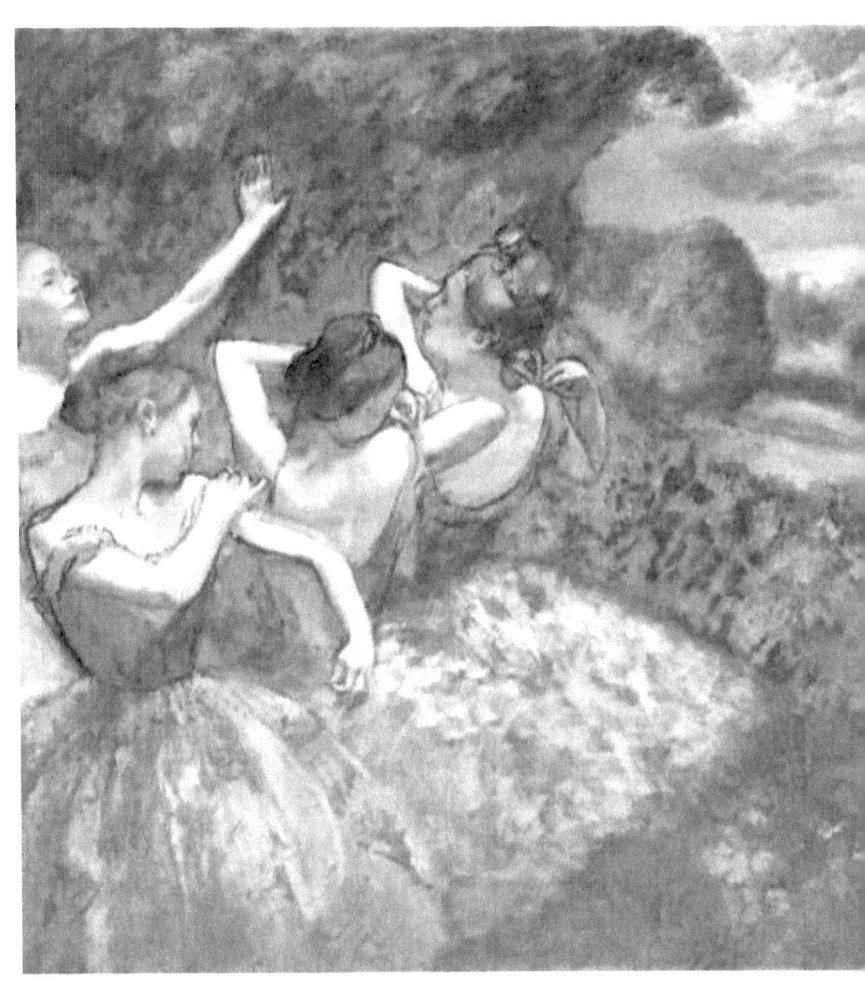

Four Dancers
c. 1899, Oil on canvas

# *Drawings*

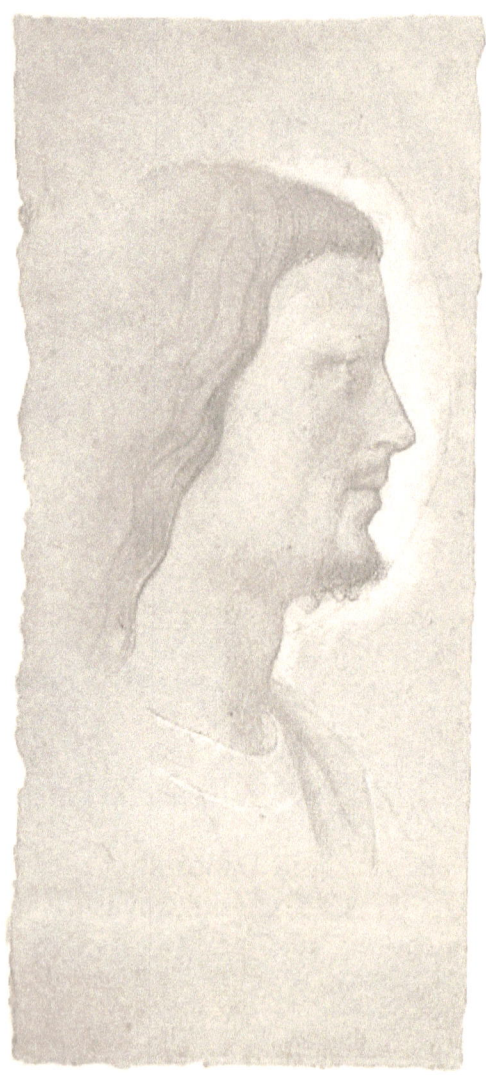

Head of a Saint (profile to the right), after Fra Angelico

N.d., Black chalk, heightened with white, on pink-beige paper

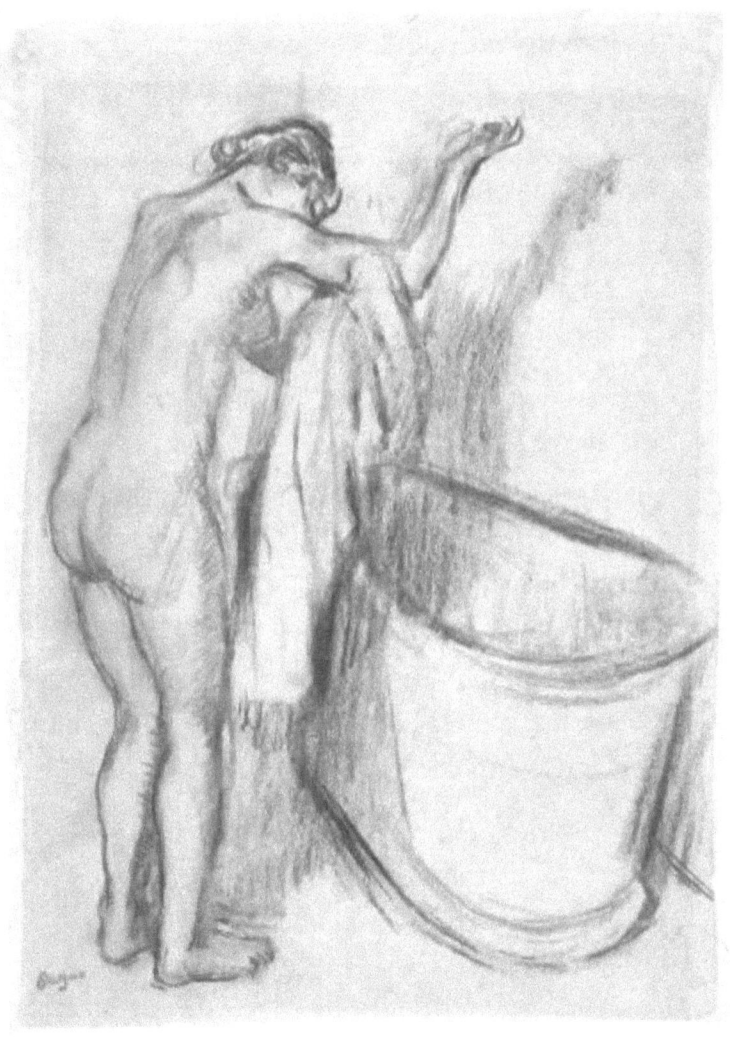

After the Bath
N.d., Charcoal on paper; laid down

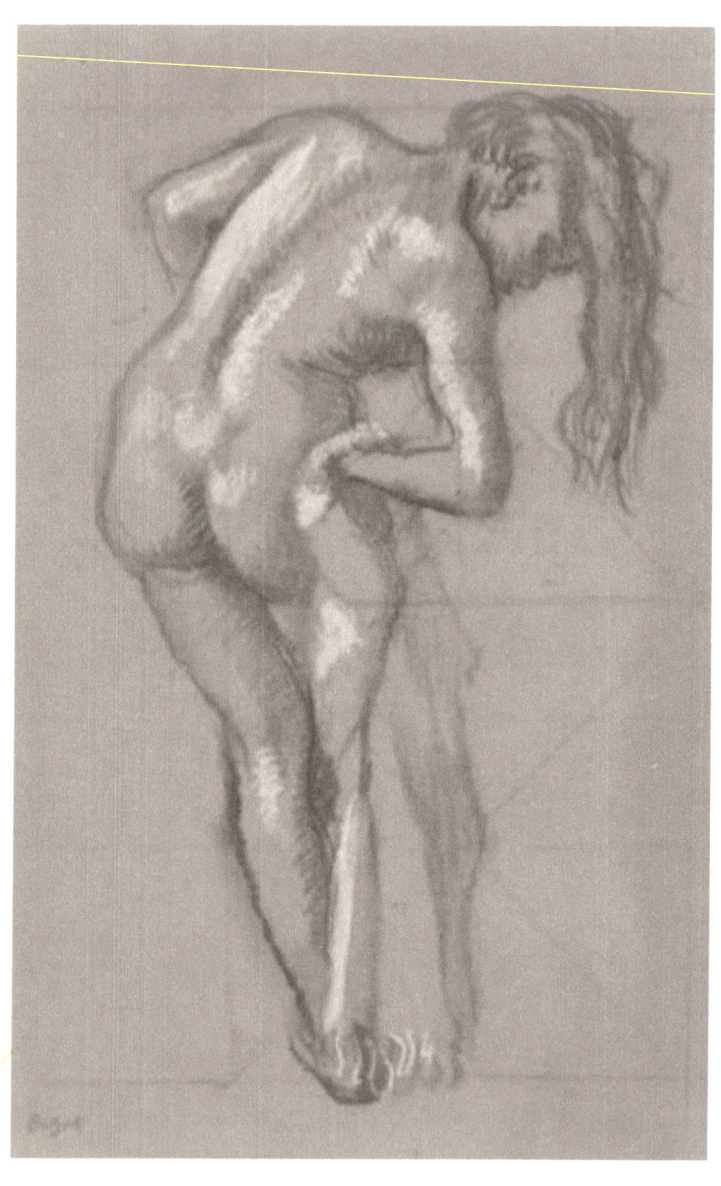

After the Bath, Woman Drying Herself
N.d., Charcoal with white heightening on buff paper squared for transfer laid down on board

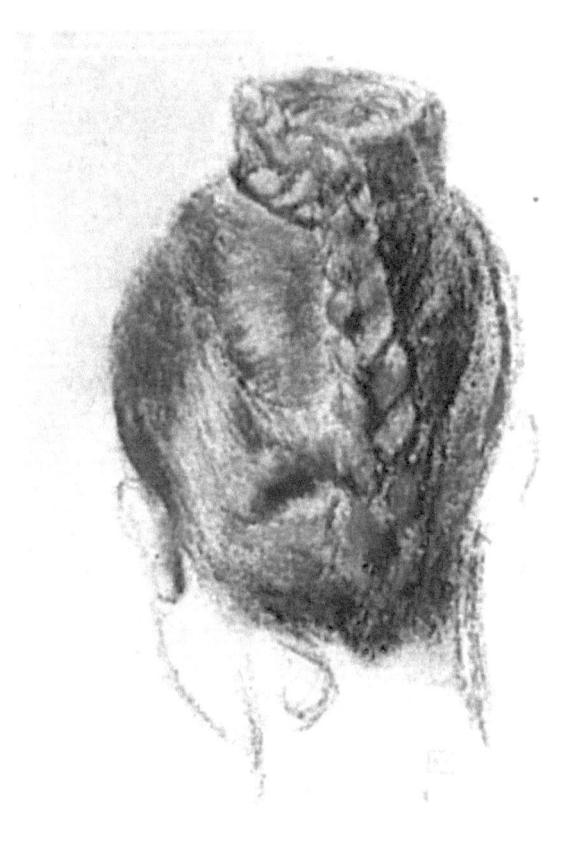

Head of a Woman
N.d., Pastel on gray paper

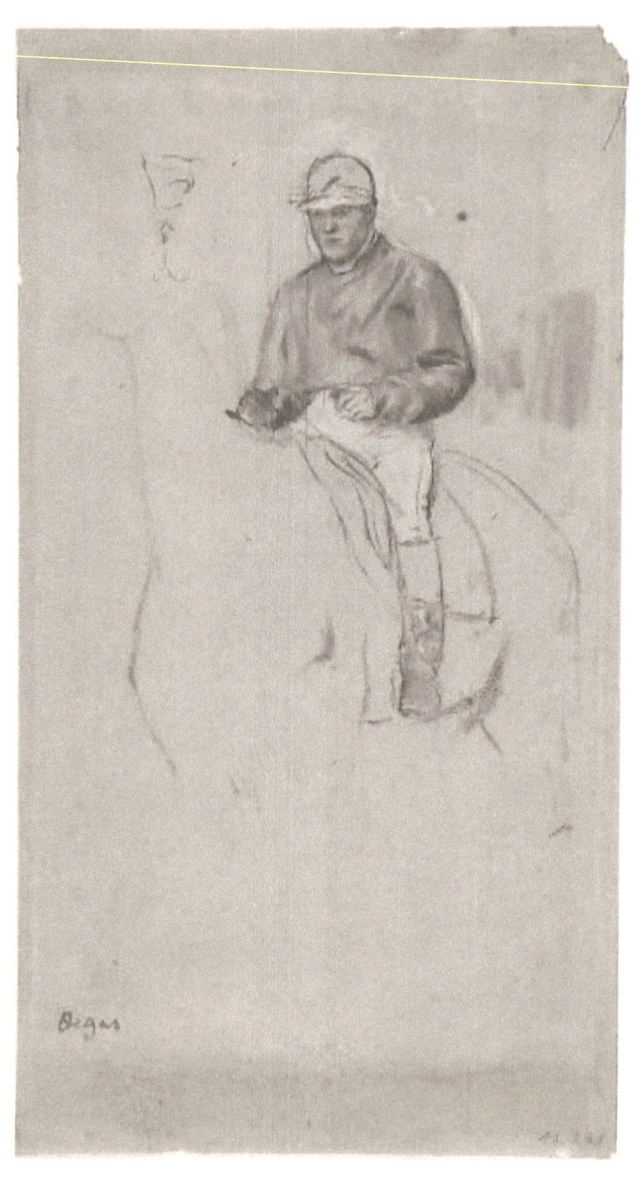

A Jockey on His Horse
N.d., Oil and graphite on faded pink paper

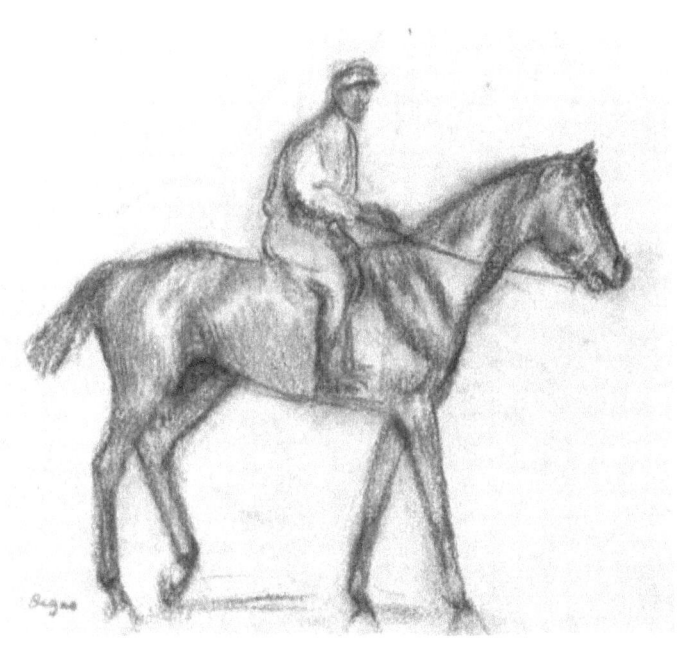

Jockey
N.d., Charcoal on paper

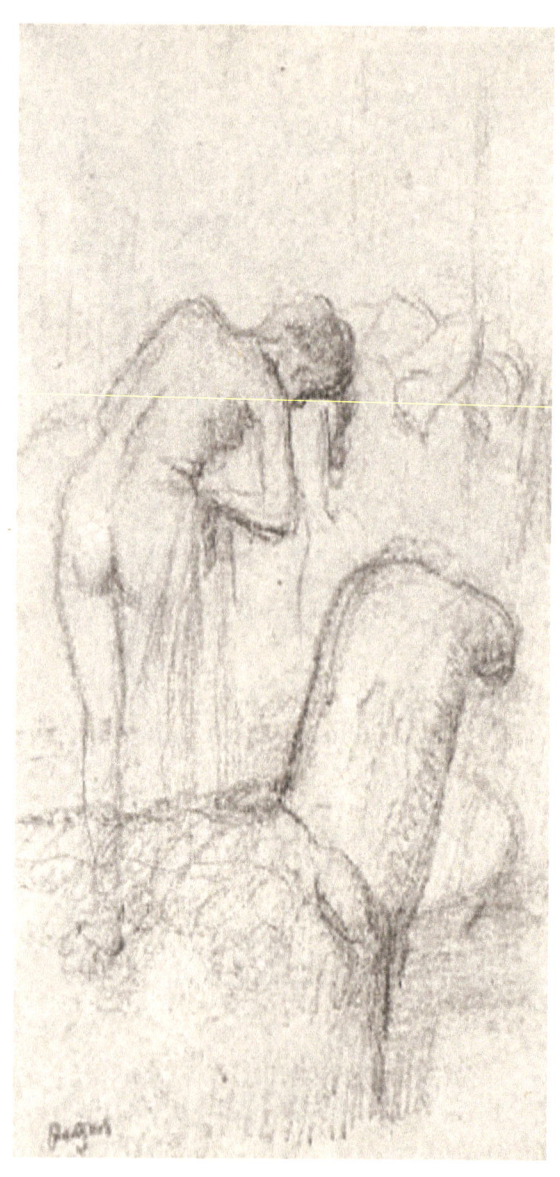

After the Bath, Woman Drying Herself
N.d., pencil on pale blue paper

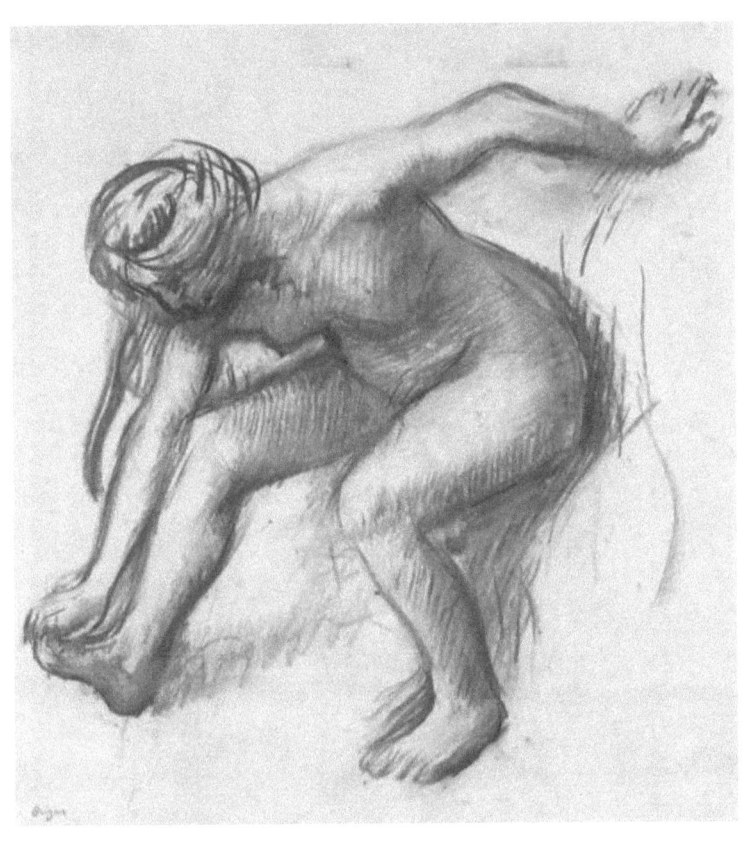

After the bath (naked woman)
N.d., Charcoal on paper lay down on board

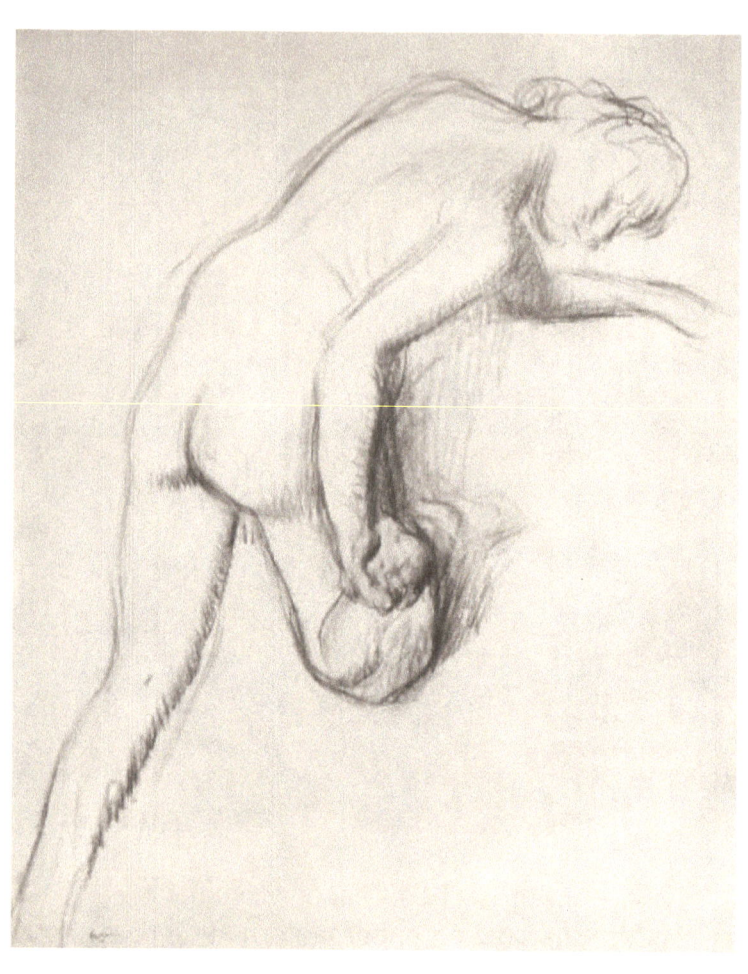

Nude Study
N.d., Charcoal on paper lay down on board

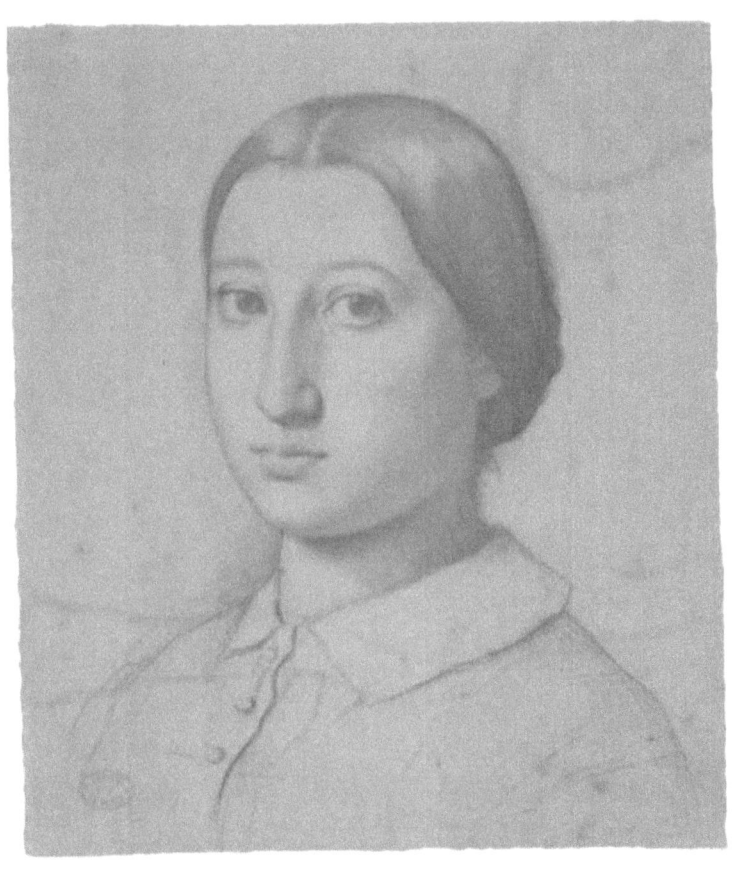

Thérèse De Gas
1855–56, Black crayon and graphite on brown paper

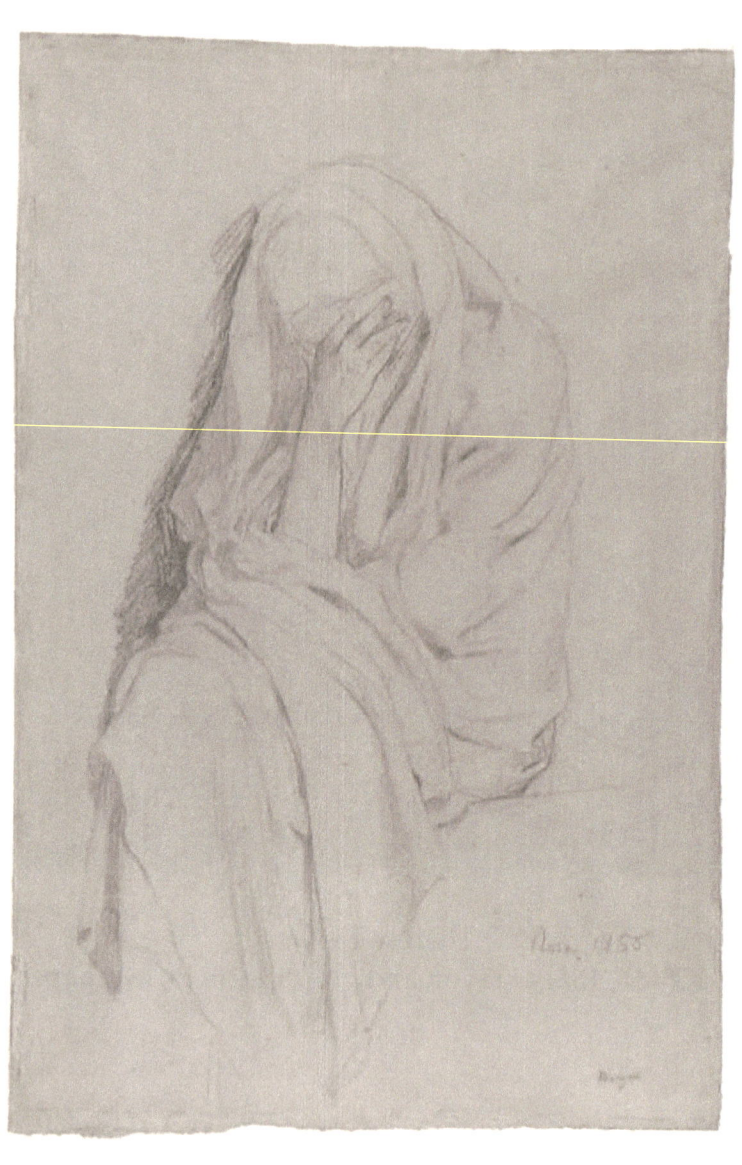

Study for Vieille Italienne
1856, Graphite on blue paper

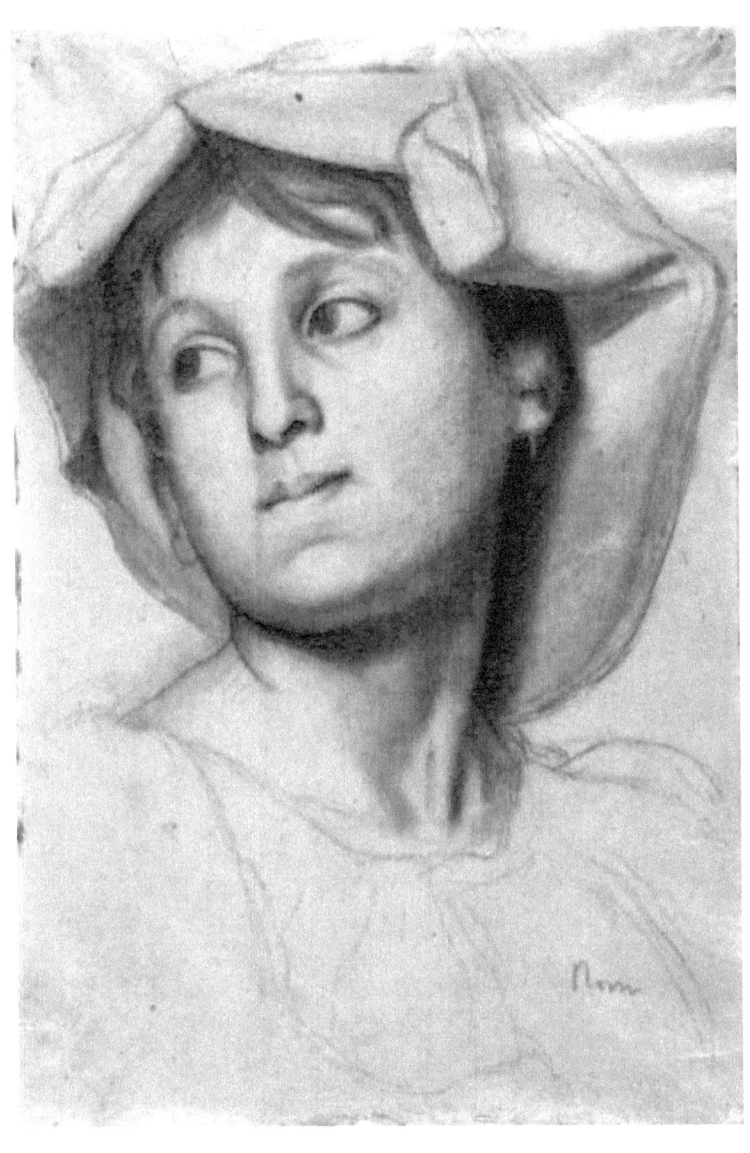

Head of a Roman Girl
1856, Black chalk with stumping and traces of white chalk on pale beige, medium-weight, moderately textured wove paper

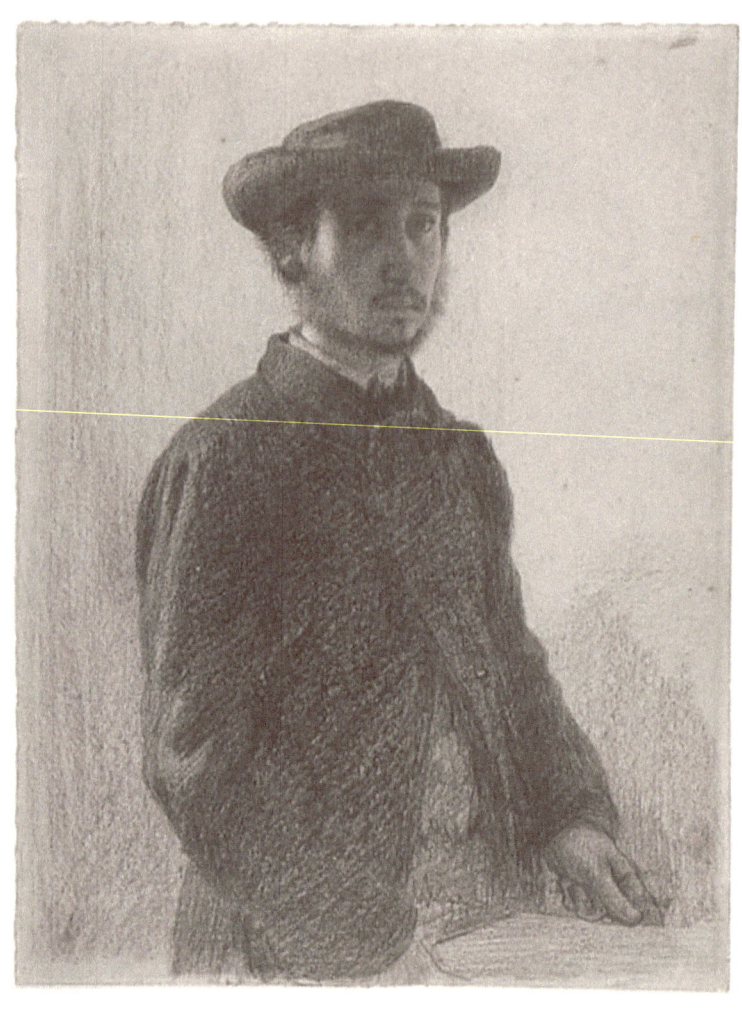

Self-Portrait
1857, Black chalk and graphite, heightened with white on heavy beige wove paper

Study after Raphael
1857, Black chalk with stumping on cream, medium-weight, moderately textured, hand made laid paper

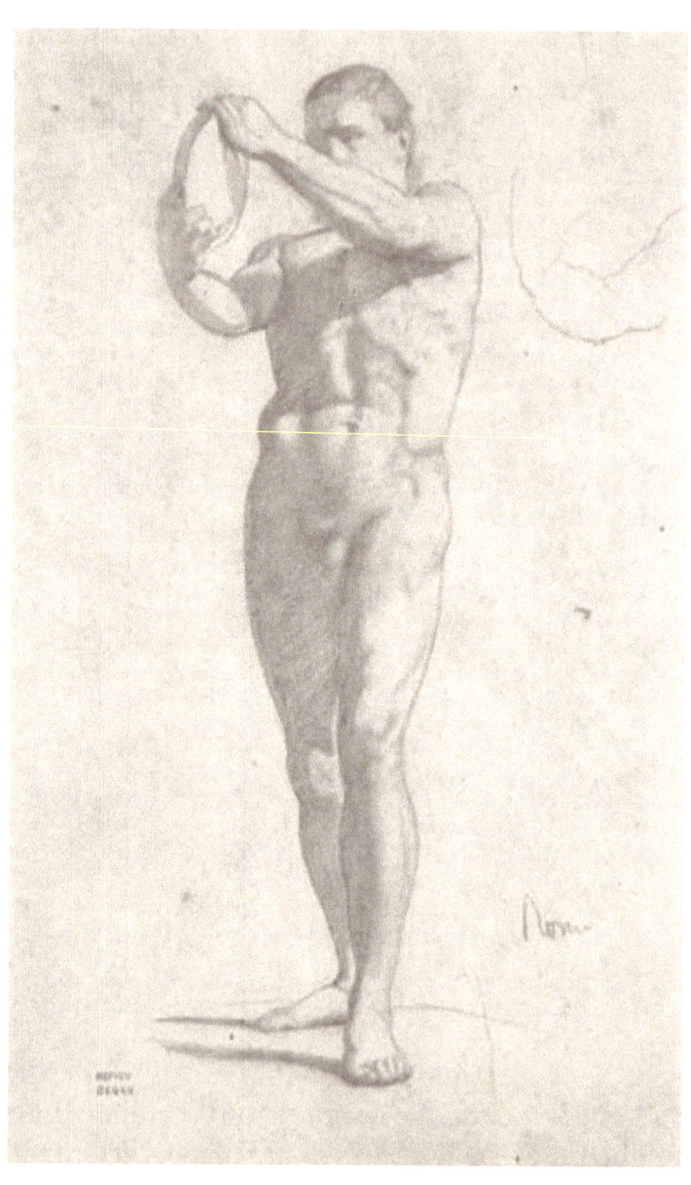

Le Discobole
1858, Pencil on paper

Study of Donatello's bronze David
1858, Graphite on paper

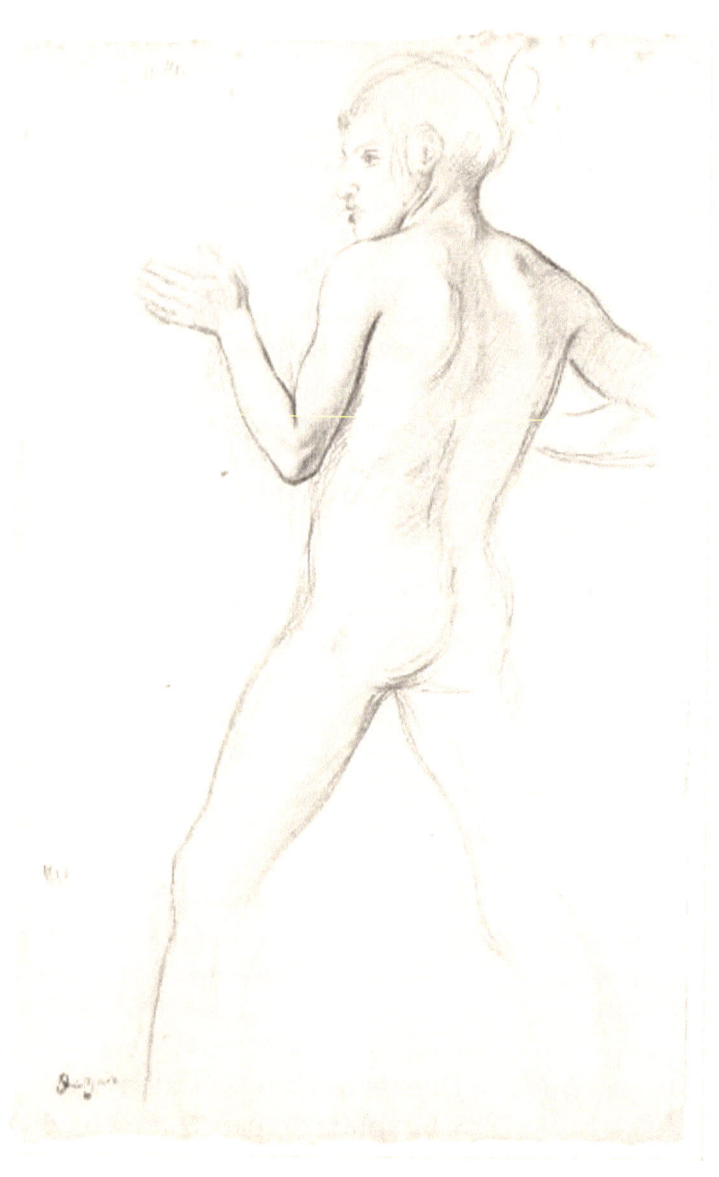

Youth in an Attitude of Defense
1859–60, Pencil on buff laid paper

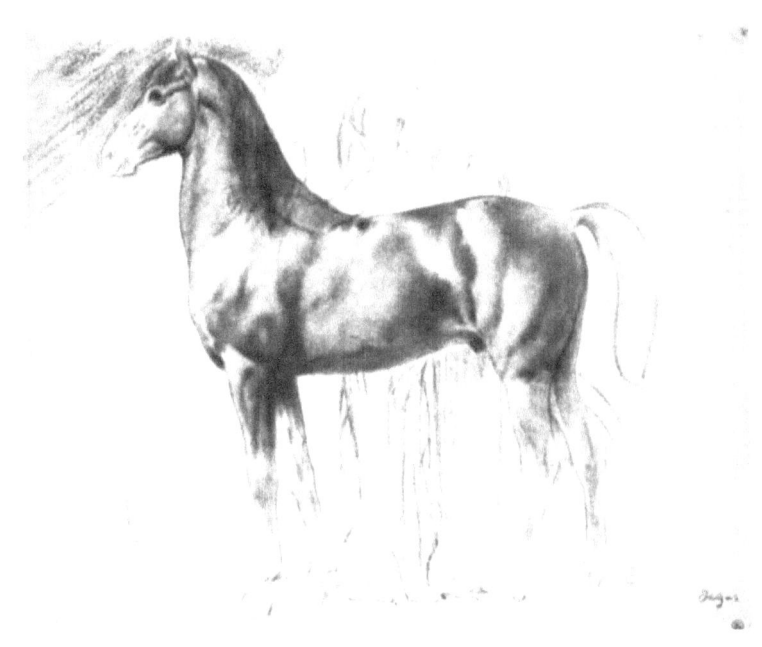

Study for Semiramis Building Babylon
1861, Pencil on paper

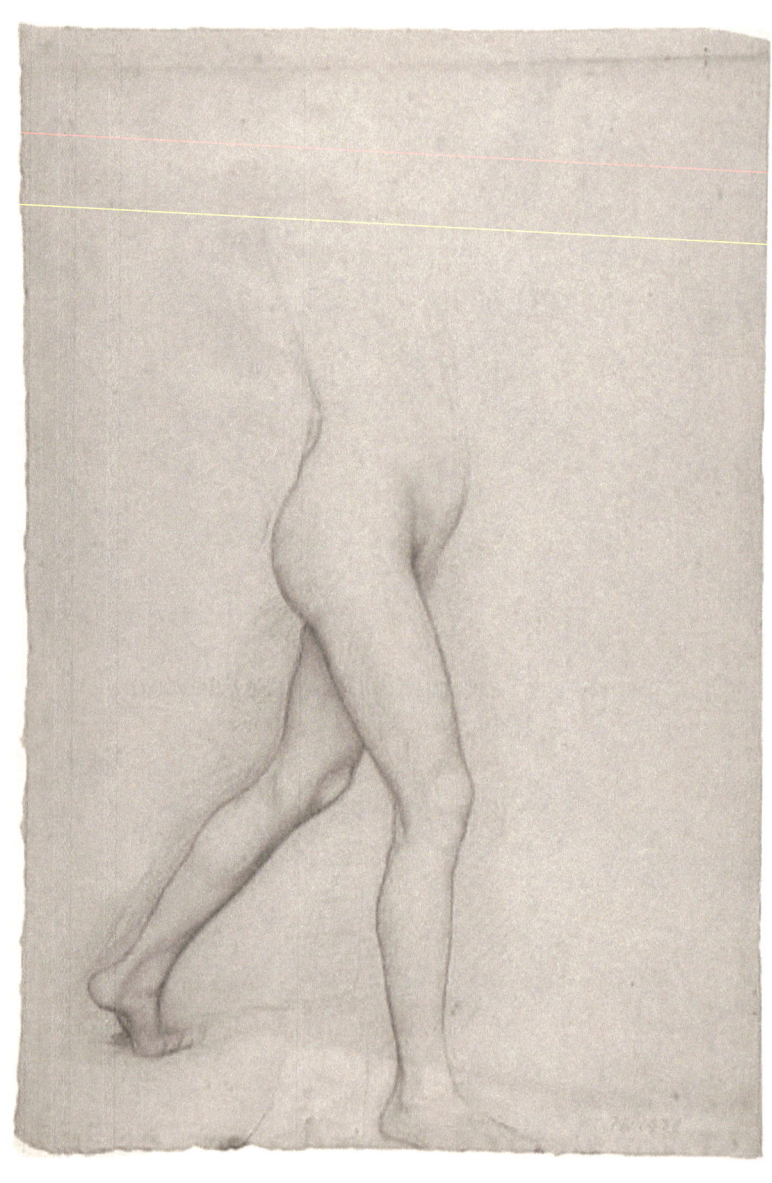

Study of a Girl's Legs for the painting "Young Spartans"
1860–62, Black chalk

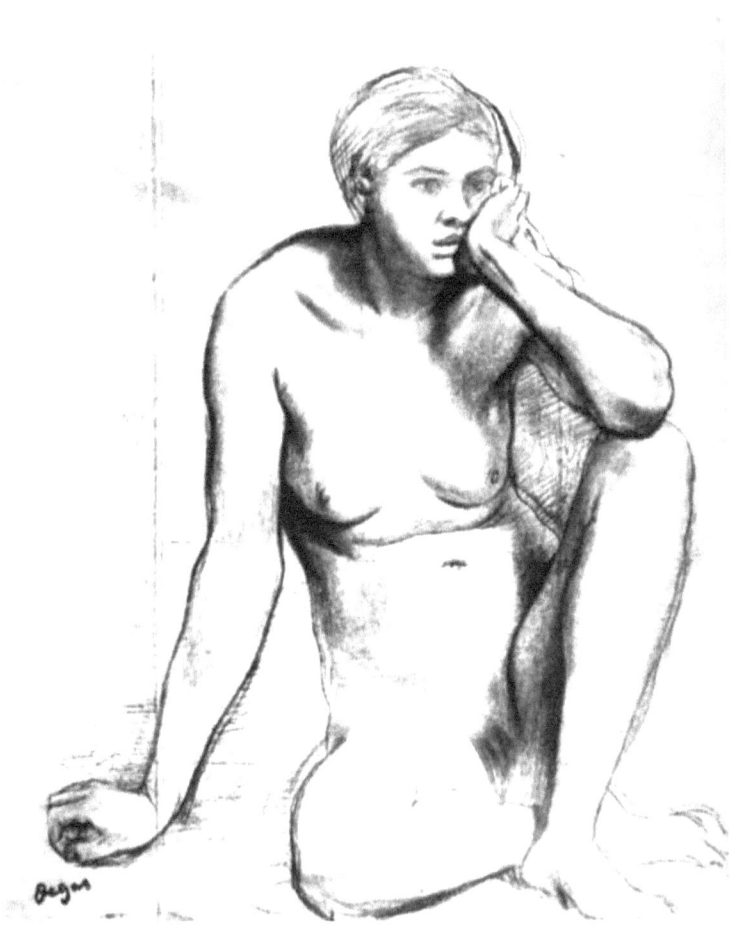

Study for the Medieval War Scene
1865, Pencil on paper

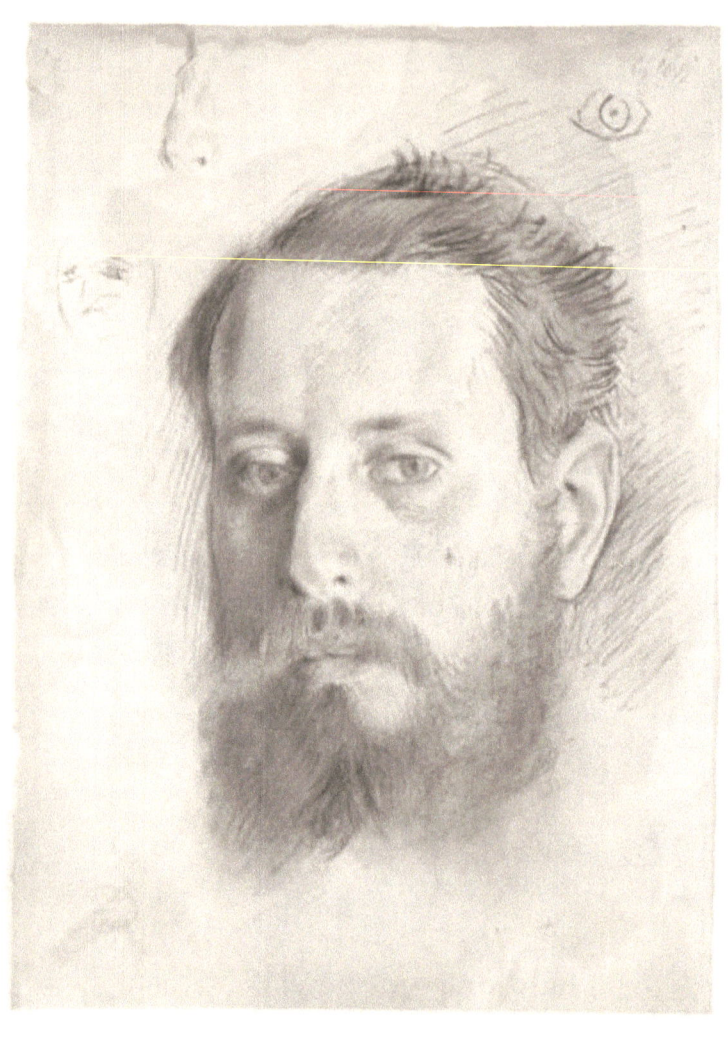

Portrait of Edmondo Morbilli
1865, Charcoal or black chalk on paper

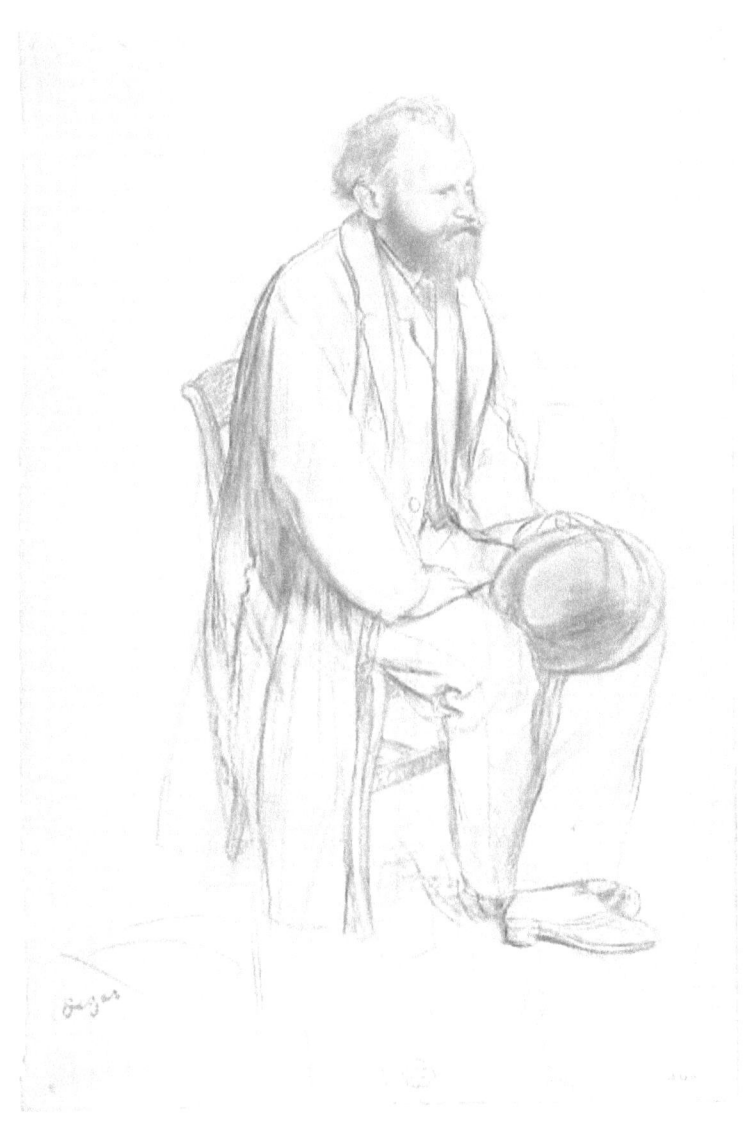

Édouard Manet, Seated, Holding His Hat
1865, Graphite and black chalk on wove (China) paper

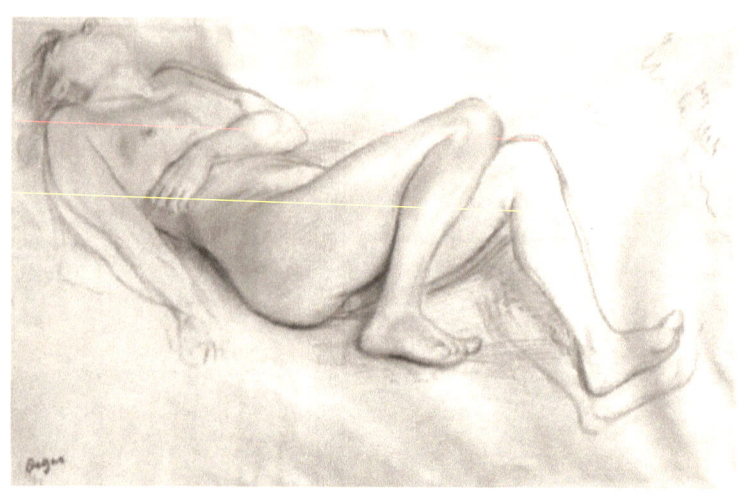

Nude Woman
1865. Black pencil on paper

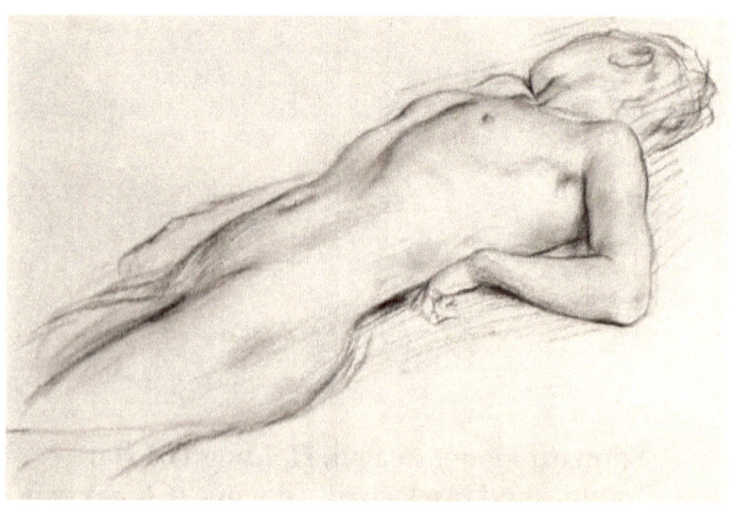

Nude Woman
1865. Black pencil on paper

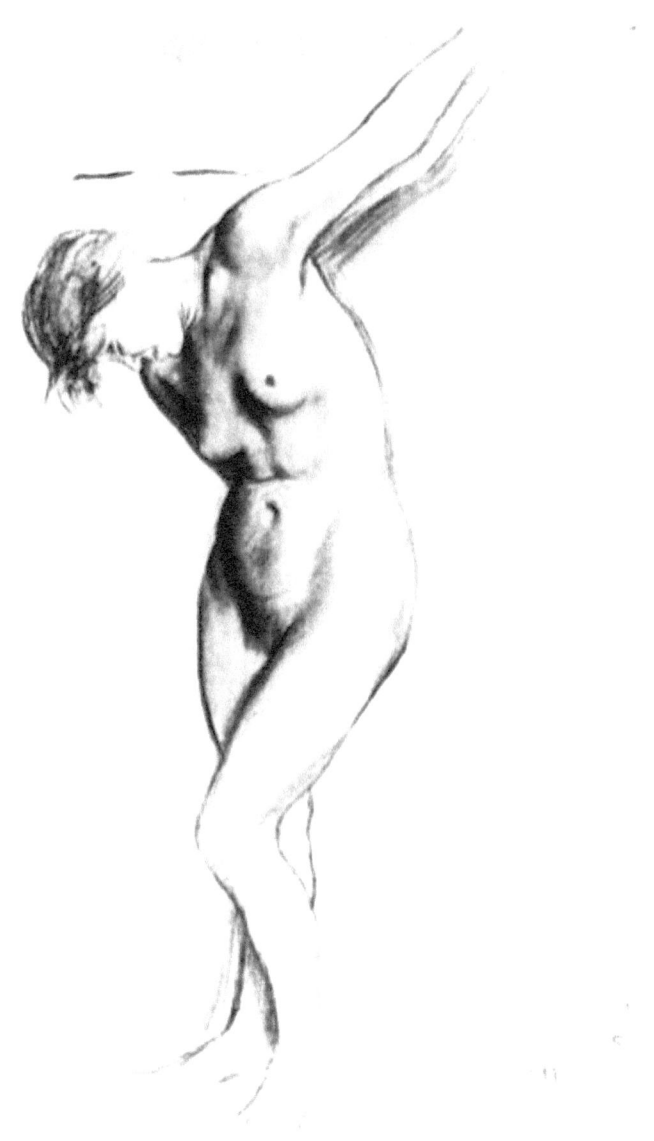

Study for the Medieval War Scene
1865, Pencil on paper

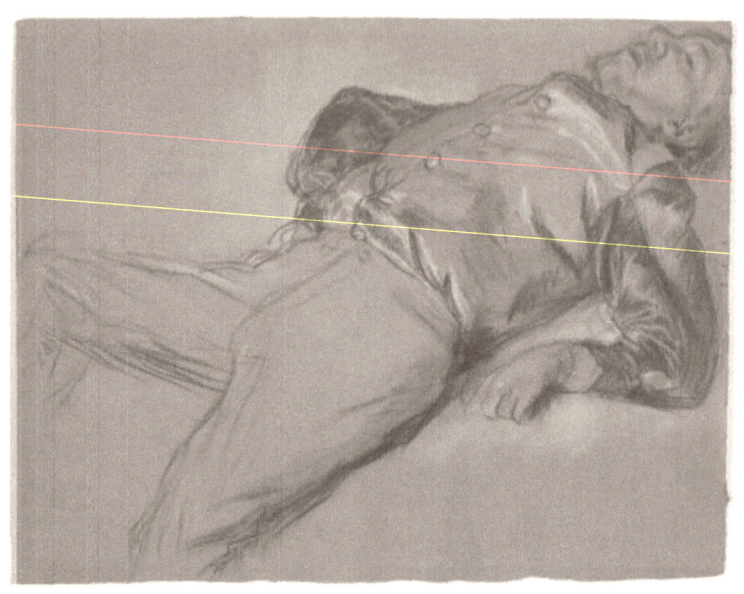

Fallen Jockey (study for "Scene from the Steeplechase: The Fallen Jockey")
1866, Black chalk and pastel on brown wove paper

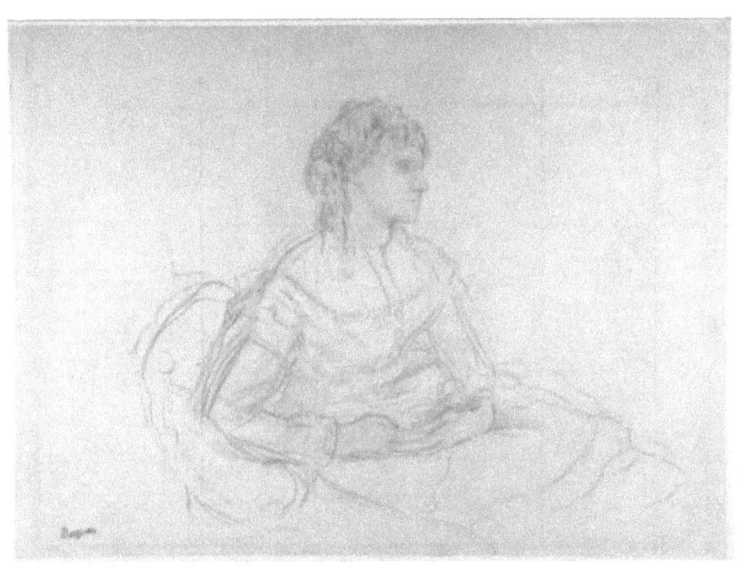

Study for Mme Théodore Gobillard (née Yves Morisot) 1869, Graphite on buff tracing paper, mounted on laid paper

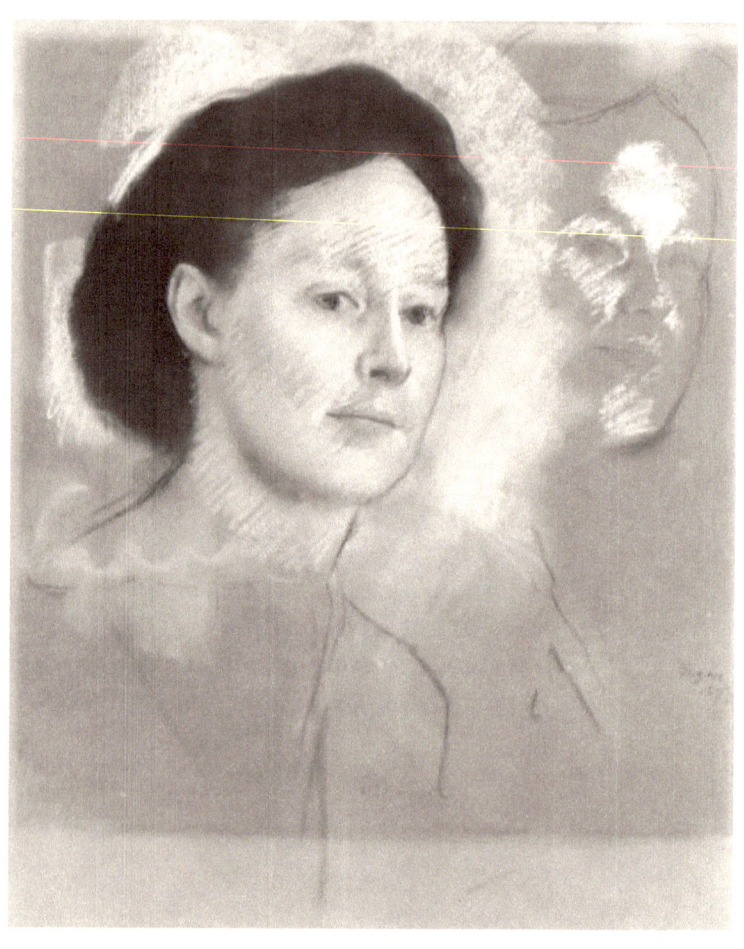

The Artist's Cousin, Probably Mrs. William Bell
(Mathilde Musson)
1873, Pastel on green wove paper, now darkened to brown

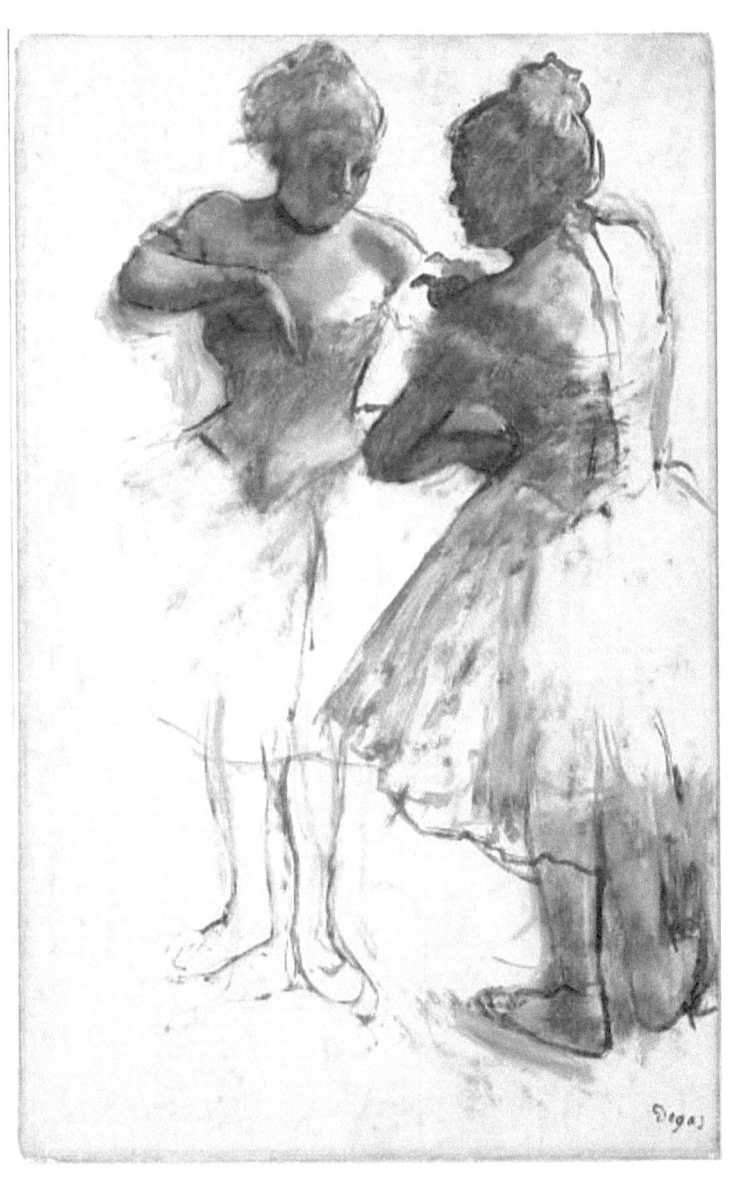

Two Dancers
1873, Dark brown wash and white gouache on bright pink commercially coated wove paper, now faded to pale pink

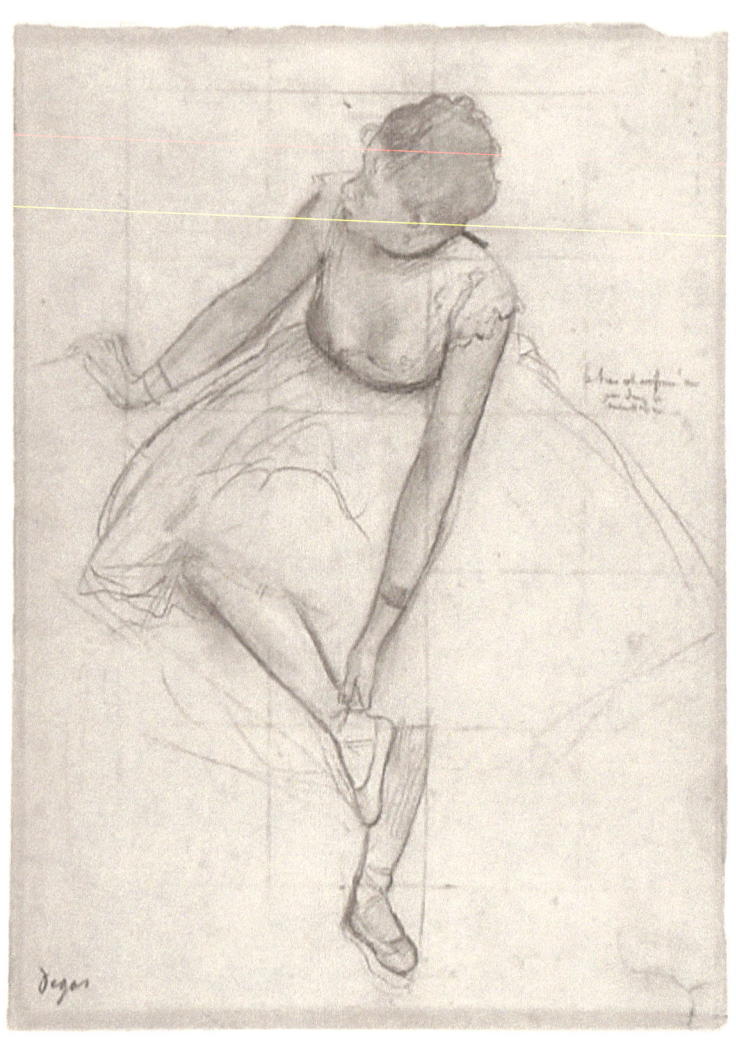

Dancer Adjusting Her Slipper
1873, Graphite heightened with black and white chalk on pink wove paper (now faded); squared for transfer

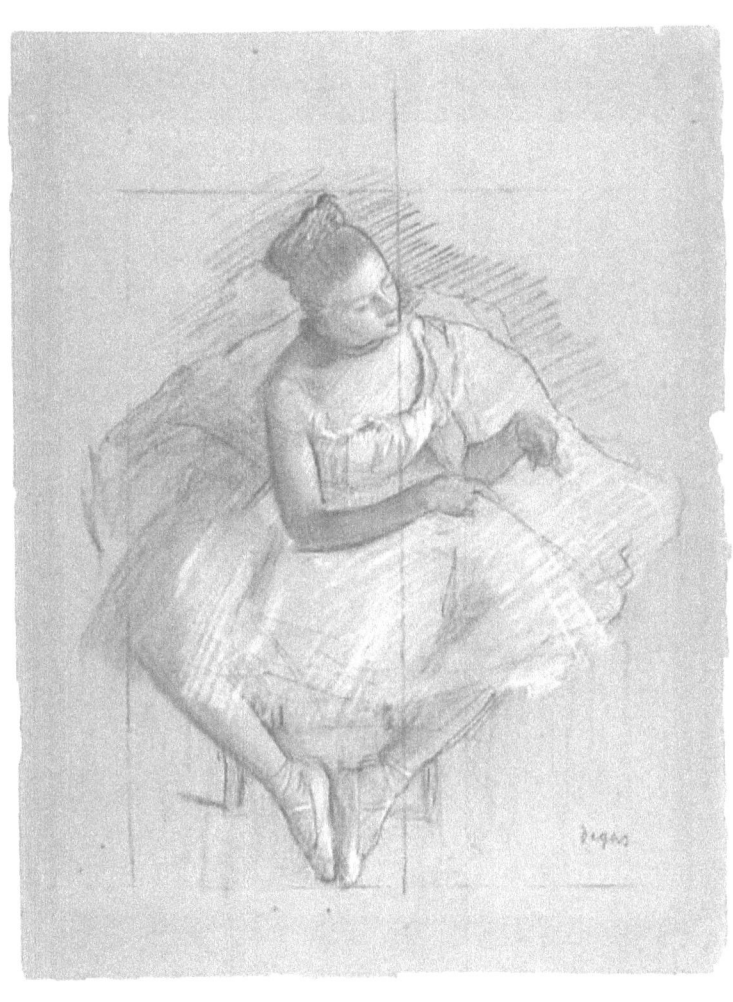

Seated Dancer
1873–74, Graphite and charcoal heightened with white on pink wove paper; squared for transfer

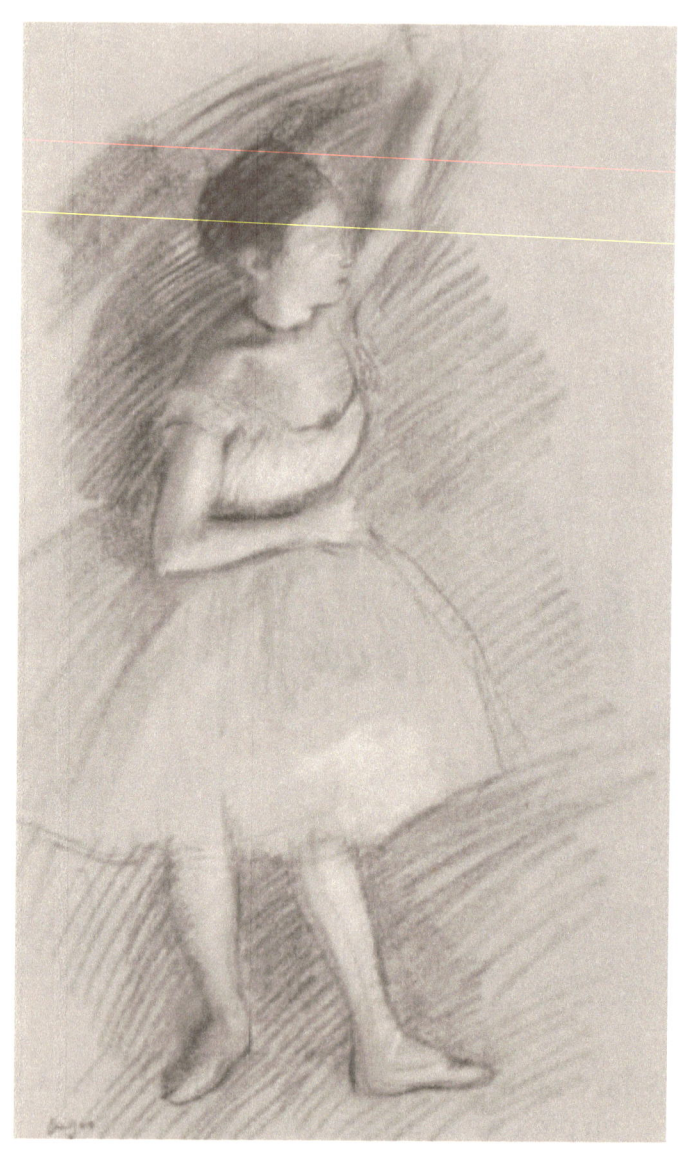

Study of Dancer
1874, Black chalk with white heightening on paper laid down on board

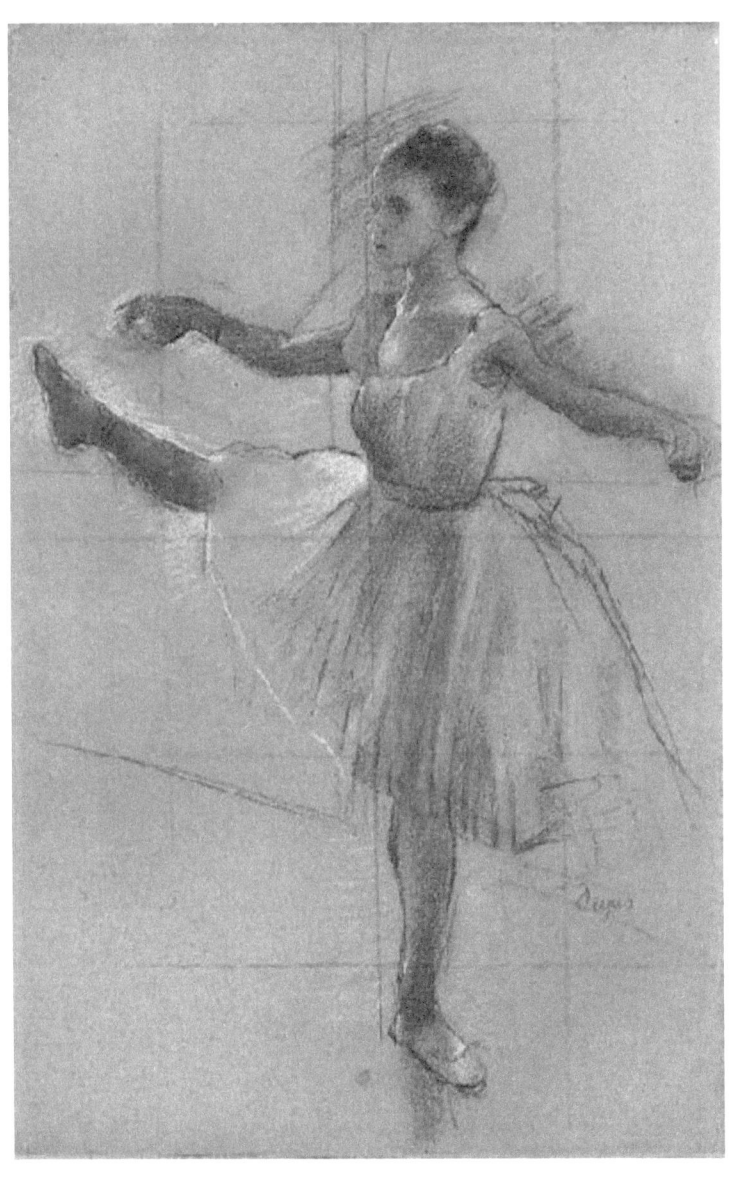

Dancer (Battement in Second Position)
1874, Charcoal heightened with white and pale yellow
chalk on paper

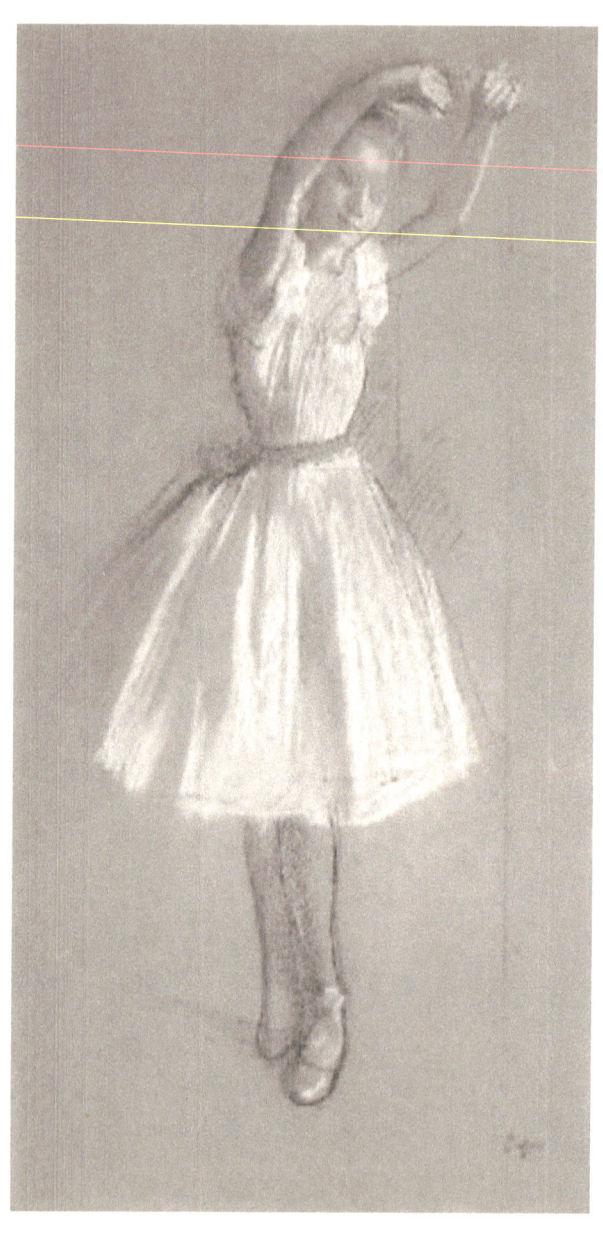

Little Dancer
1875, Charcoal and white chalk on paper

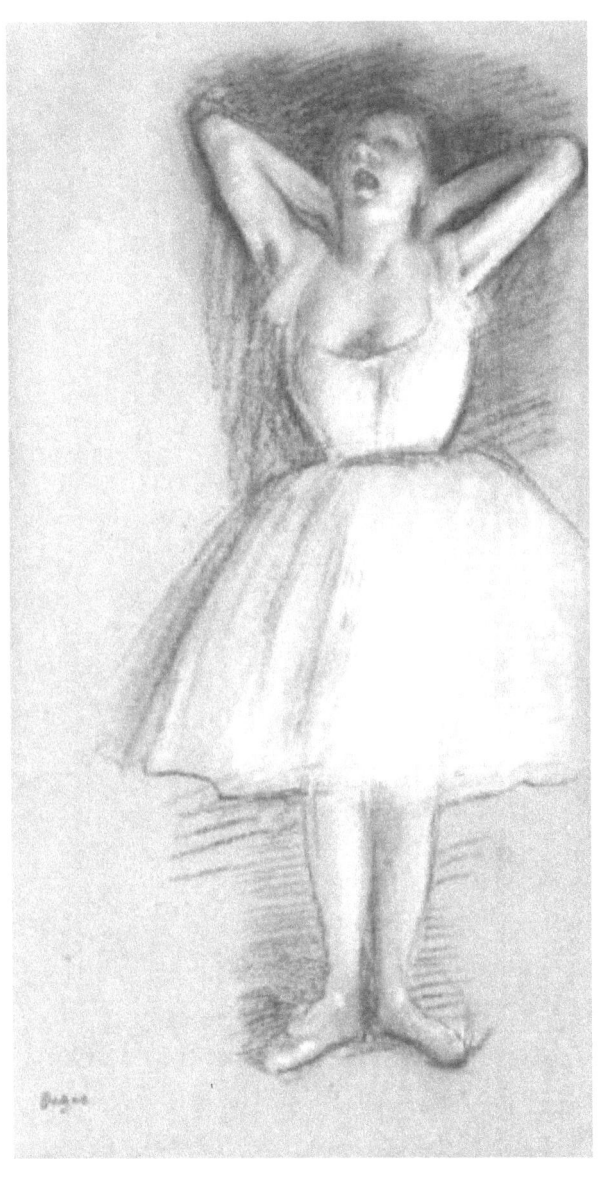

Dancer, arms raised and brought behind the head
1876, Charcoal and white chalk on paper

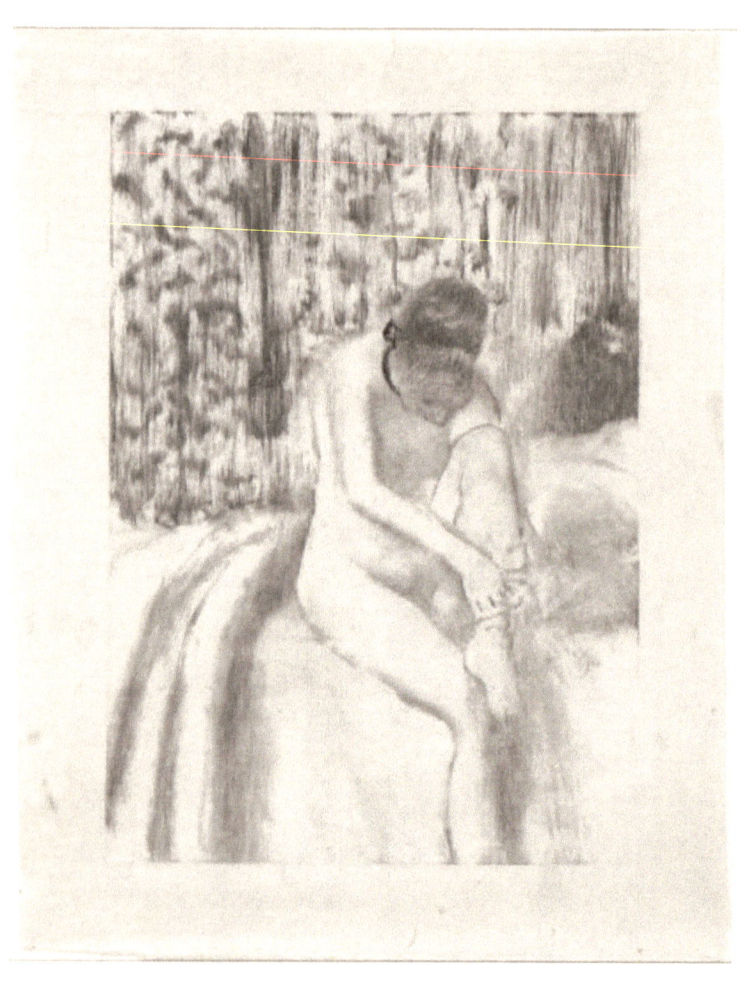

Girl Putting on Her Stockings
1876–77, Monotype in black ink printed on china paper, mounted on cardboard (monotype)

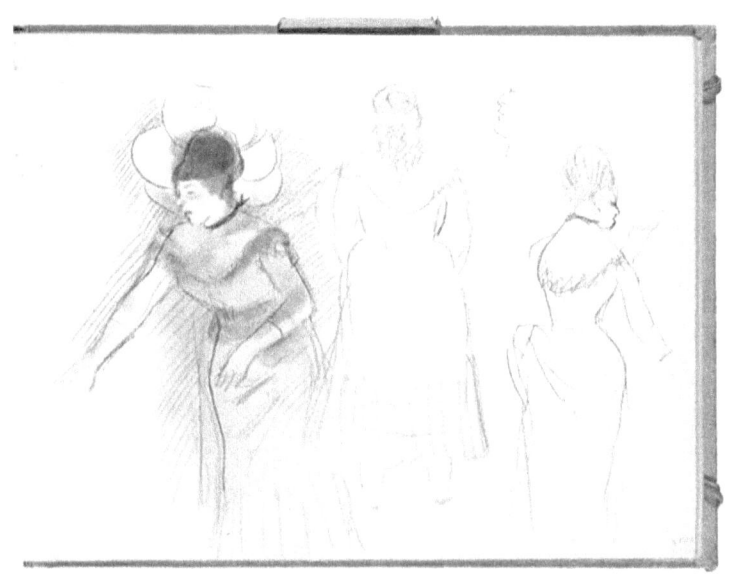

An Album of Pencil Sketches, Café Singers
1877, Graphite, charcoal, black ink on wove paper

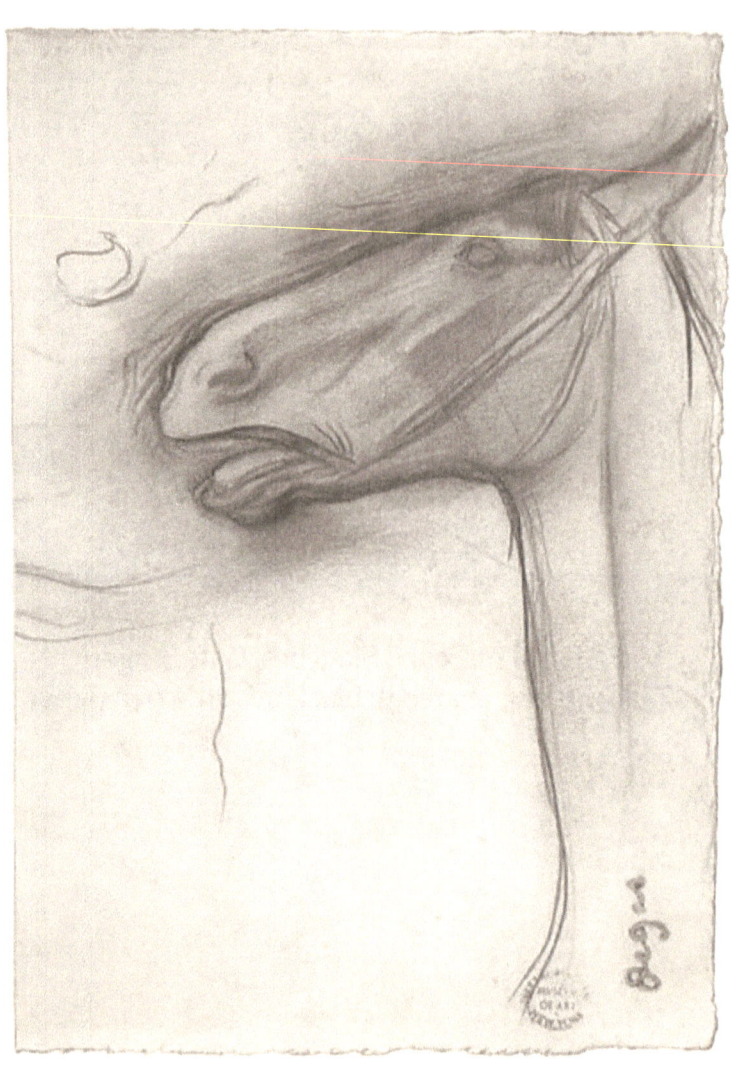

Head of a Horse
1878, Graphite on wove paper

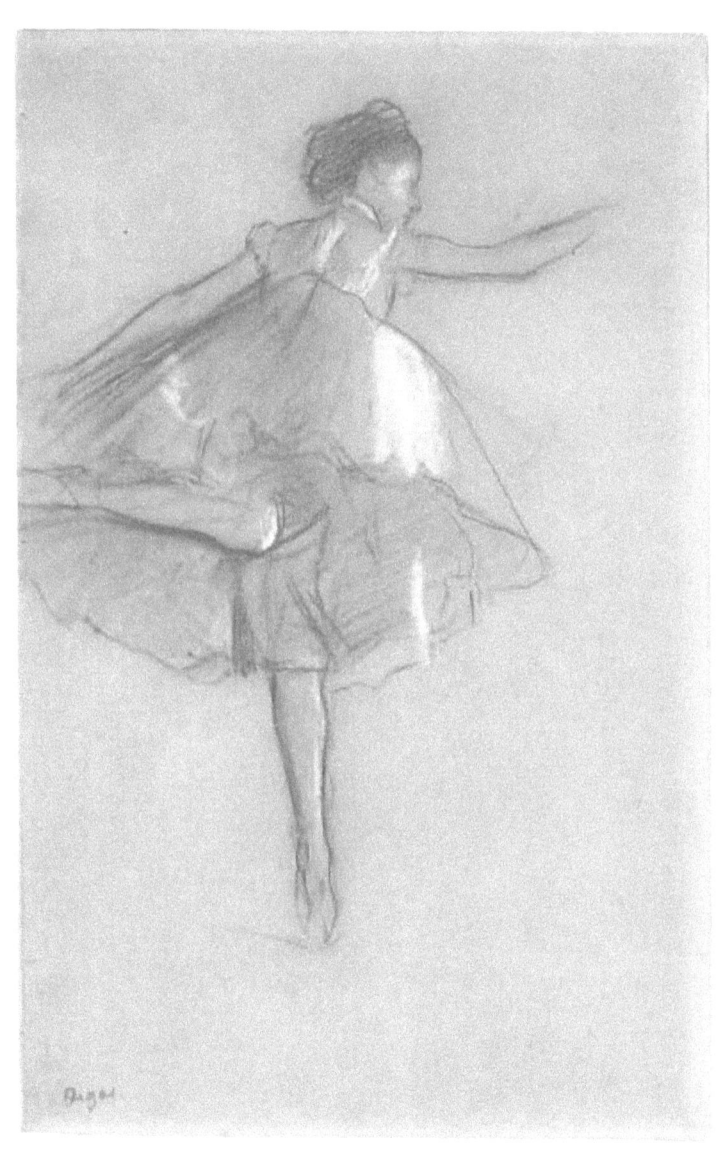

Dancer
1878, Charcoal, heightened with white on beige wove paper

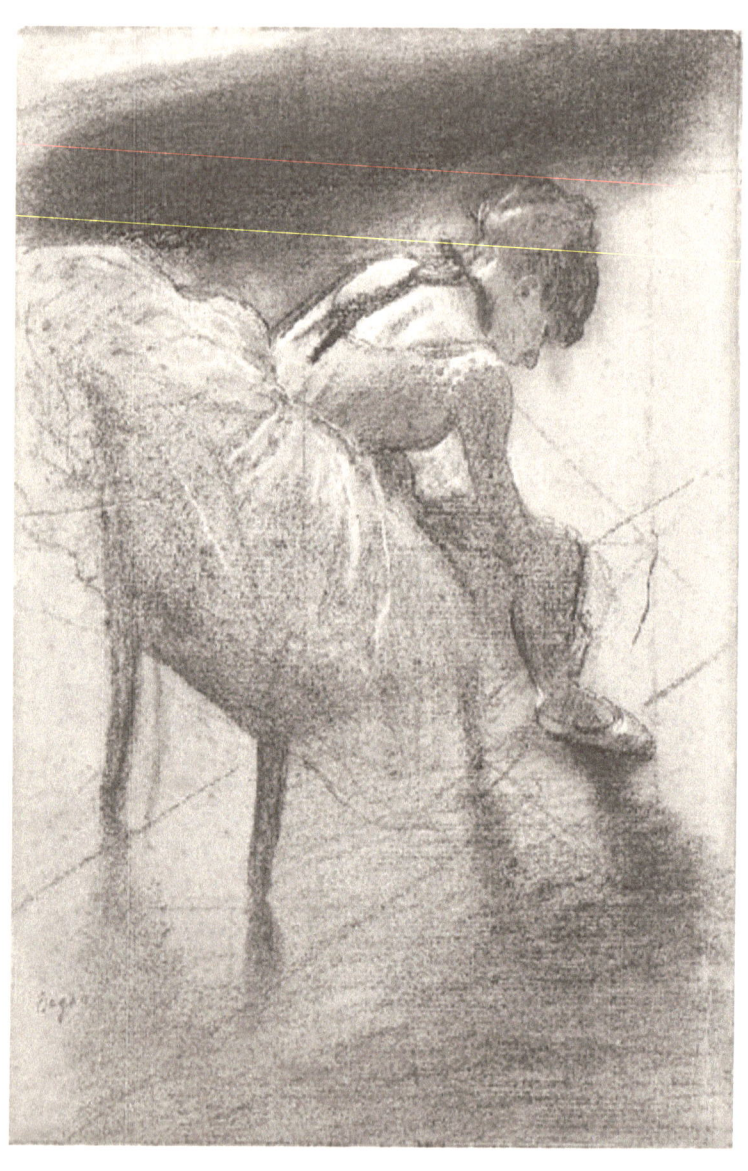

Seated Dancer Rubbing Her Leg,
c. 1878, Charcoal with white and dark brown pastel on gray-brown laid paper

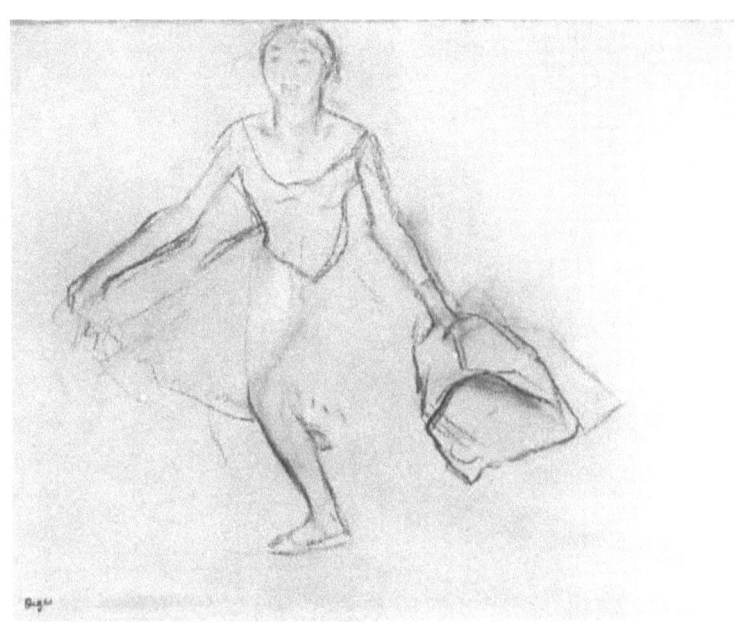

Dancer with a Bouquet Taking a Bow
1878, Charcoal on pink paper

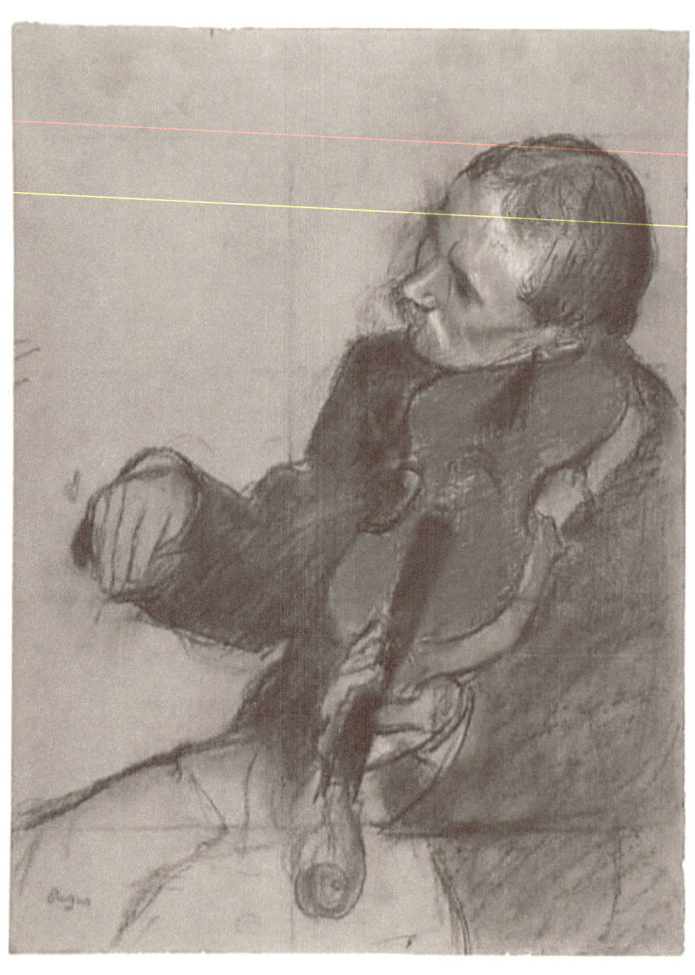

Violinist, Study for "The Dance Lesson"
1878–79, Pastel and charcoal on green wove paper;
squared for transfer in charcoal

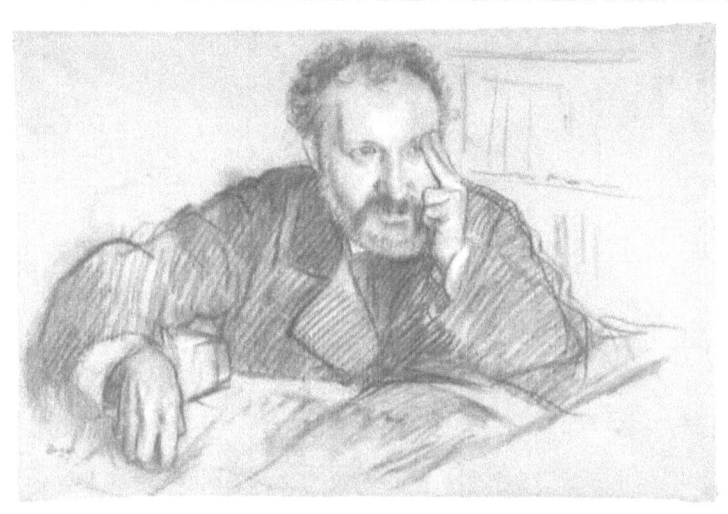

Edmond Duranty
1879, Dark brown chalk, heightened with white chalk,
on faded blue laid paper

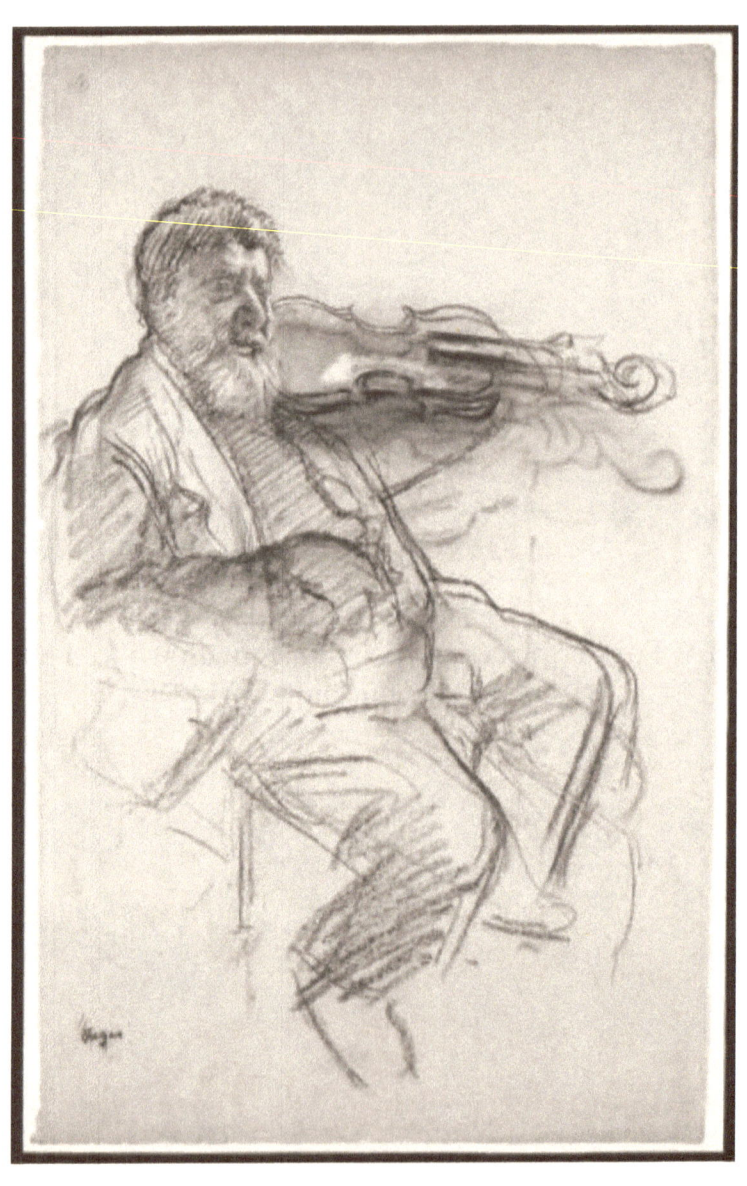

The Violinist
1879, Charcoal heightened with white chalk on blue-gray paper

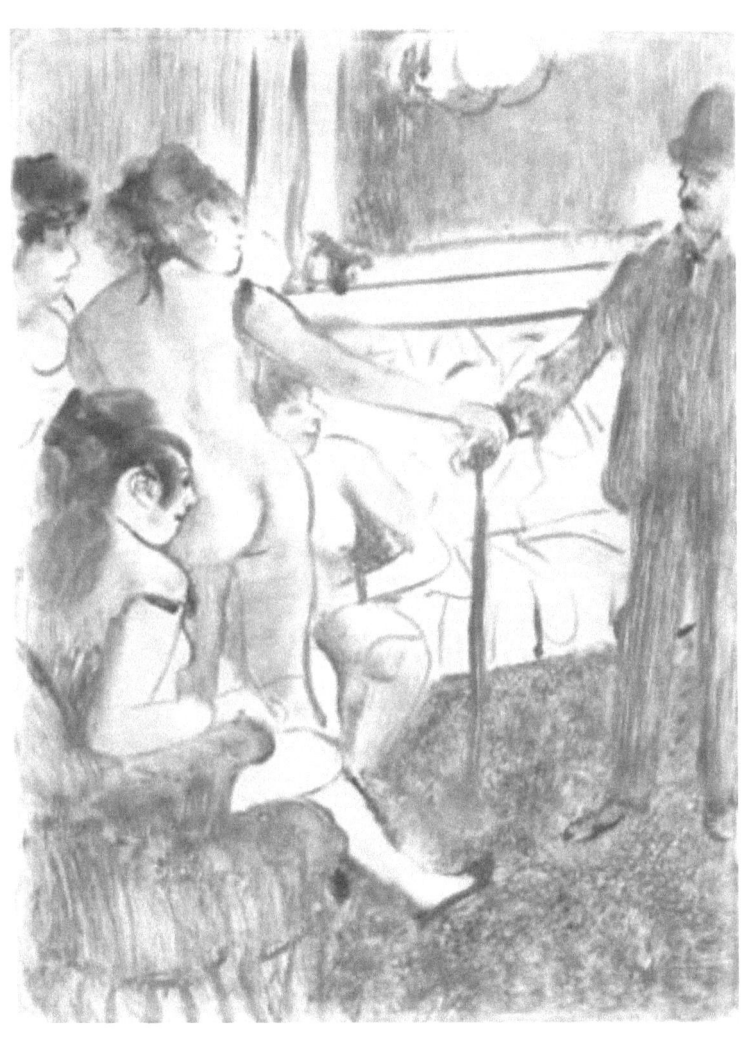

The Serious Client,
c. 1879, Monotype on wove paper

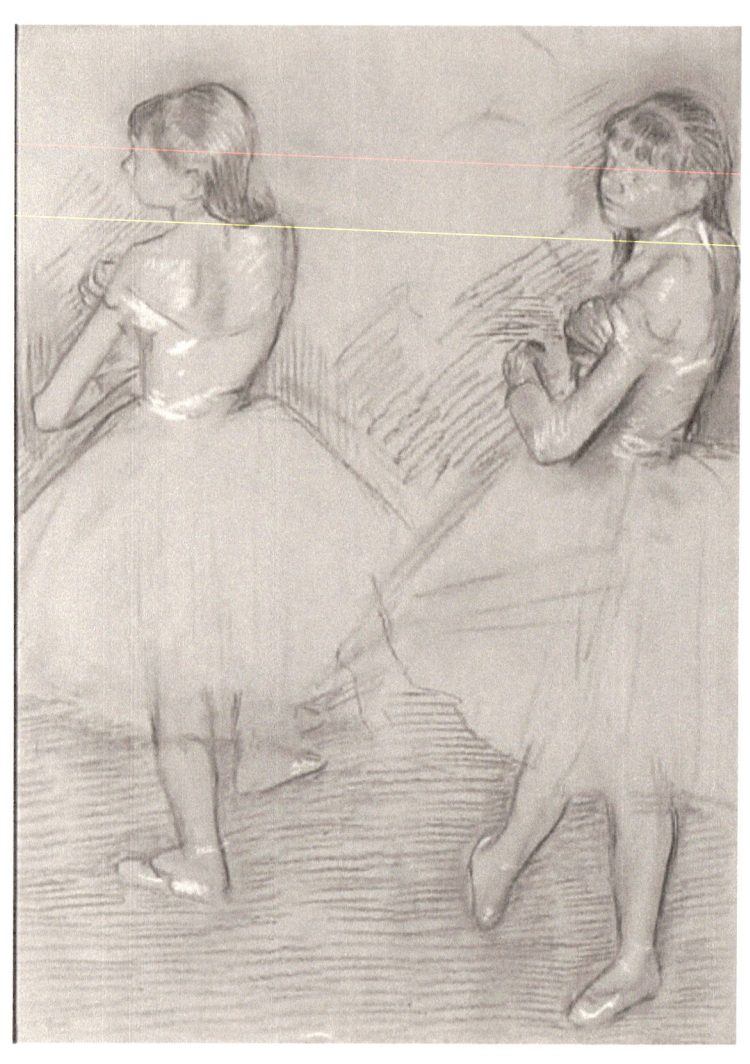

Two Dancers
1879, Charcoal and white chalk on green commercially coated wove paper

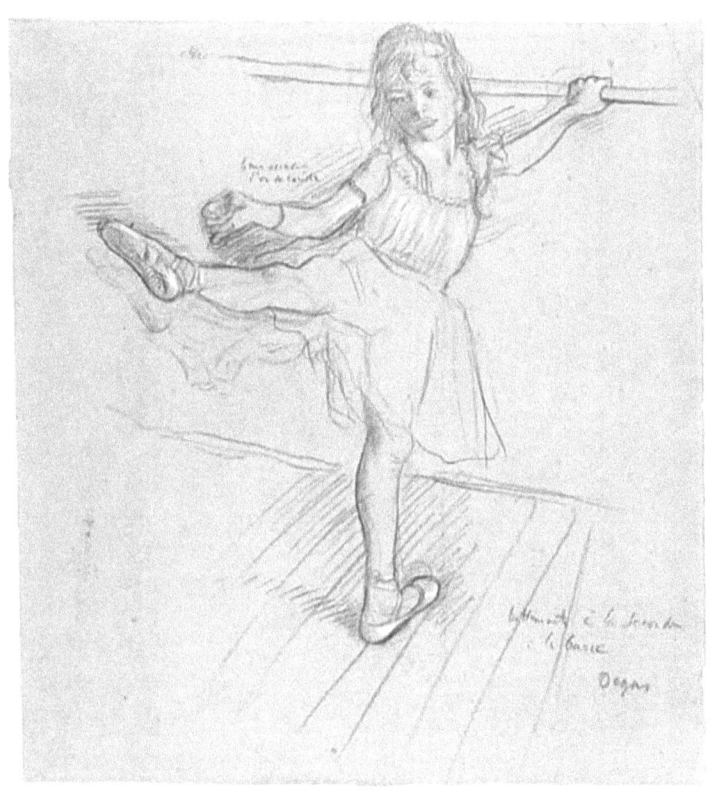

Little Girl Practicing at the Bar
1878–80, Black chalk and graphite, heightened with white chalk on pink laid paper

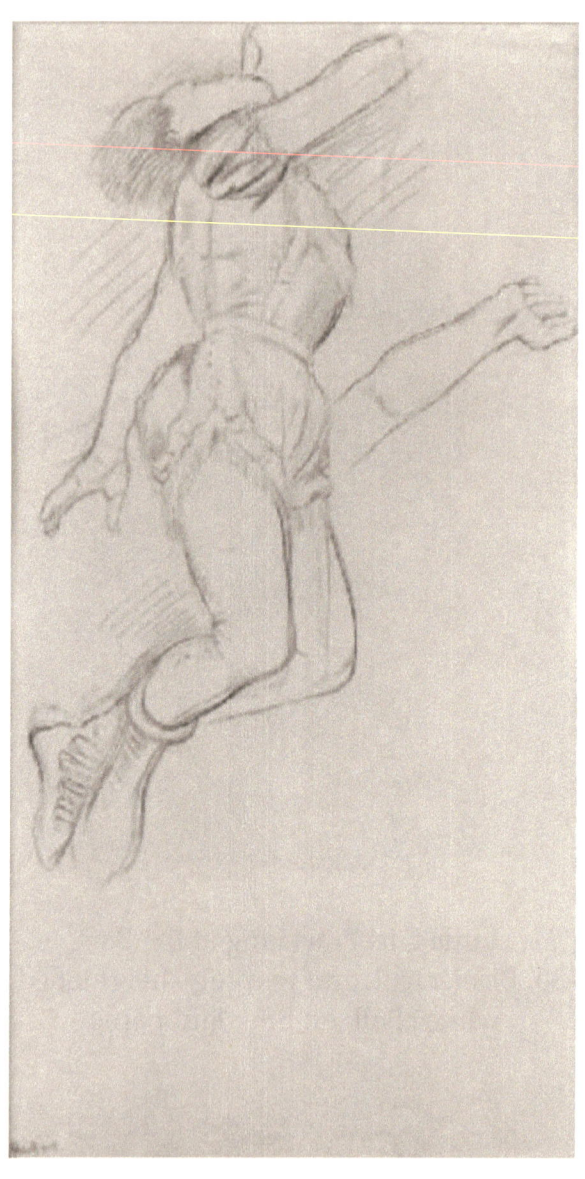

Mlle La La at the Circus Fernando
1879, Black crayon on brown wove paper

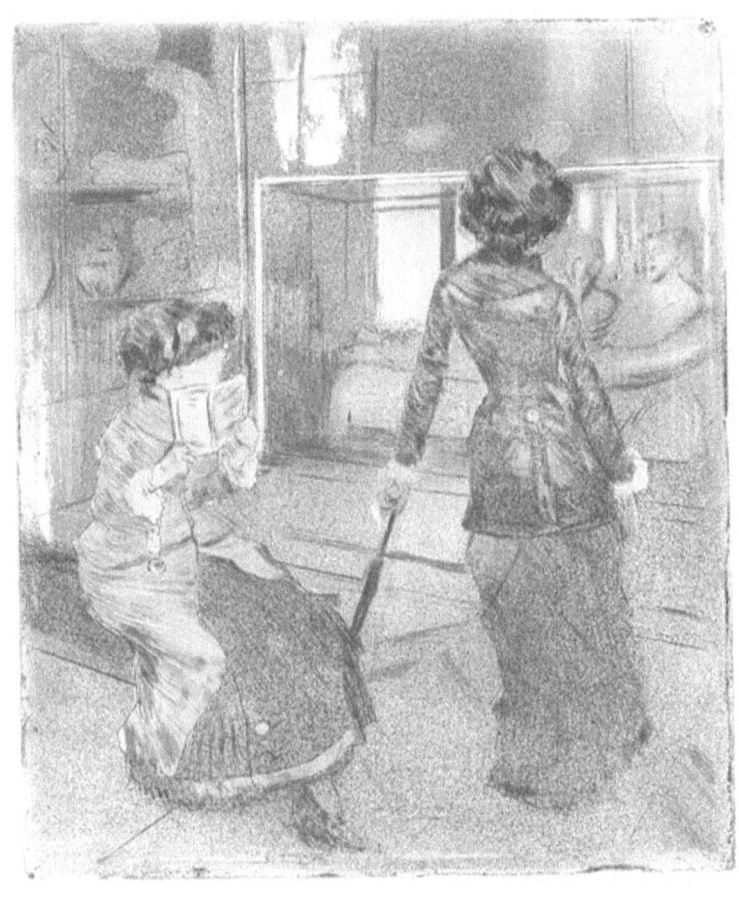

Mary Cassatt at the Louvre: The Etruscan Gallery
1879–80, Softground etching, drypoint, aquatint, and etching

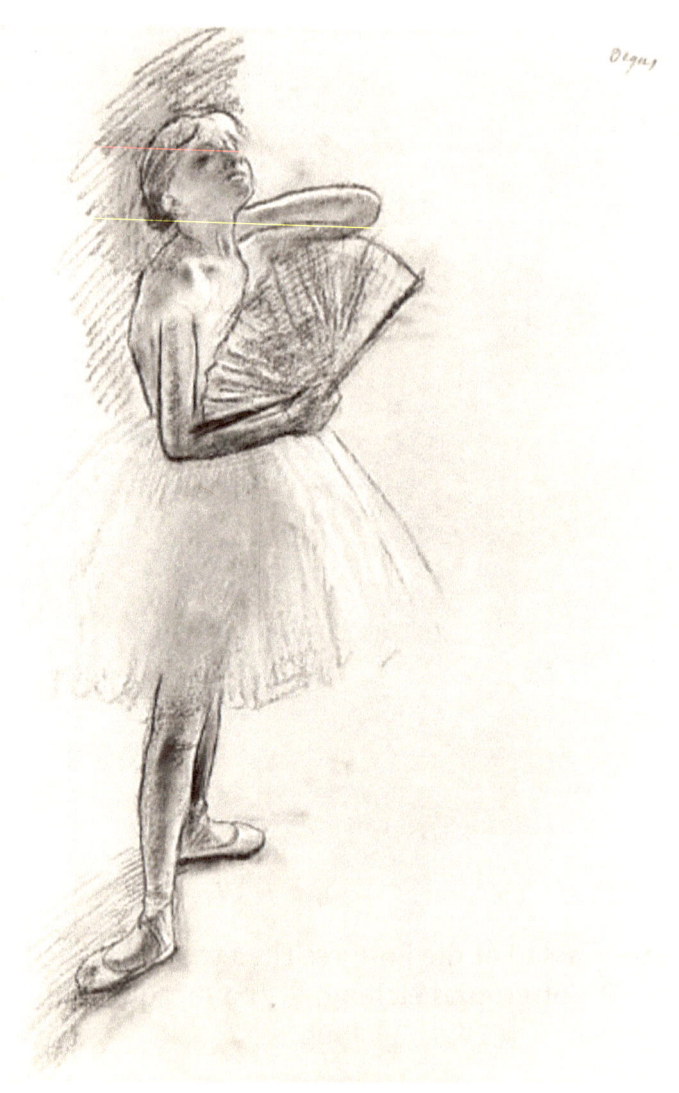

Dancer with a Fan
1880, Pastel on gray-green laid paper

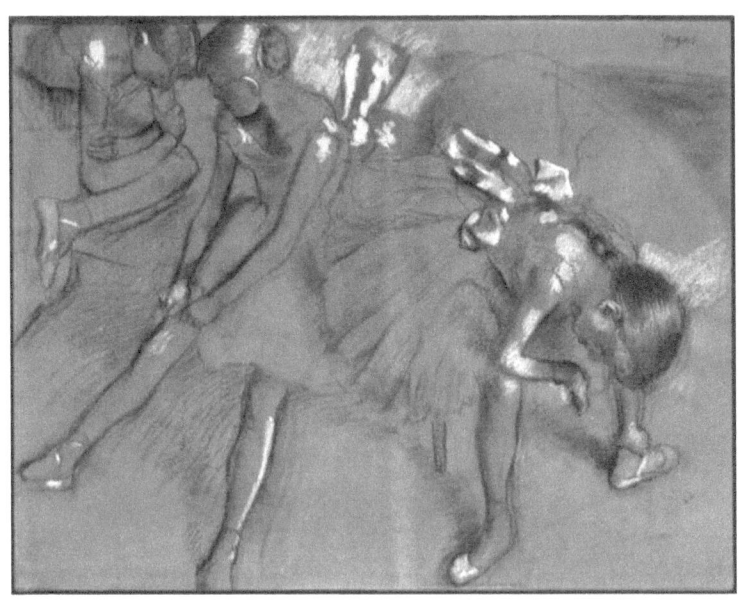

Three Dancers Resting,
1880, Black chalk and pastel on tan wove paper

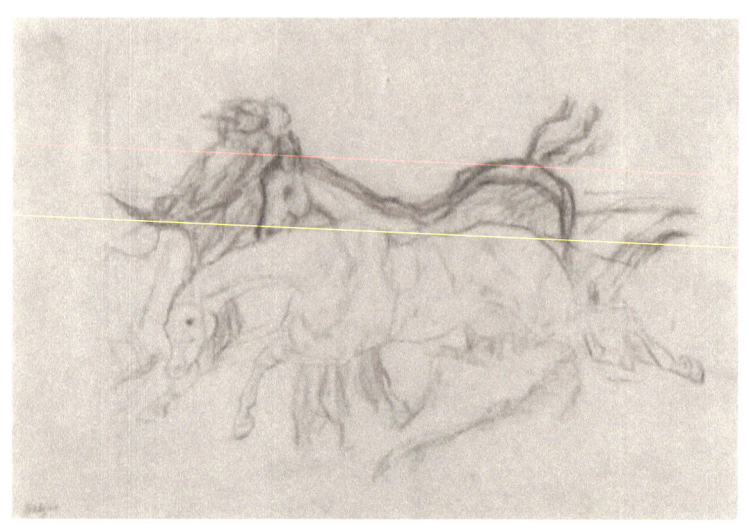

Racehorses (study for "Scene from the Steeplechase: The Fallen Jockey")
1881, Charcoal on light brown paper

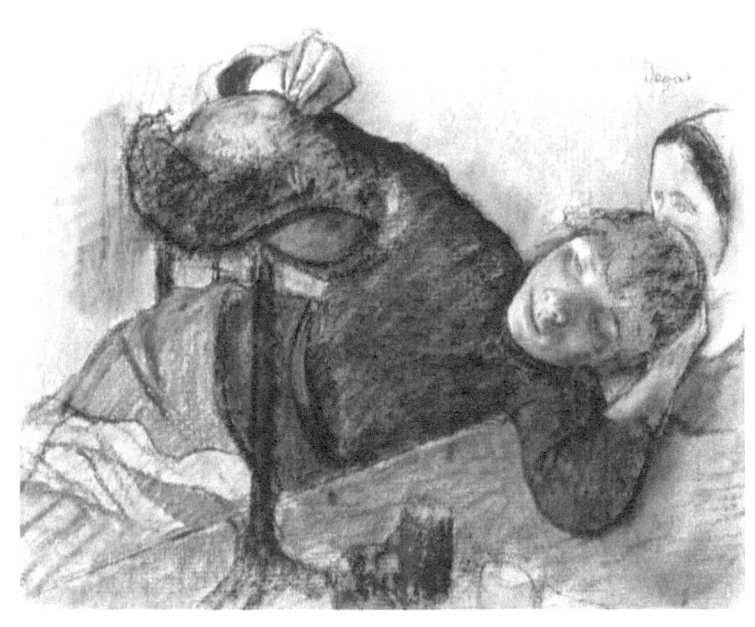

The Milliner
1882, Pastel and charcoal on warm gray wove paper,
now discolored to buff laid down on dark brown wove
paper

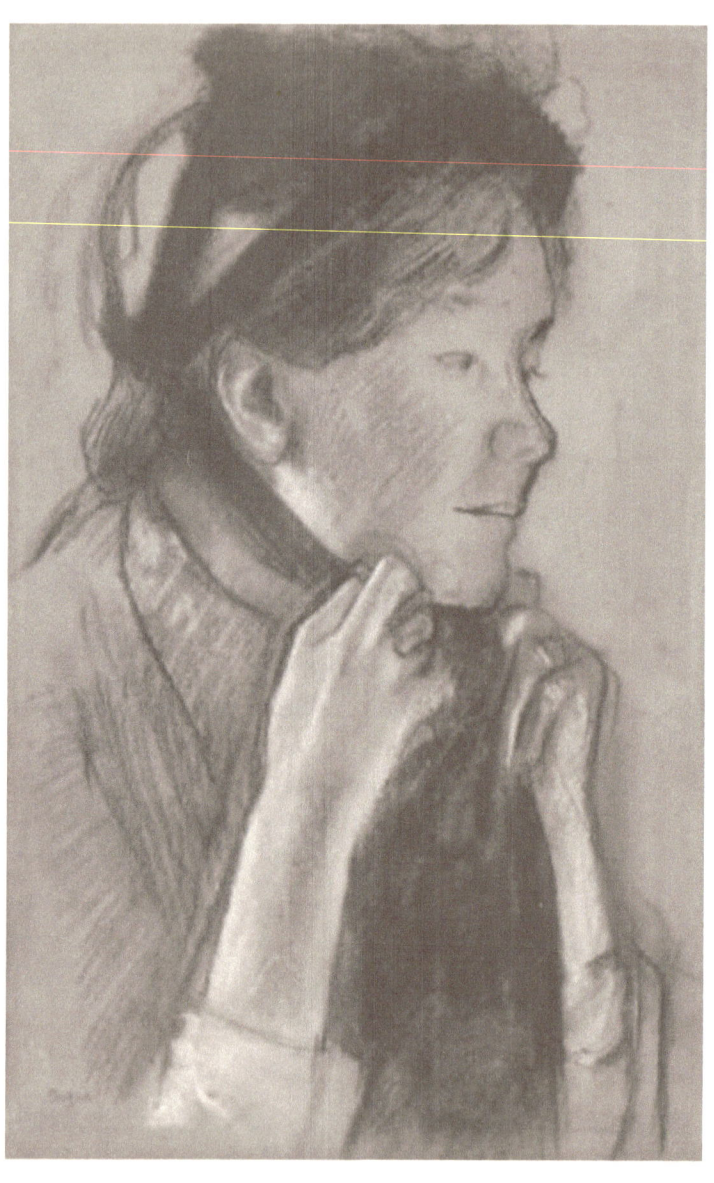

Young woman tying the ribbons of her hat
1882, Pastel and charcoal on gray-beige paper

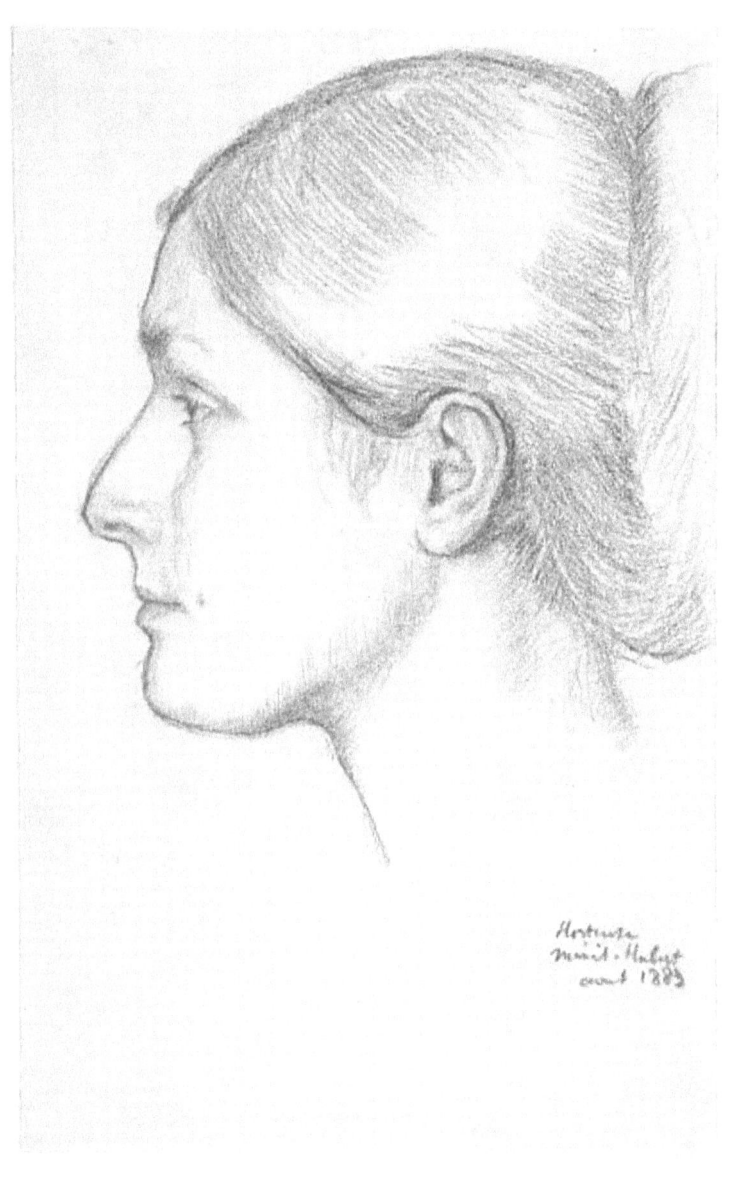

Portrait of Hortense Valpinçon (Mme. Jacques Fourchy)
1883, Black conté crayon on buff wove paper

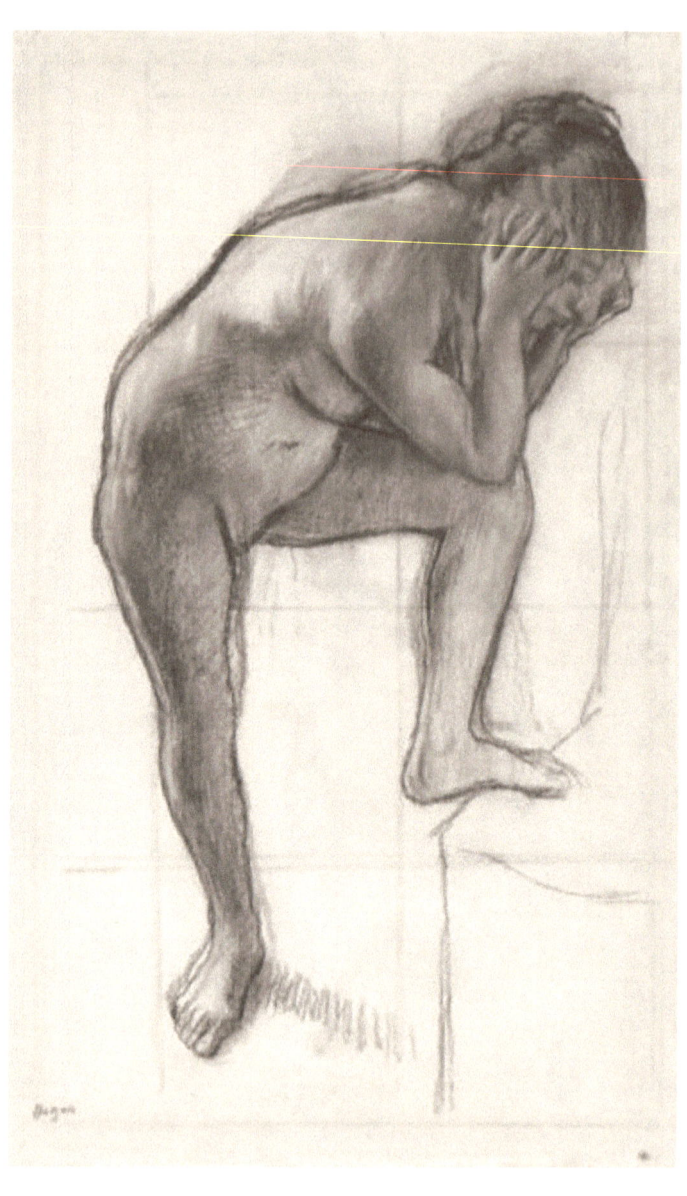

Nude woman standing
1883, Pastel and charcoal on blue-green paper

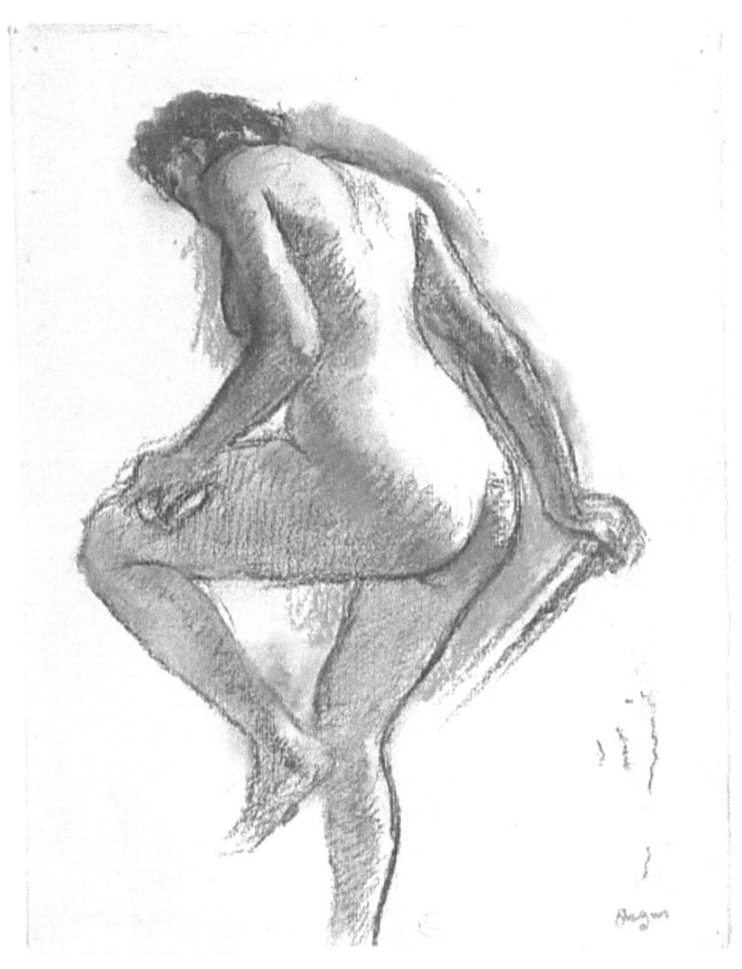

Bather Sponging Her Knee
1883–84, Charcoal, pastel, and gray wash on off-white laid paper

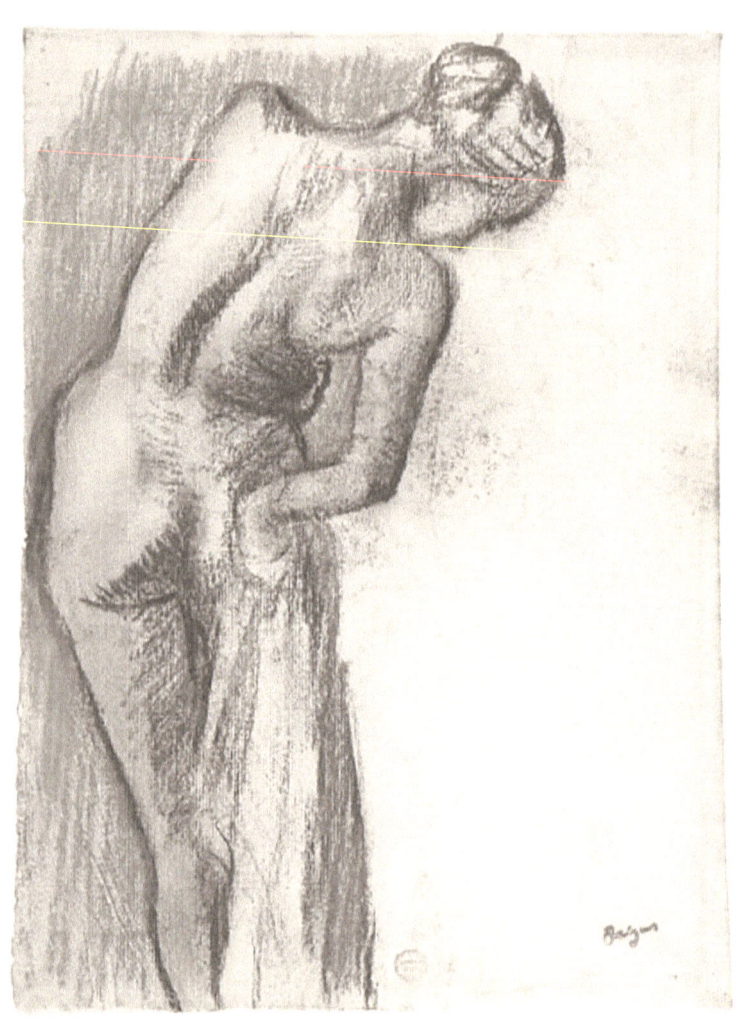

Bather Drying Herself
1883–84, Charcoal and pastel on off-white laid paper

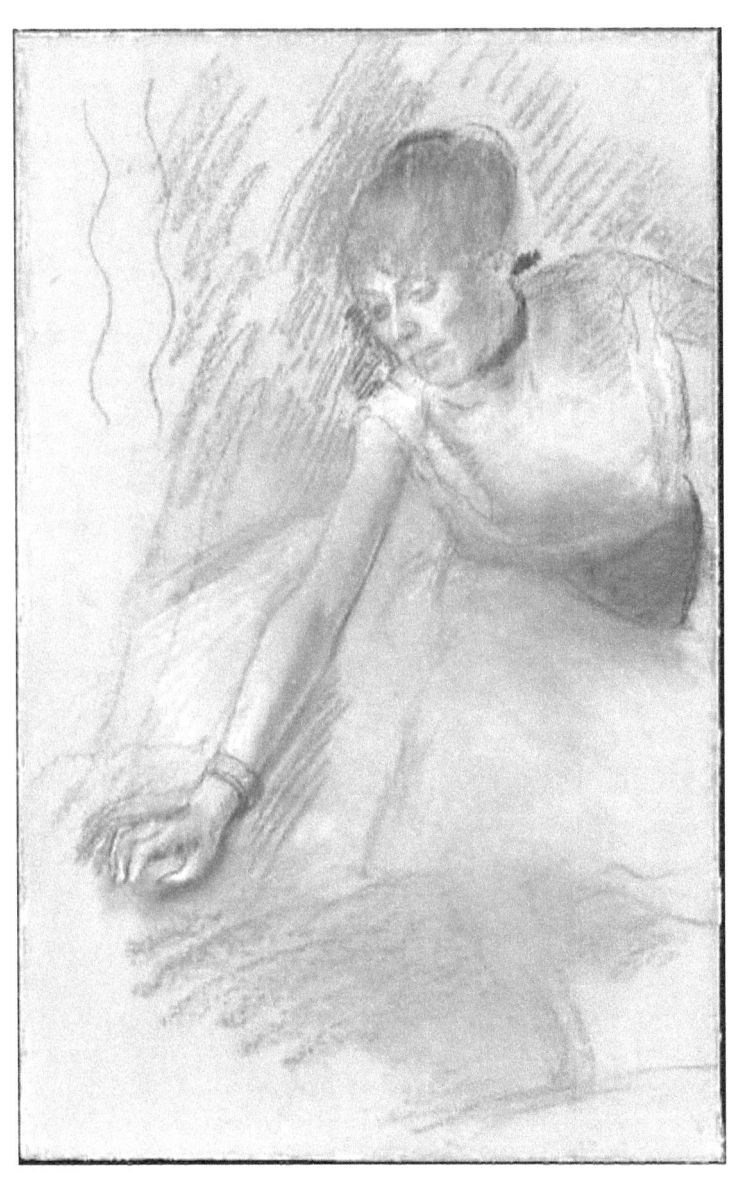

Dancer
1880–85, Pastel on paper, laid down on board

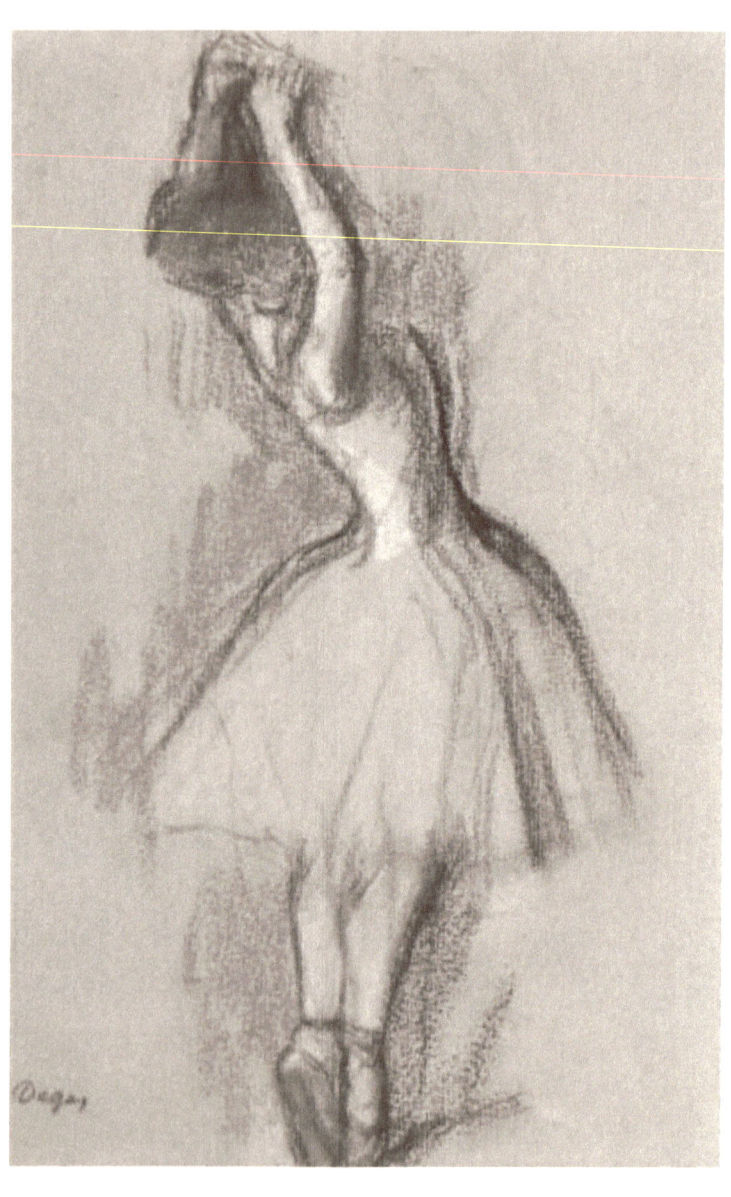

Dancer standing
1885, Pastel and charcoal on paper

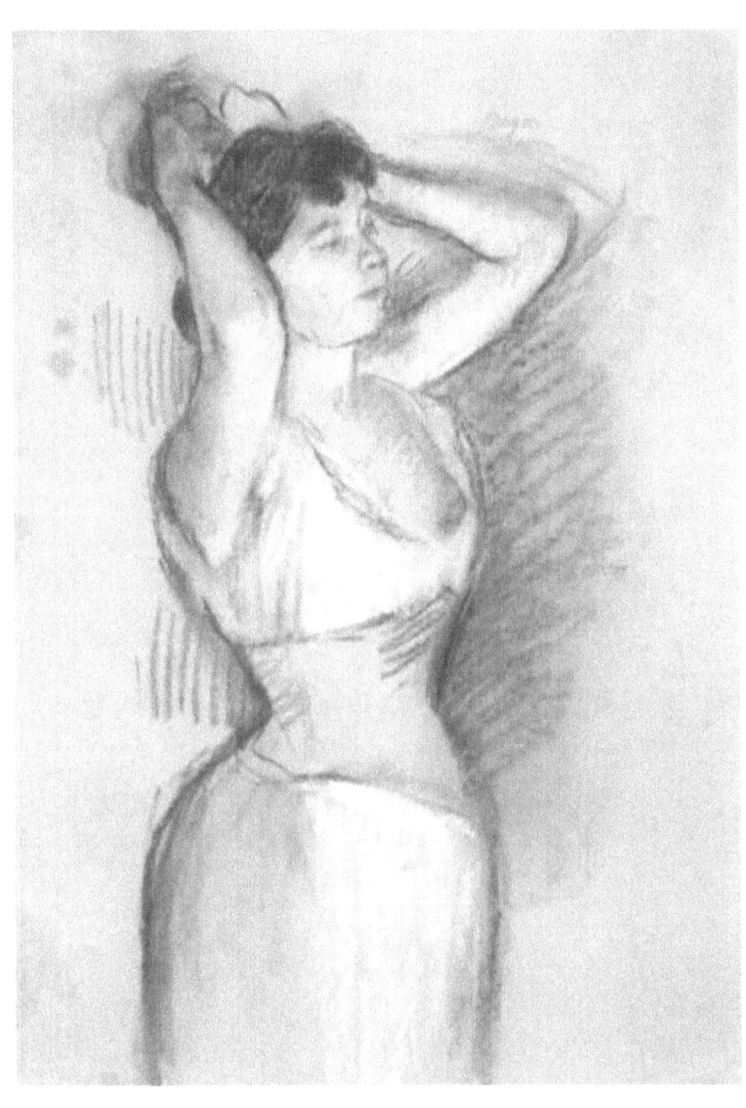

While Styling
1885, Charcoal, red, brown and white chalk on gray paper

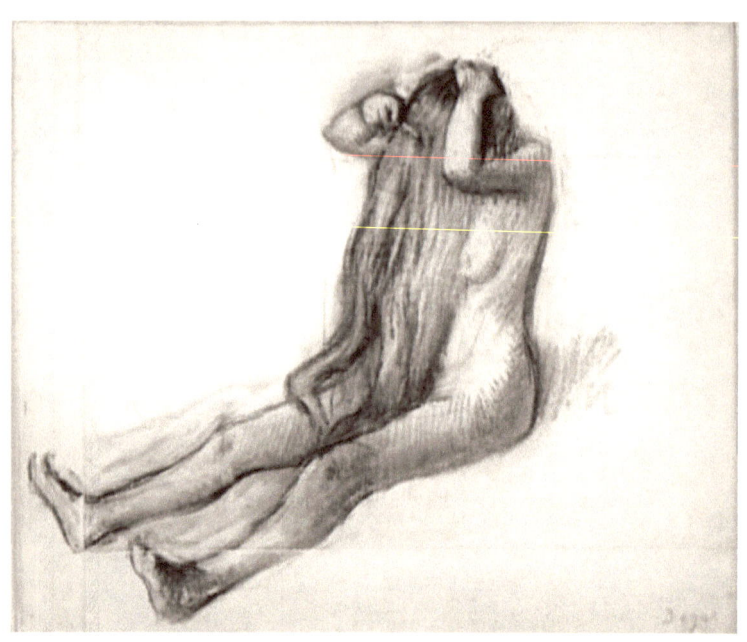

Naked woman sitting on the floor, combing
1886, Pastel and charcoal on beige laid paper

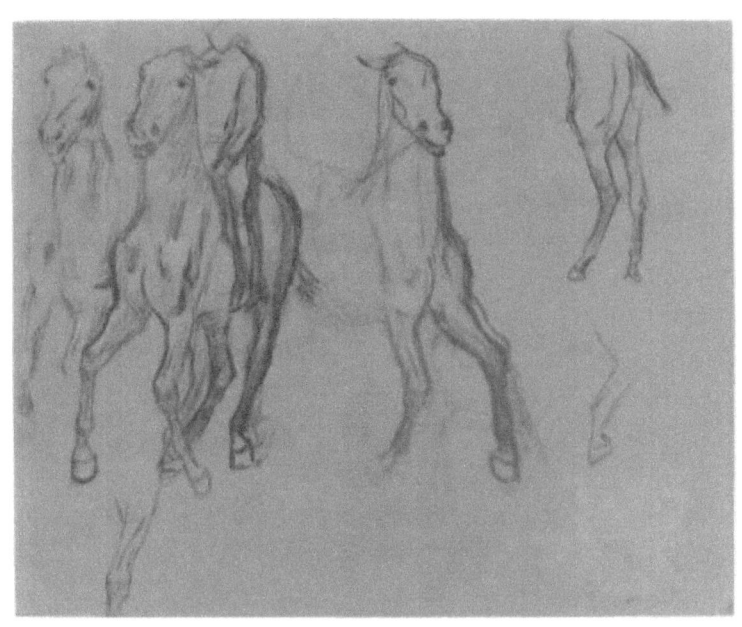

Study of Horses,
1886, Charcoal and graphite on brown paper

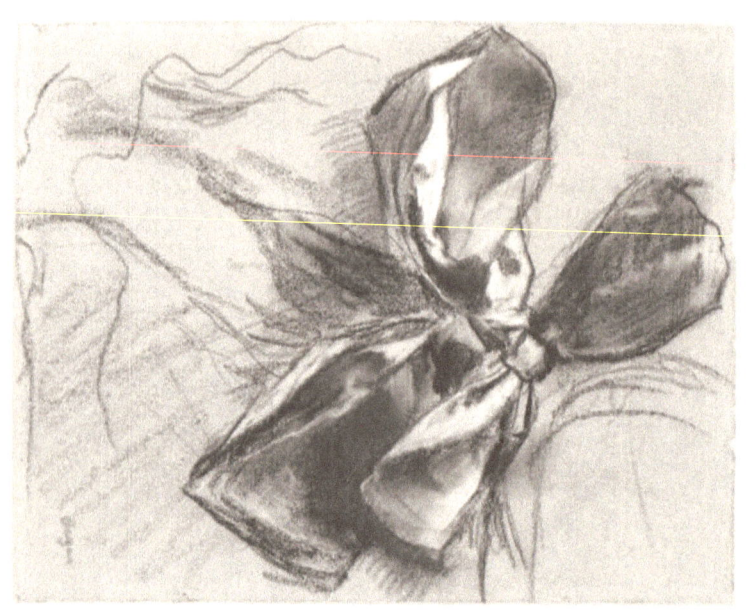

Study of a ribbon bow
1887, Blue pastel and charcoal on gray-blue paper

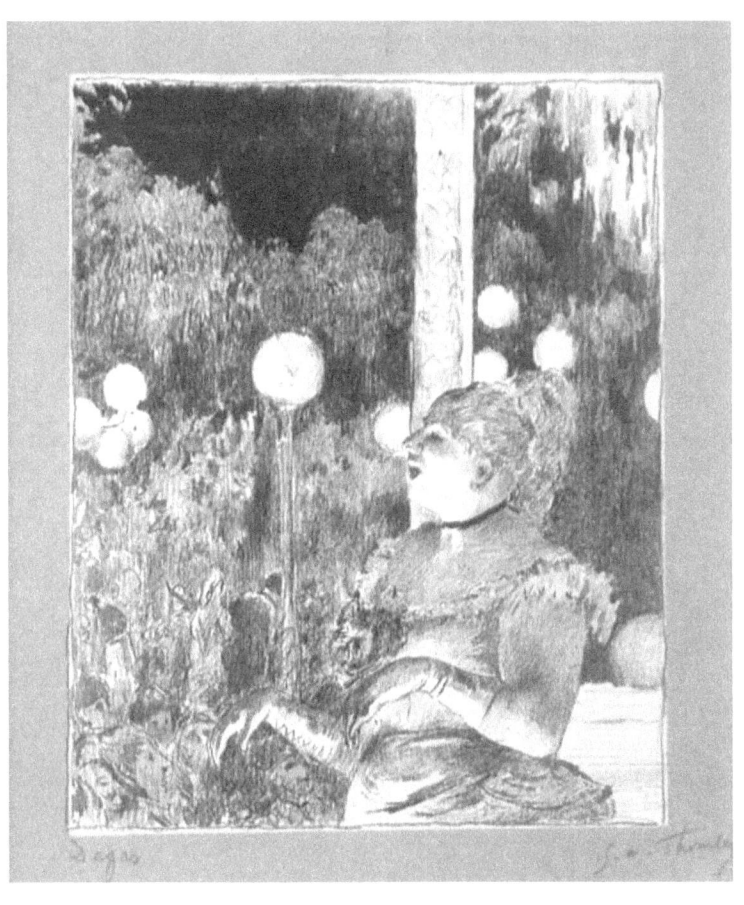

La Chanson Du Chien (The Song Of The Dog),
1888, Original Crayon Lithograph

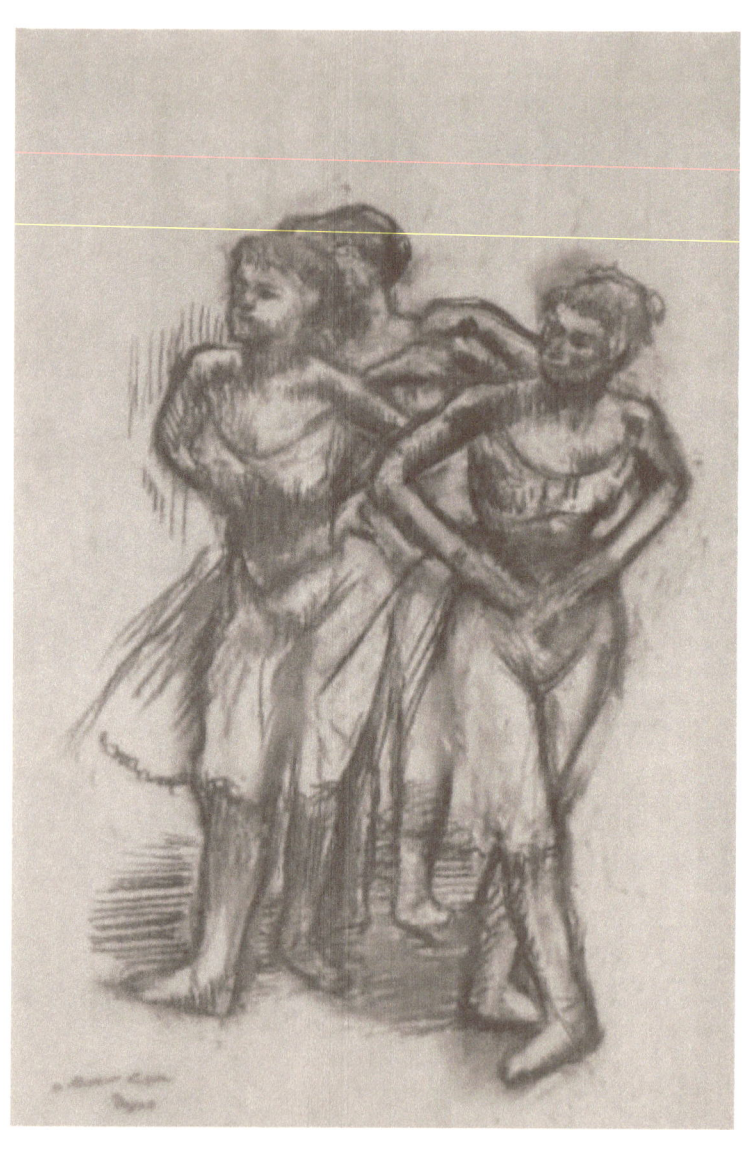

Three dancers
1890, Charcoal and pastel on buff paper laid down on board

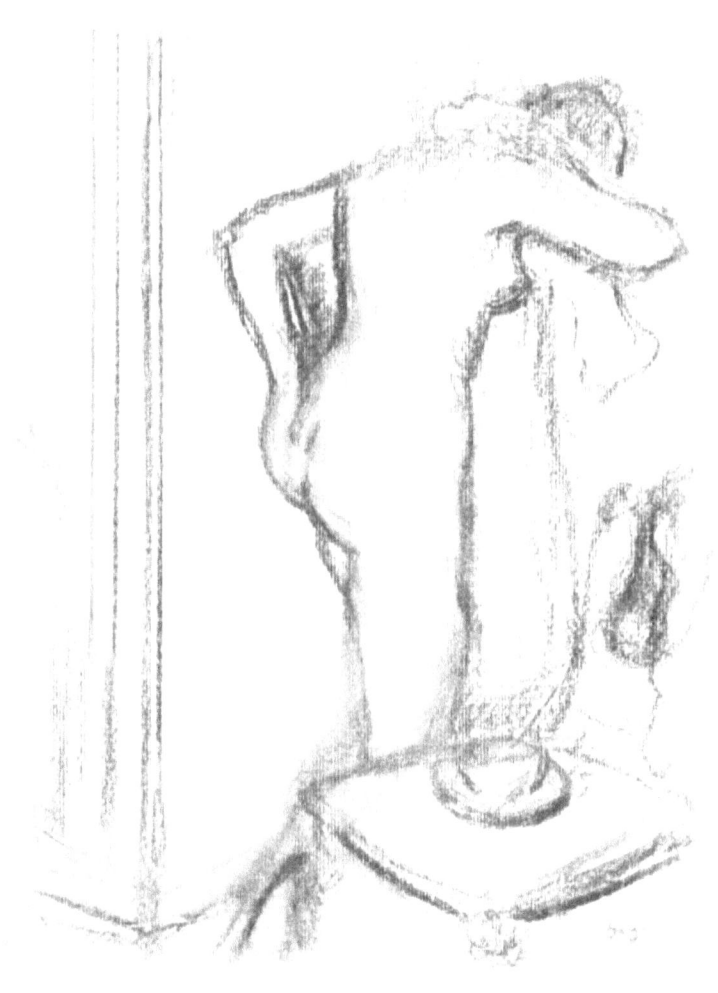

Woman at her Toilet
1890, Charcoal on paper

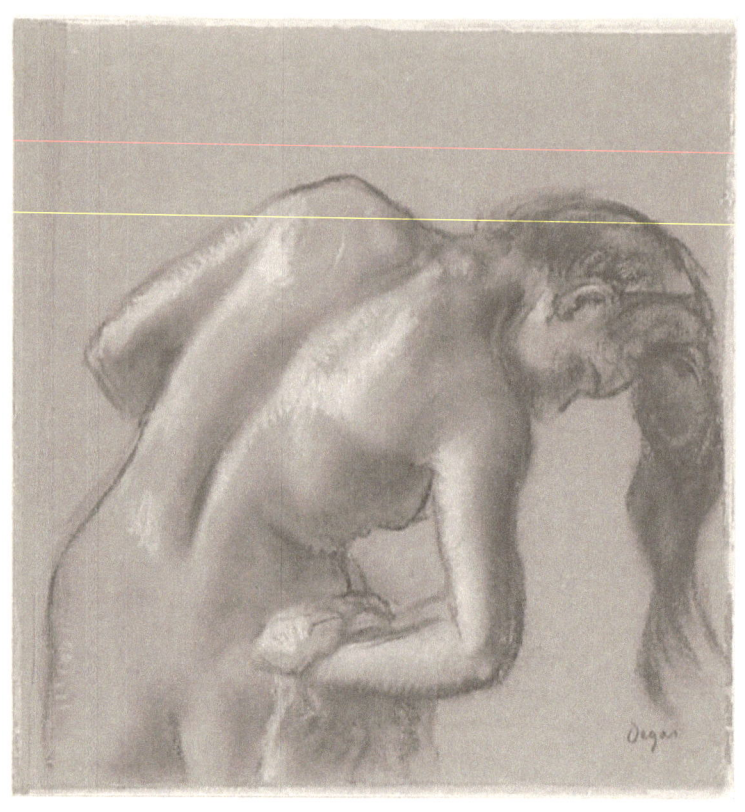

Bather Drying Herself
1892, Charcoal and pastel, heightened with white chalk,
on tracing paper (mounted on cardboard

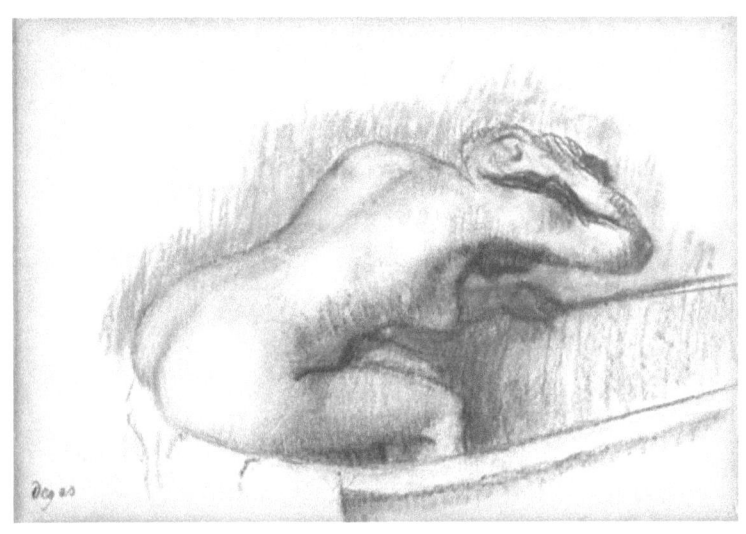

Woman washing in the bath
1892, Colored pencil and pastel on cardboard

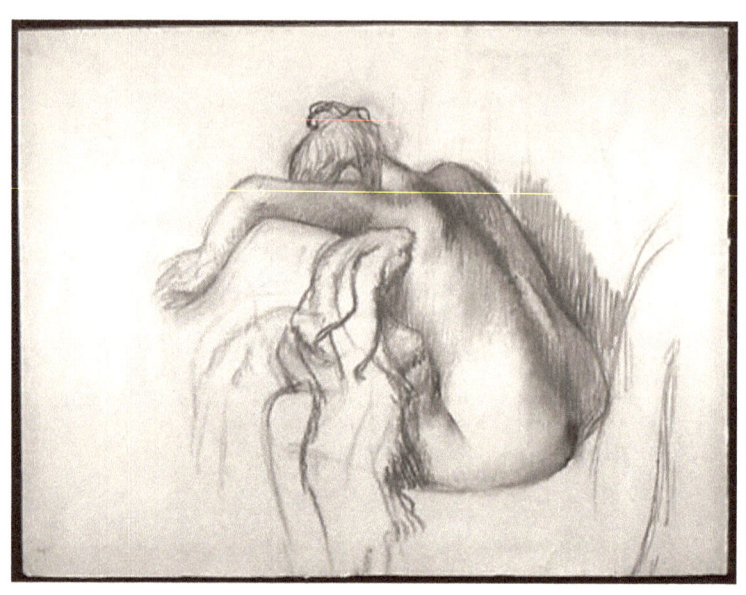

After the Bath, Woman Drying Herself,
1893-98, Crayon on yellow tracing paper

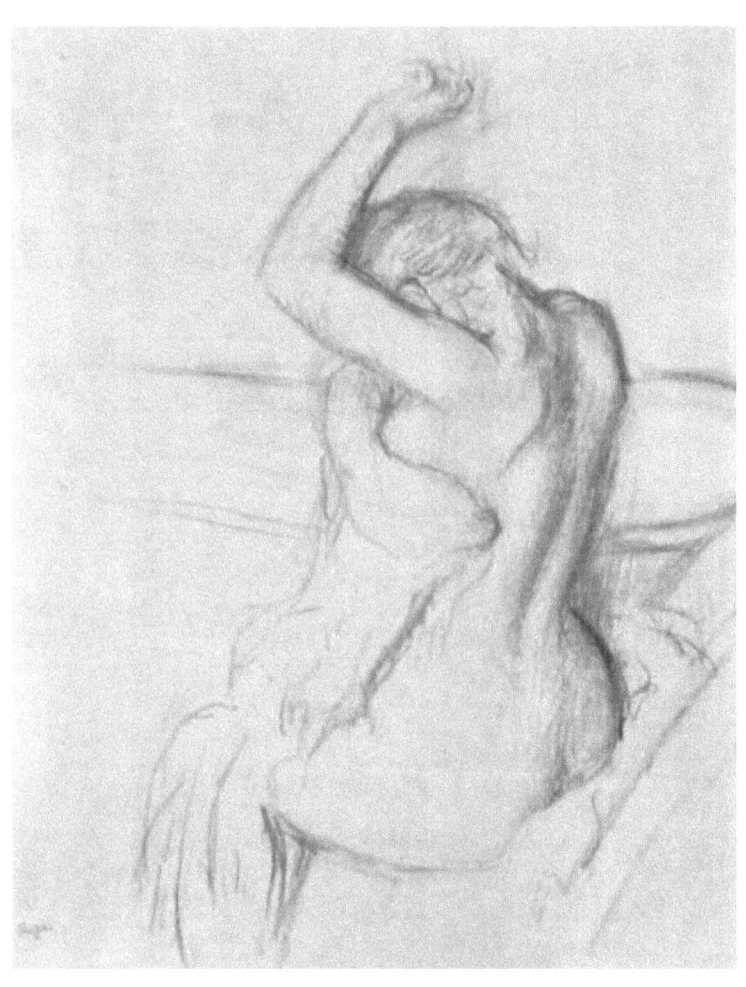

After the Bath
1895-1900, Charcoal on paper

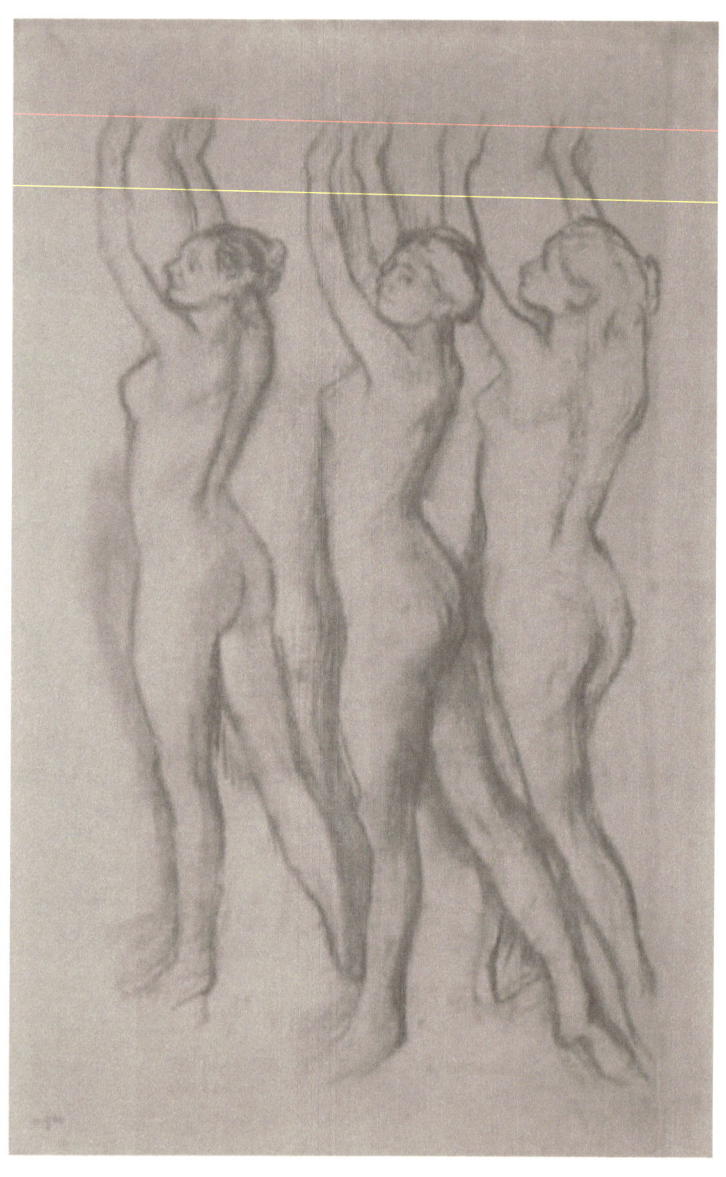

Three dancers turned to the left with their arms raised
Late 1890s, Charcoal on two pieces of joined prepared
paper laid down on board

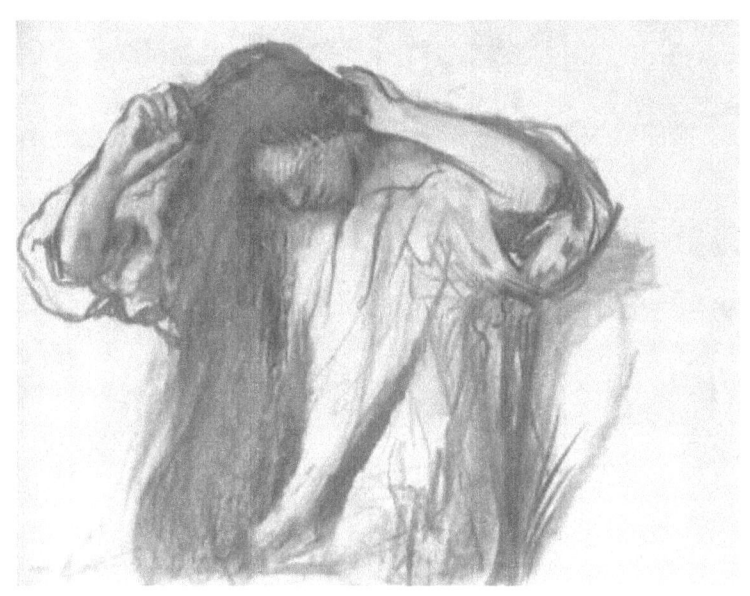

Woman Combing Her Hair
1894, Pastel and charcoal on paper

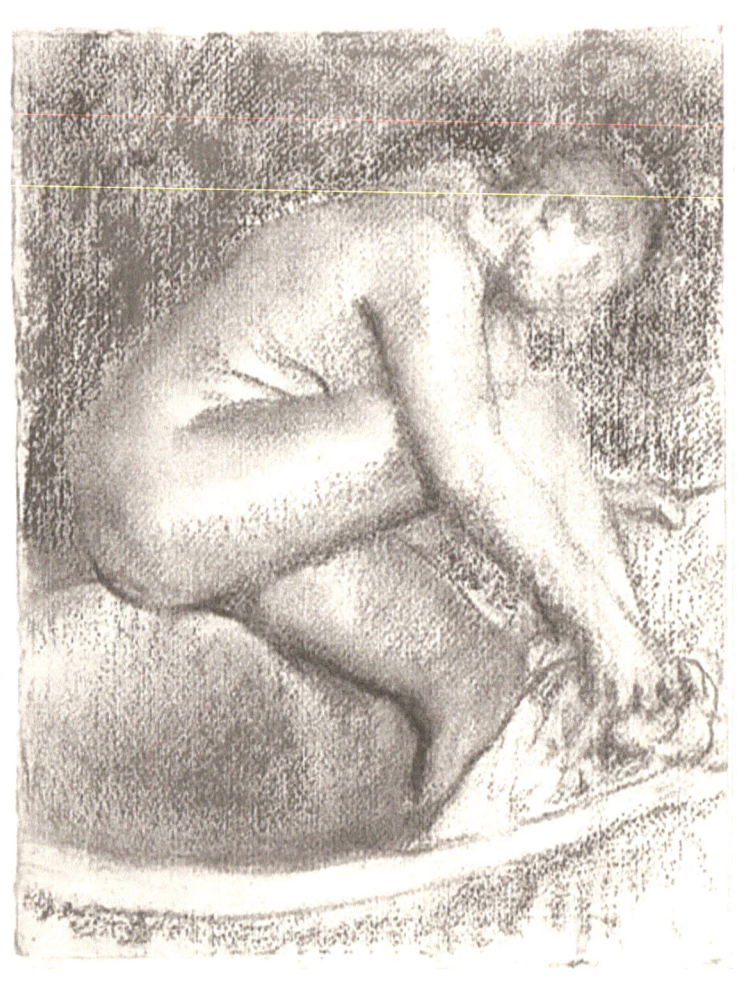

The Bath
1895, Charcoal and pastel on heavy wove paper

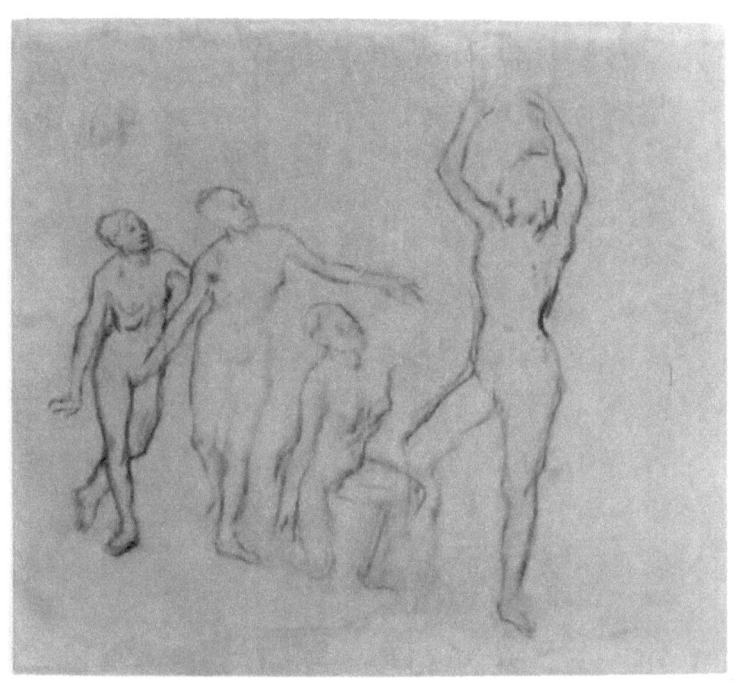

Four Dancers
1895, Charcoal on dark beige, thin, transparent wove paper mounted onto cream, thick wove paper

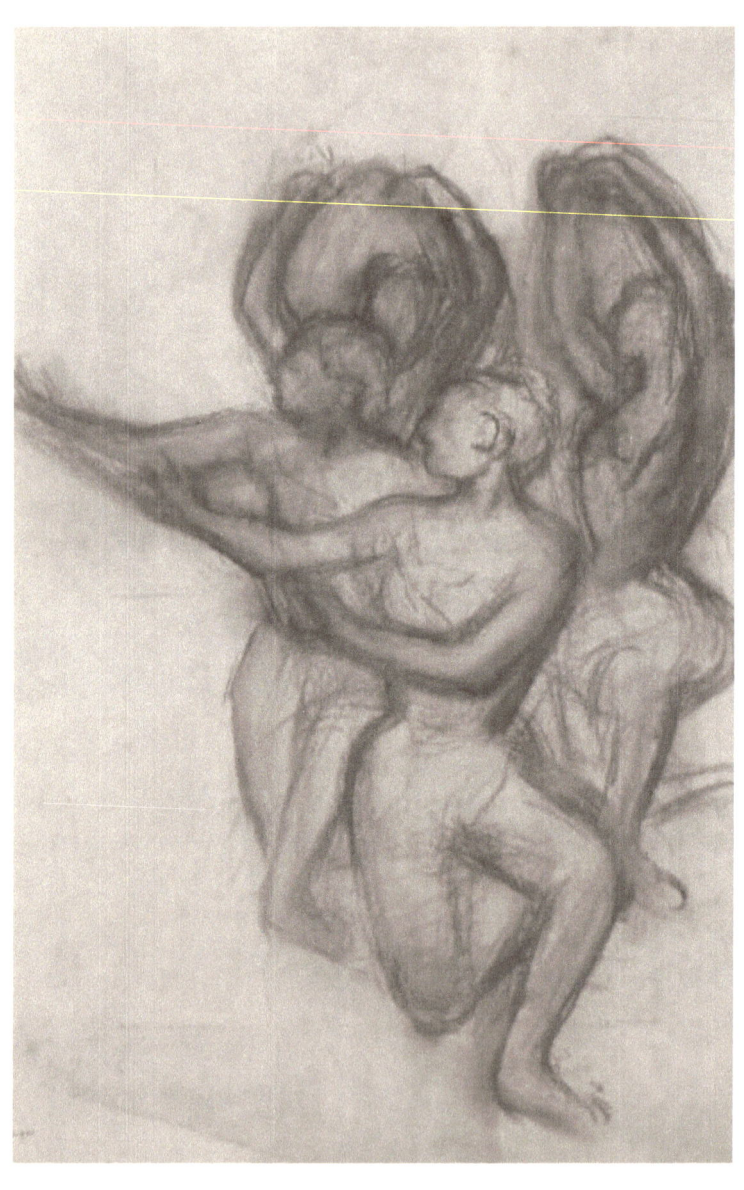

Group of dancers
1895-1900, Charcoal on joined paper laid down on board

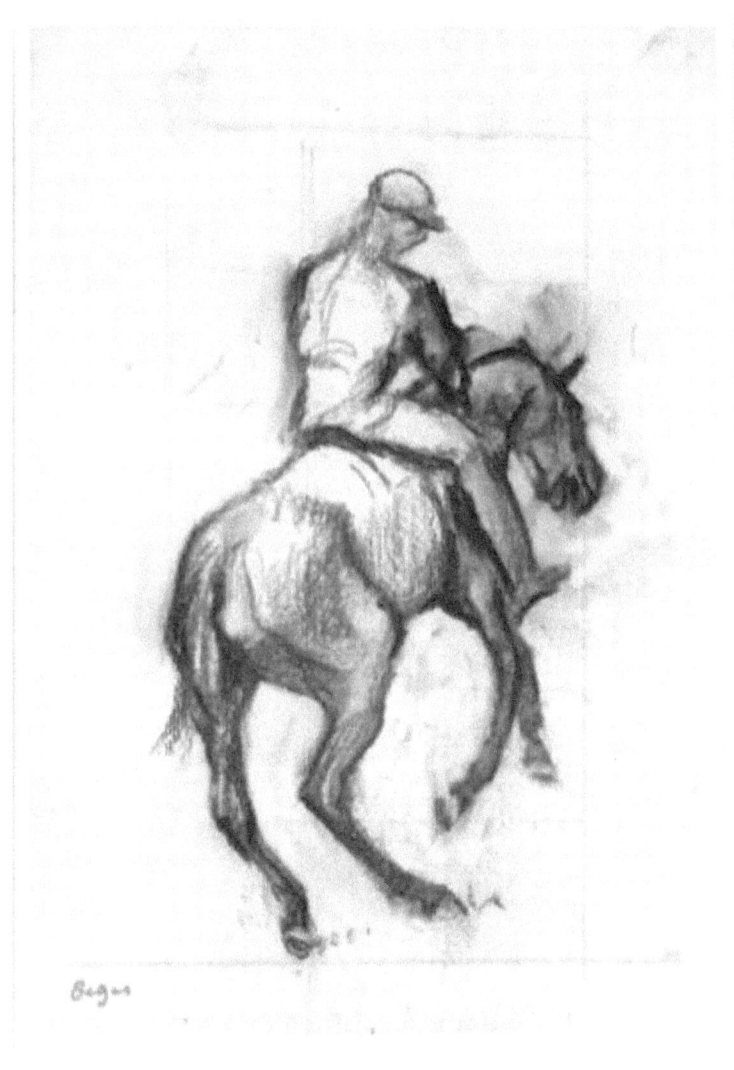

Jockey on a horse seen from behind
1900, Charcoal, wiped over grid

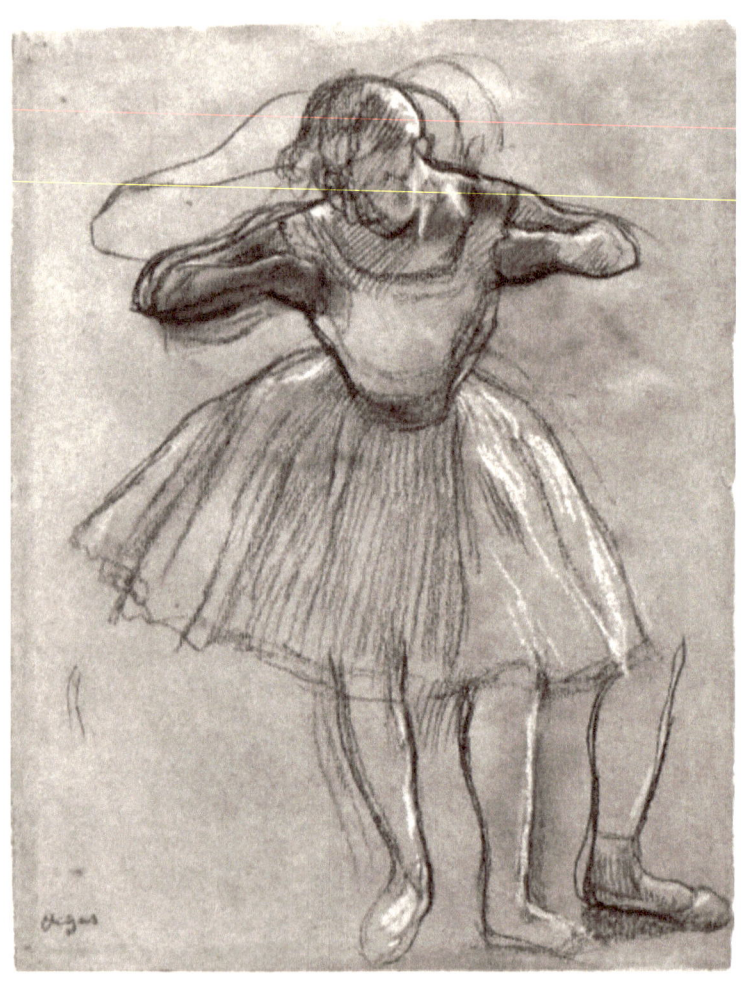

Ballet Dancer Standing
1890, Conté crayon with stumping, heightened with white chalk and pastel on blue-grey, medium-weight, moderately textured laid paper

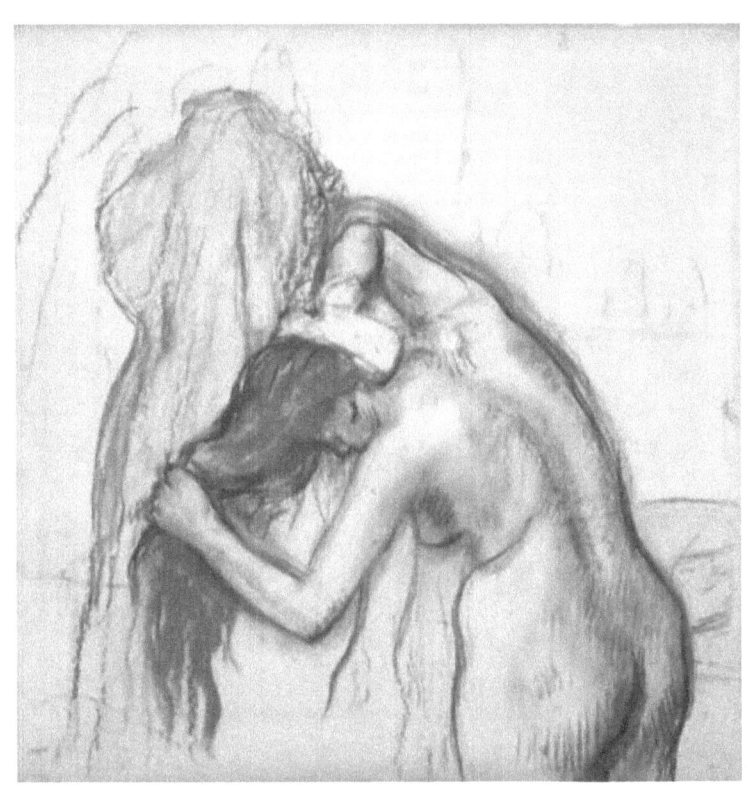

Woman Drying Herself
1905, Charcoal and pastel on tracing paper, mounted by the artist on wove paper

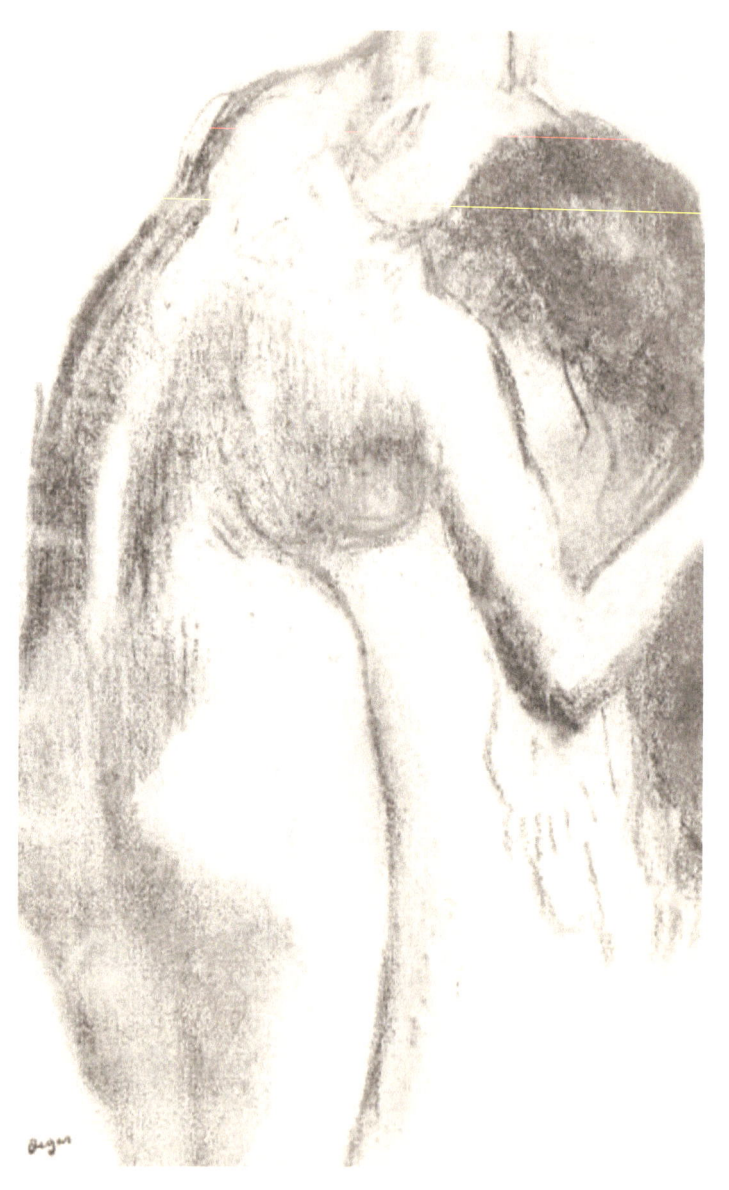

Woman Drying Herself
1906-1908, Counterproof on paper

www.ingramcontent.com/pod-product-compliance
Lightning Source LLC
Chambersburg PA
CBHW021547200526
45163CB00016B/2708